ROBERT STEWART
DESIGN 1946–95

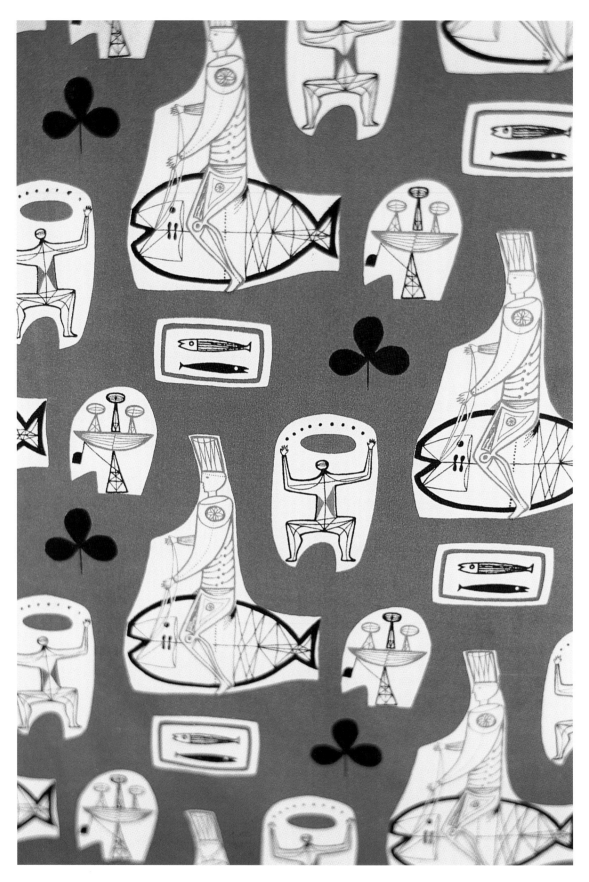

Macrahanish, 1954 (see p. 80)

ROBERT STEWART
DESIGN 1946–95

Liz Arthur

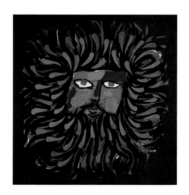

THE GLASGOW SCHOOL OF ART PRESS
in association with
RUTGERS UNIVERSITY PRESS
NEW BRUNSWICK, NEW JERSEY

First published in the United States 2004
by Rutgers University Press
New Brunswick, New Jersey

First published in Great Britain 2003
by A & C Black Publishers Limited
37 Soho Square, London W1D 3QZ

Library of Congress Cataloging-in-Publication
Data and British Library Cataloguing-in-
Publication Data are available upon request.

ISBN 0-8135-3378-3

The publication program of Rutgers University
is supported by the Board of Governors of
Rutgers, The State University of New Jersey.

Book designed by Susan McIntyre
Jacket designed by Dorothy Moir

Typeset in 11.5 on 14pt Bembo

Printed and bound in Singapore by Tien Wah
Press Limited

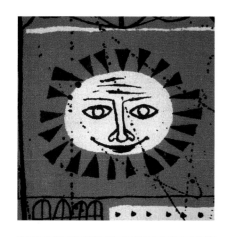

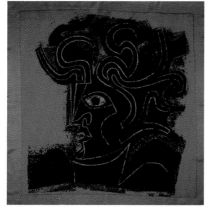

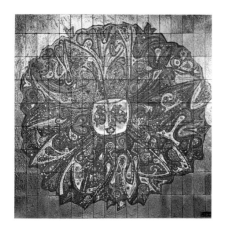

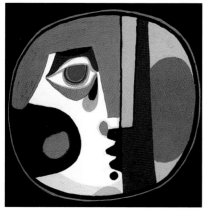

CONTENTS

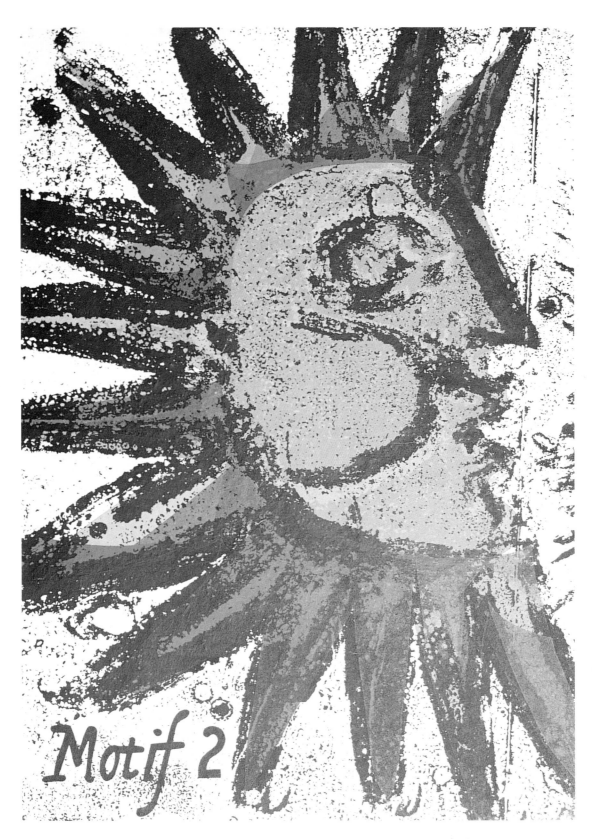

Cover of *Motif 2*, 1959 (see p. 107)

PREFACE

Robert Stewart was a designer and artist who constantly blurred the usual boundaries between the two and unashamedly called himself a decorator. He had a passion for surface design, largely on printed textiles, tapestries, ceramics and paintings, he constantly sought visual excitement and he felt impelled to share the whole experience with others, especially his students at the Glasgow School of Art. Rarely, if ever, were they aware of the extent of his studio practice, nor did they realise in what high regard he was held professionally, particularly as a textile designer during the 1950s. However, they all realised that they were in the presence of an extraordinary and demanding teacher.

Spare in appearance, Stewart walked and talked quickly, a cigarette constantly in hand, laughed a lot and had a characteristic way of sucking in breath and running a hand through his distinctive crinkly hair when he was thinking. He had a sparkle in his bright blue eyes and a playfulness that enriched both his work and his friendships. He was intelligent with an intense curiosity, he was opinionated, hardworking, unpredictable, restless, full of nervous tension and enthusiasm – he radiated an infectious energy. Above all, he was a 'doer', with no time for pretension and for whom work was everything.

A complex man full of contradictions, a mixture of ideas, concentration and impatience, Stewart always had a profound confidence in his visual judgement. He provoked strong reactions in those who knew him well, ranging from devotion to exasperation but rarely indifference. To others who met him infrequently or in passing, he appeared reticent, even shy. His reaction to others was equally polarised, he either took to someone or did not, there was no middle ground.

Despite strongly held opinions on art and teaching, he never published his views. This has made research difficult and has necessitated considerable reliance on interviews with former students and colleagues. Because of the constraints of deadlines and distance, it has not been possible to interview others who will have valuable contributions to make. To them I offer my apologies. It is, however, intended that the research continue and be added to Glasgow School of Art's Archive and Textile Resource Centre, itself forming a resource that will encourage further research.

Bob Stewart died in February 1995, and his legacy lies in the widespread influence of those he taught, whether designers or teachers. Most textile producers and major art schools in Britain will, without realising it, have felt his impact. Those fortunate enough to own his ceramics or paintings, and those in offices, schools and the public buildings where his tapestries and surviving ceramic murals feature, continue to have their lives enriched by a remarkable and diverse talent.

Liz Arthur

ACKNOWLEDGEMENTS

This project began with an idea formed by Clare Cameron, Alison Harley and Liz Munro. Thanks are due to them and the following former students and colleagues who helped turn the idea into a reality: Margaret Beck, Sheila McFadyen, Carol Paterson, Anne Ferguson, Liz Rodgers, Malcolm McCoig, Mary Duncan, Peter McCulloch, Sheila Mackay, Alex Gourlay, Una and Duncan Shanks, Lin Gibbons, Don Addison, Jackie Parry, Hannah Frew Paterson, Ivor Laycock, Ian Barr, Dorothy Crawford, Veronica Matthew, Jack Lindsay, Betty Sinclair, Alison Jeffrey, Anne Crawford, Netta Cameron (née Thomson), Tom Shanks, Dugald Cameron, Malcolm Thwaite, Freda Waldapfel, John Macfarlane, Colin McInnes, Anne and George Keith, and not least Doreen and Bob Finnie whose fund of reminiscence I have enjoyed. It is a tribute to Bob Stewart's memory that they unanimously reacted enthusiastically to the project and generously shared their experience. In particular, I owe Jimmy Cosgrove much gratitude; he read part of the script, added his insight and made a most thoughtful contribution, particularly to the discussion of Stewart's painting.

As much of Stewart's work is in private hands, l am grateful to those who have allowed access and took time to speak about his work. They include Lady Alice and Janet Barnes, Alan Gilchrist, Mr and Mrs Allen Matheson, Lesley Shaw, and Sarah and David Sumsion. To those who enabled access to the work in schools I would like to thank the Head Teacher at Glendaruel and Kilmodan Primary School and the staff at Douglas Academy and Eastwood High School.

The following archivists went out of their way to help: Pamela McIntyre, Heriot Watt University; Andrew McLean, Bute Archive, Mount Stuart; Logan Sisley, Scottish Gallery of Modern Art, Edinburgh; Steve Robb, of the Demarco European Art Foundation; Laura Hamilton, Collins Gallery, Strathclyde University; Anne Dulau, Hunterian Art Gallery, Glasgow University; Stephen Rabson, P&O Historian and Archivist; Max Donnelly, the Fine Art Society; and particularly to Anna Buruma at Liberty. To them and their organisations, to Guardian Newspapers, Condé Nast, V&A Picture Library, National Museums of Scotland Picture Library and Pringle of Scotland, I am grateful for permission to reproduce images of work.

In addition, my thanks to: Lucienne Day, Ruari McLean and Richard Demarco who shared their enthusiasm for Stewart's work; Brian Blench, Helen Douglas; Stewart's sisters Gladys Millar and Una Allen who shared their early memories; David Ferguson, photographer for the book, who quietly and efficiently coped with difficult conditions; Juliet Kinchin for advice and insight; Peter Trowles, Sarah Hepworth and GSA staff involved with the project, particularly Sarah Hall; Lou Taylor for encouragement over many years; and postgraduate students Jenny Olley and Lindsay Wells whose enthusiasm kept me going.

Tony Jones' perception and Mary Schoeser's encyclopaedic knowledge have made a major contribution to the book which would not have been possible without the Arts and Humanities Research Board who funded the research and made feasible the associated exhibition held at Glasgow School of Art from July to November 2003.

Most of all, thanks are due to Sheila Stewart for support, hospitality and patience in answering endless questions, in suggesting contacts and sources of information, and allowing access to photographs and work. Her sanction of the project ensured that it has been a real pleasure to research. Thanks are also due to her daughters Louise and Veronica who allowed us to study and photograph work.

1

ROBERT STEWART: A PERSONAL PERSPECTIVE

Professor Tony Jones
President, The School of the Art Institute of Chicago;
Director, Glasgow School of Art, 1980–86

I HAVE TWO crisp and indelible memories of Bob Stewart. One is visual, the other is aural.

The visual one is of him standing in the freezing cold in the Highland graveyard at Clachan Duich, wrapped in a beaten-up old parka, wearing black wellie boots, his frizzy hair sticking up, his brow furrowed in concentration, with a big sketchbook, clutching a handful of pens and pencils, carefully drawing a sheep. And then the pattern of the moss that has grown over the sheep. And then the letters that told the story of the McCrea clansman whose bones lay under the headstone decorated with a bold carving of that sheep, which Bob is drawing.

The aural one is the last telephone call I had from him, in which he carefully articulated how much he hated me, and how I had betrayed everything he stood for.

Doesn't matter now. It only hurt at the time, as they say. Bob was a brilliant artist, an inspiring and challenging teacher, a magnificent designer, possessed of huge generosity of spirit, and sometimes a major pain in the arse. He was a special person with unique qualities of creativity and passion, of strong character and serious beliefs, and I was fortunate both to know him as a friend and to work with him as a colleague.

Colleague twice, actually. Initially we were co-conspirators, partners-in-mischief, general stirrers and energisers, at the Glasgow School of Art in the period 1969–72, when I taught in the Sculpture Department. We were co-founders of an anarchic anti-establishment series of exhibitions, publications, lectures and performances that became known as the 'Activities Weeks'. Then, from 1980–86, he was a management colleague, academic partner and planner, senior member of the administration, and my Deputy when I became Director. A classic case of a pair of poachers turned gamekeepers ...

Bob was Head of Printed Textiles (a name intended to distance it from Embroidered and Woven Textiles) when I joined the School, but neither of us much believed in the rigidity of the nomenclature. Some people in Printed Textiles didn't ever do any, and some of the Sculpture students never made anything three-dimensional. Instead (and it's why I thought of him as

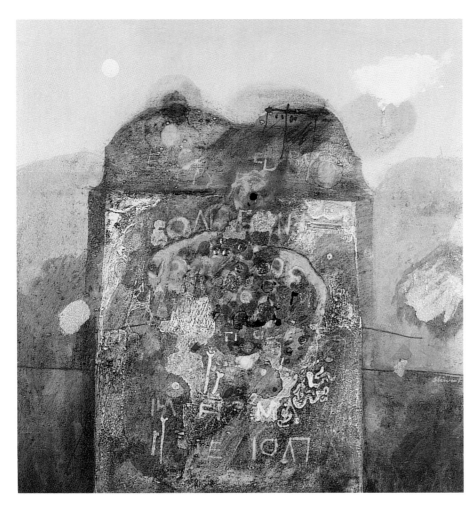

Ceramic panel; based on gravestones
at Applecross; signed: Stewart;
45.7 cm (18 in.) square
Artist's photo

a kindred spirit), we believed in the primacy of good ideas, well-expressed
with craft, skill, and even, yes, beauty ... Bob didn't believe much in a hard
border between 'fine art' and 'design', any more than I do. Although he posed
the integrated cross-disciplinary curriculum of the Bauhaus as a good peda-
gogical model, on a personal level his hero was an artist like Matisse. The
ability of Matisse to make powerfully 'designed' pictures of big bold shapes
and colours, rich in exoticism (like the Moroccan 'Odalisque' works), and
then turn effortlessly to the paper-cut collages that were produced as textiles
or finished as scarves ... well, Bob saw that as the work of a 'natural artist', not
a 'fine' one, or a 'designer-artist', just a wonderful artist who sometimes found
very different ways to 'apply' his art.

So we weren't much for narrow-minded adherence to departmental
names, and Bob initiated an informal cross-disciplinary system in which stu-
dents whose ideas couldn't come fully to fruition in their 'home' department
would be welcome in another department where they could. Well, sort-of.
Some department heads in the School changed the locks on the doors when
news of this initiative got out. But Alex Leckie in Ceramics, Dugald
Cameron in FIP (Furniture, Interior and Product Design), David Dobson
(Head of Sculpture) and others, were all part of this 'mobility of ideas'.

Bob had some influence with the Director in 1969, the seemingly aloof
and aristocratic H. Jefferson Barnes (Harry Barnes, later Sir Harry), who

would sometimes elegantly argue against Bob, but who clearly respected his complete commitment and dedication to teaching, to his students and to making their experience at the GSA richer and better. Sir Harry was far from the distant and conservative patrician we observed, as was to be revealed – though in wee increments. Bob convinced the Director that a degree of flexibility in the curriculum that allowed for student 'mobility' (a word I'd imported from America) and cross-disciplinary work would be a good thing. Somehow, later, this approach was codified and became, surprisingly, a department for lively misfits and experimenters called 'Mixed Media', which to my mind produced some of the most interesting but un-classifiable work in the School.

Bob's stock was valued by Sir Harry simply because Bob had a terrific track-record of spotting and encouraging some of the brightest talent in the School, many of whom, like Bob himself, crossed seamlessly between 'fine art' and 'design'. Internally, students in Bob's department won a disproportionate number of Newbery Medals (the School's highest academic honour), while externally his students persistently won the prestigious Leverhulme Awards (of great national significance) and relentlessly gained entry to the British centre of excellence, the Royal College of Art in London. External Examiners to the School singled out Printed Textiles for praise year after year.

Sir Harry saw Bob as sometimes abrasive, always opinionated, intermittently un-collegial and occasionally troublesome – 'hardly a biddable chap' was the phrase – but more importantly a terrific and passionate teacher full of energy and ideas. And in a School that had not seen too much national respect (let alone the national art 'renaissance' that was to come in the early 1980s led by Wisznewski, Campbell, Beaton, Hunter, Howson, Currie, Watt, Conroy, etc.), Bob Stewart was a star. And Sir Harry recognised that. Bob had done what few if any of the staff had done – commanded national respect as demonstrated by major public commissions. Bob was a very effective ambassador for the School and the Director gave him a lot of leeway inside it. More than most people were aware. Bob respected Harry for his careful far-sightedness, rectitude and high regard for Scottish traditions. Sir Harry respected Bob for his work as an artist, designer and a leading teacher in the trenches. He was far fonder of Bob than he let on.

All this was in a period of general stirring in groves of academe, but what was happening in the GSA was 'revolutionary' only in a strictly local way – other institutions had been riven by revolutions from the beginning of the 1960s. In England and Wales, there had been the student-led 'takeover' of the Hornsey College of Art, and the ferment over various issues such as the modernisation of the curriculum and courses of study and the growing importance of 'liberal' studies and cross-disciplinary programmes. All this culminated in a national sea-change signalled by the Coldstream Report on Art Education – which led to Diploma courses being upgraded to university BA degree status. Sir Harry spent more time in London than anyone else in the School (the staff said his CBE stood for 'Came Back Eventually'), and I'm convinced that he had a very astute sense of the changes afoot in England, and what they'd mean to his School. It was a considerable feat of balance that

he protected the traditions of Glasgow (while abiding by the directives of the Scottish Education Department on the matter of degree-status courses) and fully recognised the need for change – and its inevitability.

Bob followed Sir Harry's thinking in this, and became influential in changing the School's views about the coming degree-status curriculum. He had many serious reservations but he put them aside, if for no other reason than he believed the Director was right – Scottish students would be disadvantaged if there was not an exact north-of-the-border parallel to the new England-and-Wales degree. For Bob, the students came first, and this change was certainly going to affect them. Bob was quite political, dyed-in-the-wool Labour, but also smart in understanding the *realpolitik*. Bob lived and breathed the students while he was at the School. And not only at the School – students were regular visitors to parties and discussions outside the School, sometimes at Chuck and Marion Mitchell's flat in Clouston Street (where Billy Connolly would sometimes drop in and belt out some very rude songs on the banjo).

Or they'd go to Bob's home on Loch Striven. I'd go down there myself and find 'mummies' littered all over the place – they were students from the GSA in sleeping bags on a field-trip – who'd been drawing and walking and beach-combing. But not all the students went down to Striven. Bob himself, and Bob's mentoring style of teaching, did not suit all students and some complained that they felt they were being herded, suffocated or even ignored. Bob was very personality-orientated, so if he did not get on well with certain students who he thought were obstinate or slackers, he tended to put them on the back burner and let them cook themselves.

The Printed Textile course was notable for its liberality and encouragement of different ways of expressing ideas, and often in very non-traditional ways. Students shifted to and from other departments to execute their work, using PT as their home base. This led to a certain amount of administrative turmoil, certainly, but it also gave the department a vibrancy and unpredictability that made it stand out. But any idea that the GSA was a totally rigid and hidebound place that never thought outside the box is not true. There was a tradition of maverick activity, and the impact of the quite revolutionary Section V of the First Year Course has been underestimated in overviews of the School. The School, compared with other institutions I saw in the same period (I won't say which), was actually a melting pot of ideas and innovations. And the School was changing. It was the 1960s. Changes happened, controlled or not, and Bob was at the centre of those movements, 'Activities Week' being the most graphic and blatant. I think I'm to blame for this.

Bob and I were talking about how I noted that the students in the post-Christmas Holiday period were surly, uncommunicative, struggling with their work – as the Americans would say, they had 'cabin fever' from the long dark days cooped up in the studios. I'd moved back to Britain and to Glasgow after three years living in the exotic hedonism of New Orleans and the American deep south, so I was feeling it, too. Bob said he'd recognised it for years in his students, and in himself.

Glasgow Plus or Minus, 1970s;
screenprinted poster for Activities Week;
101.5 x 76 cm (40 x 30 in.)
GSA archive

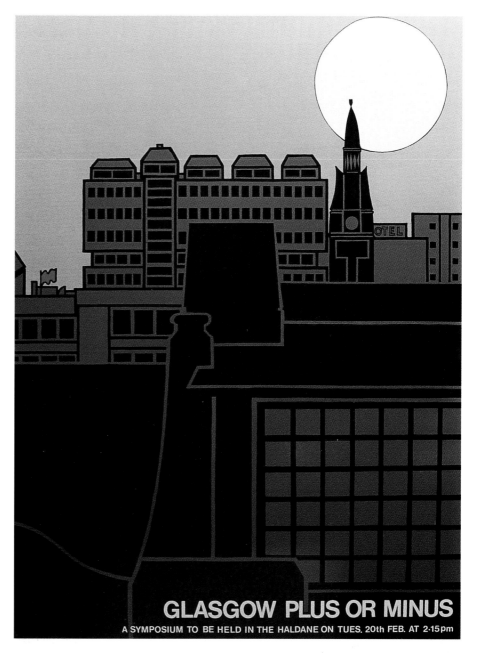

So we talked about jump-starting everyone out of their winter funk – 'what about getting a really terrific artist to come and speak to the whole School – an art star, someone we'd never ever get to see and hear' (there followed a list of names); then 'let's get that chap who writes about the counter-culture' (Theodore Roszak), 'what about your friend from New Orleans who does those beautiful screenprints sending us a show?' (Robert Gordy), 'do we think that Paolozzi would let us show his beezer new collage?' (yes, he would), 'what about that amazing American writer who calls himself a 'Futurologist'?' (John McHale), 'who's that loony performance artist who makes the environments and robots and is in the Beatles movie?' (Bruce Lacey), 'what about that architect who worked with Lord Snowdon in the London Zoo?' (Cedric Price), 'would Peter Blake come, and bring Ian Dury?' (yes, and no), 'who's that French woman who writes what she calls Concrete Poetry?' (Lily Greenham)

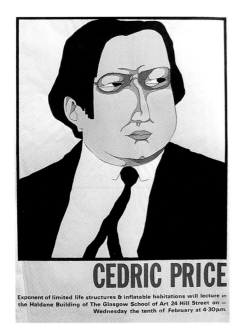 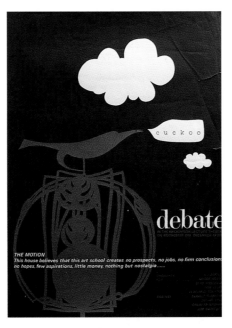

and, in the end, 'could we get David Hockney's and Eduardo Paolozzi's phone numbers and ring up and ask them to come?' (yes, yes, and they did). Selfish? Just a wish-list of people we wanted to meet? Confrontational? Calculated to discombobulate those we saw as hindering organic growth and modernisation? Of course. But wasn't it all intended just to challenge students' preconceptions, stir the grey matter in the months of grey skies? Yes. Guilty as charged.

We were not alone in this by any means, with many staff and mature students all adding new ideas and plans. But Bob's seniority as a staff member and a head of department ensured that it wasn't all talk, it became action. I can't describe Sir Harry as our silent-partner-in-crime, he wasn't, but he did ease our path, in spite of protestations about this 'anarchy' from some other School staff. And he funded us – a modest amount, to be sure, but enough to enable us to invite speakers by giving them a train ticket. Enough for the School to get the idea that the Director thought a change in pace and a break in the 'cabin fever' to be a good thing. I got on the phone, Bob sent official letters, we went to see Paolozzi and Hockney, and everyone we asked immediately agreed to come. The 'Weeks' became a regular fixture, running alongside the regular day-to-day life of the School, and were taken over by other lively staff so that they grew and changed. They were spice in the soup.

They were not entirely welcomed, obviously. Some staff said they were disruptive, some ignored them completely, some refused students permission to attend events that would 'interfere' with studio time. And a few things that happened were uncontrolled and over the top, and caused a row.

The visit by performance-artist Bruce Lacey, for example. Bob and I went to Central Station to meet him off the London train. He was wearing thigh-high suede boots, like a pirate, and a full-length coat made of the kind of plastic grass that greengrocers use. We toured him round the School, and in passing the Painting Life Studio, he saw students were painting the nude figure, standing at actual easels, with actual palettes and actual oil paint. Lacey dropped to his knees, crawled across the floor, pulled himself up by the

ABOVE LEFT TO RIGHT:
Screenprinted poster for Cedric Price's lecture, 1971; 101.5 x 76 cm (40 x 30 in.)
GSA archive

Design based on the GSA weathervane designed by Mackintosh; poster for Activities Week Debate, 1970s; 101.5 x 76 cm (40 x 30 in.)
GSA archive

Activities Week screenprinted poster, 1970s; 99 x 73 cm (39 x 27 in.)
GSA archive

clothes of a lady student, and gasped, 'Linseed oil, I need linseed oil' ... which, stunned but functional, she gave him. And which he glugged down – the whole bottle. Every painter in the studio stood, frozen and slack-jawed, watching. He then rose and strode manfully from the room, noisily licking his chops. Wonderful. But the Head of Painting was teaching that class, and spotted Bob and me in the corridor outside, laughing like a fool, so I was banned from the Painting Department. Sir Harry chastised me and said that I'd have to remain 'below stairs' in the Sculpture Department, and that Bob would henceforth have to keep me, 'that impresario in the basement', under better control. (Bruce, by the way, spent much of the rest of his visit skipping off to the toilets – and even during his standing-room-only lecture! – suffering from 'a raging case of the Glasgow shits' because of the linseed oil ...).

David Hockney's visit was accompanied by a film series of his favourite movies (including *The Producers* and *Singing in the Rain*), and his lecture was invaded by interlopers from the other Scottish art schools who had heard that he was coming to Glasgow – our students repelled them. And it was given at the height of the social warfare occasioned by the government of Prime Minister Edward Heath and his clash with the unions, which resulted in power and heat being rationed and the country working a three-day week, so there was no guarantee that David's projector wouldn't be cut off in mid-lecture by

Activities Week, May 1975; printing on an Arab press in Sauchiehall Street
Photo GSA archive

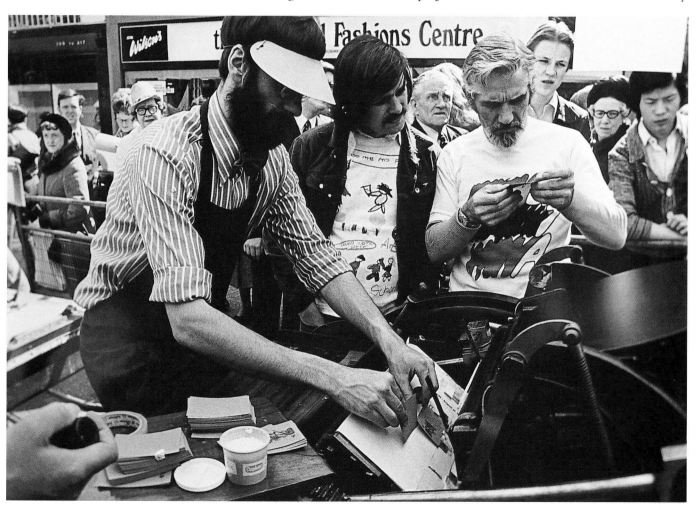

a power failure. Cedric Price's visit resulted in an apoplectic Director furious that we'd paid for the rail fare for Cedric's 'popsie' (a WWII word for 'girl-friend'), until he met her – it was the actress Eleanor Bron, then at the height of her television popularity. Eduardo Paolozzi spent the first day of his visit cruising the porno shops looking for vintage non-Scandinavian erotic comics for the collages he was making. So many stories ... and some are best not told.

Outside the School, going to Bob's studio and house in Loch Striven was an adventure, though it was hardly a convenient place for him to live. But it was quite magical, perched almost at the head of the loch with a quite astonishing view sweeping away to the sea. It was full of happiness, people wandering in and out, great big Pyrenean dogs, the six kids, and Doctor Sheila, who was a truly wonderful person and pathologically tolerant – though she often commented that she thought artists were a different species, and that the politics of the School of Art rivalled the Byzantine empire. Very good at giving us a reality check. There were rambling talks long into the night after whopping suppers of mackerel caught in the loch below, much wine and whisky, the usual disagreements and reconciliation.

I left the School in 1972 and moved to Texas, but I came back several times over the following years, and visited Bob both at the School and out at Loch Striven. His studio was always full of vast amounts of work in progress, work being rejected, work being finished, new ideas being batted around. I don't think he ever stopped making work, it was an ordinary passion that was always there, every single day. He was a natural at playing with materials, experimenting with work like Procion textile dyes unconventionally used for staining the paper for his landscapes. Paint was mixed with glue and applied to roofing slates, and there were tablefuls of glazes and strange concoctions for baking onto tiles in the ceramics try-out kiln. There were lumps of stuff all over the place, just materials he liked for their surface and texture. I've mentioned Matisse, but the other artist whose work he loved was the Spanish painter, Antonio Tapies. The sensuality of surface, the slathering of rich slops of thick paint like the icing on *gâteau*, the collaging of materials into the abstract composition; Bob's work didn't ape that of Tapies, but you could see why he liked it. And if you asked him about how his work was developing, the answers would be simultaneously opaque and quite specific: he said some of the work was just 'playing', finding out how some new paint, dyestuff, pen or Magic Marker could perform, so some of it was undirected 'experimentation' that might lead to something or other and was driven by the novelty of the material. (Often this 'playing' was imported into the GSA studios with a 'look what I've found' enthusiasm, materials shared so that students could play and find applications suitable to their own work).

But sometimes the answer was very specific – the work was about going to a place, what happened there, what the weather was like, what textures he found, what event informed the work. The whole story. Sometimes it was about a need for an environmental contrast. I'd run into him and he'd be excited because he'd just been down to a travel agency – usually to 'Tommy Twaddle's Travel Trips' (I kid you not). He'd booked a flight to the Algarve in southern Portugal, where the harsh daylight and soft peachy gold of the

Activities Week Poster, 1970s;
101.5 × 76 cm (40 × 30 in.)
GSA archive

8

sunsets were in marked contrast to the flinty sidelight of the Highlands. And when he talked about this, he had a hand gesture that went with his description – he'd rub the tips of his fingers and thumbs together. He was talking about light, but he felt it as fabric.

The Striven studio was filled with lumps of wood shaped by sea that he'd found on the beach – and one extraordinary object that he'd discovered tangled in the flotsam – a long decorated gold-and-black name-board from a vessel long-lost at sea, In all the world, surely only Bob Stewart would have stumbled upon the final remains of a boat called 'Good Design'.

In 1980, I came back to the School as Director. In the period I'd been away, Sir Harry had received permission from the SED (Scottish Education Department) to launch an innovative new course of four terms' duration, which led to a postgraduate Diploma in Design. It was very much Bob's creation, widely known as the BSC (for Bob Stewart's Course), and was housed at the top of the Mackintosh Building – a symbolism lost on no-one. It was a curious amalgam of Bob's ideas, run with staff he trusted, and was intended to be a small-scale and truly cross-disciplinary programme. There was no model for it to follow (not even the vaunted Royal College's postgraduate courses) and it intrigued the CNAA (Council of National Academic Awards) External Examiners no end. Its students graduated at an odd time of the year and their exhibition stood out, for better or worse, from everything else in the School. It was successful, if flawed mostly by Bob's irascibility and a certain amount of resistance within the School. Some staff asked me to explain exactly what the course was and why I supported it, and were suspicious that it was 'over-provisioned' in comparison with others.

The reality was that Bob wanted complete control of this course, but the students couldn't actually make very much unless they had access to the workshops and technicians of the many departments in the rest of the School. Given that Bob had alienated some who controlled access to 'their' facilities (being every bit as territorial as Bob was ...), a spirit of happy partnership was sometimes absent. Demanding 'tool-time' of his colleagues did not always work. In spite of this, excellent work came out of the course and we took the plunge and went for full CNAA and SED approval to upgrade the course to an MA in Design, which was approved. A triumph for Bob, another feather in Glasgow's cap. But also the seed of the issue that separated us.

Bob was an active partner in my Directorship. I'd appointed him Deputy Director, in the teeth of some fierce opposition. But I was determined to create a 'balance' in a School that had become so top-heavy in the area of the Fine Arts. There had not been a major force in the GSA that had come from the Design School for a very long time and Bob's appointment was a sure signal that I wanted the design disciplines to assert themselves. I wanted his experience, his commitment, his ideas, his creativity, to serve the School on a bigger stage than his MA course. Some of the Fine Art people got the willies over this, sensing that what was 'theirs' would be 'taken from them' and given to Design. Not so, but that was the view at first. It took a long time for the School to believe in even-handedness, and that we were a single institution with a single mission, not a Balkanised university. Moving Bob to the Deputy

Director post also allowed me to make other significant appointments – making Dugald Cameron and Jimmy Cosgrove into a pair-in-harness with a lot of authority and responsibility to get things moving and changing. Imagine gallus (cocky) Dugald and Jimmy towing Bob into my office with the temerity of the idea of taking a Design School exhibition to Milan ... the Holy-of-Holies of Design – and then doing exactly that!

It was a great team of very bright and very talented people. And we were lucky. Incredibly. We were at the School when the fortunes of the city changed, Glasgow brightened up, Mackintosh was finally being given recognition, and the School was a powerhouse. And the School was lucky – it had some absolutely great teaching staff. The Design School was booming and Dugald Cameron (who later became Director of the GSA) took it to new heights with a completely unique new joint GSA/Glasgow University degree in Design Engineering that received national attention. Bob ran the 'think-tank' MA Course in addition to being Deputy Director. Architecture was thriving under Andy Macmillan's strong leadership, the First Year Programme had the driving progressive Jimmy Cosgrove (who later became Deputy Director) at the helm with a great teaching staff, while the brilliant, calm and diplomatic Bill Buchanan held the reins in Fine Art and planned several new initiatives including the MA in Fine Art, and we got Thomas Joshua Cooper from the States to begin the Fine Art Photography course. The intense and tireless Jack Knox was appointed Head of Painting. On the administrative side Frank Kean, the GSA's Secretary and Treasurer, and Drew Perry, who oversaw all buildings and services, and my assistant Margaret Maxwell, all tried to keep the School solvent, fully functioning and organised. Bob and I did our regular dog-and-pony shows for the Board of Governors, which was Chaired by the ever-supportive Bill Leggat Smith, and was fully and enthusiastically behind the work of the staff. The Scottish Education Department watched from a distance, sometimes bemused, but always giving solid help and great advice, mostly from Eddie Frizzell at the SED. The *Glasgow Herald* arts critic, Clare Henry, was a tremendous supporter of the School's work, and very effective in getting the message out that the School and its students were doing terrific things. This was true, and people came to see for themselves.

The two successive generations of new 'Glasgow Boys and Girls' were graduating from Painting in this period, Design and Architecture were outstanding, and the annual Degree Shows became a circus, mobbed by local and national visitors. The London critics and gallery owners called, wanting early access to get ahead of the crowds. The attendance on the opening nights was so large the Police stationed squad cars at either end of the street to stop traffic from running over the pedestrians. The London *Times* described the GSA as 'the liveliest art school in Britain'.

What happened in the School to make all that happen was done by a team – a great team. I can't name them all, there are far too many. They had fights and unholy rows, battered ideas around, shifted things, built and rebuilt. And with Bob Stewart in the middle of it, shouting the odds, laughing and scowling, fully a part of it all.

Bob was a rail-thin scrawny man who never looked in great health. He had a bright and intelligent face, but deeply lined and etched. His frizzy hair was often on end – he'd made it that way pulling it out in frustration over, well, whatever he was frustrated about that day. He was passionate in defending his position, putting over his point of view, pointing his finger, pounding the table, but also full of fun and laughter. He was a lifelong smoker, though all of us who cared for him implored him to stop. The problem was that when he did stop he was even more difficult to work with – and at his absolute worst when he was on a tobacco substitute called Nicorette. It sent him bonkers – and us running for cover. He became quite unwell, developed respiratory problems, lost his temper more often. And, I think, he believed he'd lost control of his course, his teaching strategy was struggling, and he said his energy was flagging while the rest of the School was running flat-out. Finally, it was too much and he took sound medical advice and decided to retire.

My time with Bob, before he retired, was an attempt to do what I'd failed to do with my predecessor, Sir Harry Barnes – talk about the spirit of the School, its history, the stories in its stones and bones, what had gone right and wrong in its past, what were seen as changes for the better or worse. Harry had died not long after I was appointed, which deeply saddened me – I'd needed to understand that history and have his counsel. My attempt to do this with Bob also failed, largely because at that time he was more concerned with tactics than strategy. He was very much 'in the moment, and on his way to the door', just wanting to ensure that the students had a good exhibition, which would be the the last he'd steward before he left. He said he had no onward plan for the MA course after he'd left, 'it was up to us where it went'. Several senior staff were very worried about this as the course was so personality-based and idiosyncratic, thus taking it on and moving it forward was not going to be easy. Bob himself was clearly badly stressed and unwell. But in the end, he retired on a very high note, pleased with the students and apparently the condition of the course, and with a history of achievement as an artist, designer, craftsman and inspiring teacher that was extraordinary and truly enviable.

With more time in the studio, not travelling from Loch Striven, and a more restful life, we all thought that he'd not only mend but also be very productive. And he was. Some truly powerful and beautiful work came out of his last years – I particularly admired the huge tapestry piece for the Glasgow City Chambers as being the finest distillation of what Bob could achieve – craftsman-made, moody and rich in its themes and textures, elegantly proportioned and perfectly integrated into the architecture that surrounded it, a *tour de force* by an artist at the top of his game.

But there was a sour note in it all. That phone call I mentioned. Bob Stewart called me some time after his retirement to say that he was intensely aggrieved by what the School was doing – where was the craft, the skill, the beauty? – the work was incomprehensible, rubbish, all bad ideas and poor execution. But most of all (no surprise), the call was really about *his* MA course, which had been 'destroyed', put in the wrong hands, infected with phony intellectualism, and was a mockery of everything he'd stood for. And

after 40 minutes of this came the Judgement of Robert: it was all my fault and I should be cast into the pit. I never heard from him again.

There is no simple way to sum up Bob Stewart, and what he achieved, he was far too complex a man. There is no sound-bite to gives you a finger-snap image. But the essays in this book try to tell you who he was, so it's a warts-and-all portrait, and Bob always preferred honesty over cosmetics. An often exasperating person in his later years, yes. But in case you get only that impression, try to think of this intense, skinny, brooding man dressed in evening-wear, his face in white make-up and dark eye-shadow, with red blood (of poster-colour) dribbling from his lips, being Dracula at one of the Activities Weeks dances, standing at the bar with Chuck Mitchell, who'd come swathed head-to-toe in bandages as the Mummy. He had a great sense of humour and of the absurd, along with being naturally intelligent and a huge pleasure to be with. Think of him also as an energetic and very challenging teacher, one of the very best – not for everyone, but for most. He didn't just enjoy being in the teaching studios, he absolutely loved it.

Think of him also as a teacher who said that he could only teach from one perspective – what he'd learned himself in his own studio, which gave him core insights into the creative process, that he tried to share. He learned from being locked in that chamber of the imagination, where artists are utterly alone – originality and innovation are the only ghostly companions they have. And it's hard work: every day in an artist's studio is unarmed combat with ideas and materials. I think he commanded respect from so many students and so many colleagues for that reason: he'd been there, so many many times and come out with wonderful work and a new way of thinking about being an artist. He knew it was never easy. So, to student or friend or colleague, he gave unvarnished truth. Art schools are filled with amazing and extraordinary creative people, and also with some frauds and impersonators, and Bob was a challenge to them all. The really creative students and staff gravitated to his ideas and his passion, the poseurs were scared to death of him. He gave you his truth straight from the shoulder; it was emotional, direct, there was no fooling around, no bullshit, and it was the voice of an artist's experience that was completely original and authentic. Bob was the real thing. I am lucky to have known him.

2

A BIOGRAPHICAL
SKETCH

R‍OBERT A‍LLAN S‍TEWART 1924–95
Born 14 April 1924
eldest child of Robert Stewart and Gladys Milne (2 sisters)

educated	• Hutcheson's Grammar School for Boys, Glasgow
September 1942	• Glasgow School of Art two-year General Course, component of Art Diploma
September 1944	• Glasgow School of Art two-year specialist Textile Course, component of Art Diploma
September 1946	• special award: post-Diploma Course year
	• D. P. Bliss became Director of Glasgow School of Art
June 1947	• advertising department of Scottish Co-operative Wholesale Society, Glasgow
July 1948	• travelling scholarship: six months in France, Switzerland, Italy
November 1948	• while in Italy, appointed by D. P. Bliss to take charge of the Printed Textile department
January 1949	• took up post at the Glasgow School of Art
1949–50	• first commissioned work, textile furnishings for John Noble, Ardkinglass
1950	• first contact with Liberty's, London – work on textiles, scarves and graphics until mid 1960s
	• sold six designs to Morton Sundour, Carlisle
	• two tapestry designs included in the Saltire Society's Edinburgh Festival exhibition, 'Dovecot Tapestries'
	• work on embroidery designs for the Festival of Britain
1951	• married Sheila Constance Anne Harris, doctor of medicine, with whom he was to have six children
c1951	• prizewinning design in a competition for proscenium curtains at the Cosmo Cinema, Glasgow
1952	• consultant to interior design company Form & Colour, Stirling
1953–58	• produced textile designs for Donald Brothers, Dundee
1954	• became designer with Edinburgh Tapestry Company, designing ceramic tiles, graphics and textiles, working two days each week at Dovecot Studios, Edinburgh, until 1957

Robert Stewart
Collection Sheila Stewart

	• ceramic tiles produced at Dovecot Studios on exhibition at Centre for Scottish Crafts, St Ninians, Stirling – these were also exhibited regularly at the Scottish Crafts Centre, Edinburgh
1957	• set up Robert Stewart Ceramics Ltd, producing ceramic kitchenware first at his home and then in a factory at Paisley
1957–63	• ceramic kitchenware shown at New York and Tokyo World Fairs
1957–64	• graphic designs for Scottish Crafts Centre, Scottish Crafts Council, Austin Reed, Liberty and Schweppes
1959	• major graphic contribution to *Motif 2*, published by Shenval Press
1960	• ceramic commission for the swimming pool of P&O cruise liner Oriana
	• as an invited artist, showed designs and monoprints at 66th exhibition of Scottish Society of Artists, Edinburgh
1961	• moved to Loch Striven from Glasgow
1962	• ceramics on display at the British Pavilion of the Seattle World Fair
1963	• abandoned his ceramic kitchenware business
	• ceramic mural and fireplace for Campsie Glen Hotel, Lennoxtown
1964	• D. P. Bliss succeeded by Harry Jefferson Barnes (later Sir Harry)
	• Robert Stewart approached by British Nylon Spinners
	• ceramic mural for Royal Garden Hotel, Kensington, London
	• ceramic mural for Elders, Argyle Street, Glasgow
1965	• via BNS, invited by ICI to design fabrics for men's shirts but after first enthusiasm, plans failed in 1967
	• graphics work for Commonwealth Arts Festival in Glasgow
	• set up Loch Striven Studio Ltd to design and produce ceramic murals
	• completed ceramic murals for Adelphi Street School, Gorbals, Glasgow, and for Eastwood High School, Newton Mearns, Renfrewshire
	• ceramic mural for West Dumbartonshire County Offices
	• ceramic mural for Tappit Hen restaurant, Brabloch Hotel, Paisley
1966	• completed ceramic mural for Douglas Academy, Bearsden, East Dumbartonshire
	• two pairs of murals, one pair for each entrance of the Motherwell and Wishaw Concert Hall
1966–67	• ceramic mural for casino, Isle of Man
1967	• 1966 Concert Hall murals won him Saltire Award for Arts and Crafts in Architecture

OPPOSITE: Mirage, 1955, detail (see p. 84)

	• exhibited at Saltire Society Conference, Hamilton
	• began to assist Pringle's, Hawick, to print on cashmere
1968	• sabbatical leave: visit to Germany, France, Italy and Czechoslovakia, followed by exhibition of 50 paintings at Glasgow School of Art
	• 5 paintings in Richard Demarco's Edinburgh Festival exhibition
	• ceramic panels at Handwerkmesse exhibition in Munich brought award of Bavarian Gold Medal
1969	• new Scottish Design Centre with exhibition of ceramic panels by Robert Stewart opened by HM The Queen
	• one-man show of 20 paintings at Richard Demarco Gallery, Edinburgh
1960s	• also exhibited at Linlithgow Arts Week and at Caballa Gallery, Harrogate
1970	• completion of tapestry for the University of Strathclyde
1971	• first Activities Week, Glasgow School of Art
	• ceramic wall panels for student refectory of the College of Commerce, Glasgow
1972	• ceramic walls of underpass at Greenock
1973	• unveiling of ceramic mural for international departure lounge at Prestwick Airport, Ayrshire
	• private commission for ceramic mural for a flat in the west end of Glasgow
1974	• ceramic mural for Hebridean restaurant, Queen Street Station, Glasgow
	• ceramic mural for Elderslie Swimming Pool, Renfrewshire
1975	• introduction of degree courses at the Glasgow School of Art
	• ceramic mural for the Glendaruel and Kilmodan Primary School, Argyll
1976	• ceramic mural for the Dunoon cinema
late 1970s	• completed commission for the altar steps of St Joseph's Church, Faifley, Glasgow
1978	• experimental extended postgraduate diploma course, that was to become a Master of Arts degree
	• ceramic walls of underpass at the Brandon Shopping Centre, Motherwell
	• one-man show of 26 paintings at Compass Gallery, Glasgow
1979	• completion of tapestry in 3 panels (woven at Dovecot Studios) for the Bishop of Jocelyn Chapel in the Lower Church of Glasgow Cathedral
1980	• Head of Design School, Glasgow School of Art, in addition to being Head of MA course
	• Sir Harry Jefferson Barnes retired
	• retrospective exhibition at the Collins Gallery, University of Strathclyde

	• exhibited in a Scottish Arts Council touring show *Screen-printing: an exhibition of screenprints and how they are made*
1982	• Deputy Director of the Glasgow School of Art (director: Tony Jones)
	• completion of tapestry (woven at Dovecot Studios) for the entrance hall of Glasgow City Chambers
1983	• member of the Glasgow Incorporation of Weavers
1984	• retired from the Glasgow School of Art through ill health
mid 1980s	• exhibition of small-scale clay pieces at Peacock Print Studio, Aberdeen
February 1995	• died

3

FORMATIVE YEARS

Robert Allan Stewart was born on 14 April 1924, the eldest of three children. His father Robert was a manager in industry, eventually becoming a director of Colville's (later known as Ravenscraig) steel works in Motherwell. He was a shy, decent, honest man, who was strict, careful with money and rather Victorian, although he had a flair for sketching and enjoyed performing in amateur dramatics.

His mother Gladys Milne was born in 1900 in Canada of Scottish parents, but when she was eleven her mother died. Gladys was sent back to Scotland to be brought up and indulged by two aunts and her grandfather. She was vivacious and fun loving and sang soprano for the Paisley Operatic Society.

There were two younger sisters, Gladys and Una. They all had a happy if restrained middle-class upbringing. On Sundays they adhered to a strict routine of Church and Sunday School in the morning and a visit to their paternal grandfather's in Glasgow for tea. (Stewart is remembered as being happy – even at an early age – to sit quietly if provided with paper and pencils.) Occasionally on Sundays there was a walk in the park with their parents but, if the weather was poor, the children were expected to keep busy: the girls would knit, or they would all read something improving from their father's bookshelves. Their father was a good pianist and on Sunday evenings they would sometimes sing hymns round the piano. Later Stewart taught himself to play a little but preferred boogie-woogie.

His sisters remember him as a quiet schoolboy focused on his own pursuits and spending most of his time in his room. The characteristic that impressed them most was his patience. This may have been the result of his illness. Stewart suffered recurrent painful bouts of osteomyelitis from the age of six and these confined him to bed for long months when he played with the Hornby train set laid out round his room, the controls by his bed. Una was much younger than her brother but she, too, was allowed to play with the precious train set. He was interested in what she did as a child and this delight in children's activities was to remain with him. As a student, he said that he would like to have twelve children and later showed the same patient concern for his own children and their various interests.

At Hutcheson's Grammar School for Boys, standards were high, the atmosphere competitive and ambition encouraged. The teaching was good, aimed particularly at the pursuit of academic excellence and generally at a well-rounded education. However, because of ill health, Stewart was not good at games and did not excel academically. He had rather a miserable adolescence

Stewart with his father, mother, and sisters Gladys and Una, 1940s.

and was deeply unhappy at school. It may be that this experience made him suspicious of an intellectual approach.

Again because of ill health, Stewart was not permitted to enlist for war service. He decided to apply to the Glasgow School of Art. His father insisted that to go to an art school Stewart must agree to train as a teacher and, despite reluctance, he agreed. His father regarded teaching as a respectable profession that would provide a secure future.

Despite Stewart's success as a student – and later professionally – he believed that his father was disappointed in him. It is perhaps a Scottish trait to give praise too seldom where it is due and this affected Stewart who was a sensitive, quite elusive and private individual. This lack of approval, whether imagined or real, together with the adversity of ill health, created in Robert Stewart a need to prove himself and a determination to succeed that shaped his subsequent career.

His mother was protective of him. She died at the age of 52. His father was later to remarry happily. Stewart was not particularly close to his father, though he remained in contact with him and with his sisters.

Stewart entered GSA in September 1942. Until his marriage, Stewart, like most of his contemporaries, lived at home, travelling daily by bus from Newton Mearns, a dormitory for Glasgow professionals to the south of the city. There was a great boom in house building in Newton Mearns from the 1930s and it very much typified the suburbia that Stewart vehemently rejected later.

At that time student numbers were depleted because of the war and those who attended had been excused military service and were training to be teachers. Stewart was hospitalised again during his first year. On recovery, he managed to cram two years' work into one and continued to work 'double-quick' for the rest of his life, living for the moment and never looking back.[1] The capacity for hard work had been inherited from his father and reinforced at Hutcheson's School.

As a student attending the two-year General Course, Stewart studied drawing under Harry Jefferson Barnes, who joined the staff in 1944 and with whom he was to have a long association. As subjects of the Diploma course, Stewart studied drawing and design, modelling (in clay) and historic ornament, fashion, fabric printing, design and art history. (The textile students also studied weaving at the Royal Technical College which later became Strathclyde University.) This grounding established his fascination with techniques that lasted throughout his life. Drawing underpinned everything and was a constant study in both the general and diploma courses. Stewart was a perfectionist and it offended him in later years when drawing no longer carried quite the same importance.

As a student he discovered an innate sense of space and an ability to pattern. Although not the most outstanding student and rather in the shadow of his friend Dirom White, he was awarded Allan Walton's special prizes for textiles in 1946 and 1947. He was also awarded a post-diploma year at the end of which (because of his post diploma show) he won a travelling scholarship worth £120.

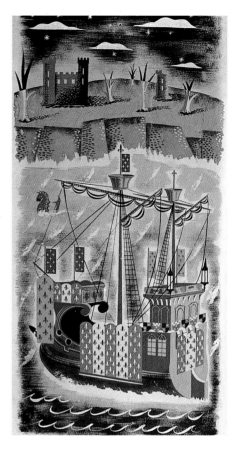

Painted panel, 1947; gouache on board; 67 × 34.5 cm (26½ × 13¾ in.). This is the only remaining one of 8 painted for the GSA Brough Memorial competition to design a waiting room for a steamship company. Stewart made a joint submission with Netta Thomson a second-year architecture student.

[1] Interview with Clare Henry, *Glasgow Herald*, 18 October 1980

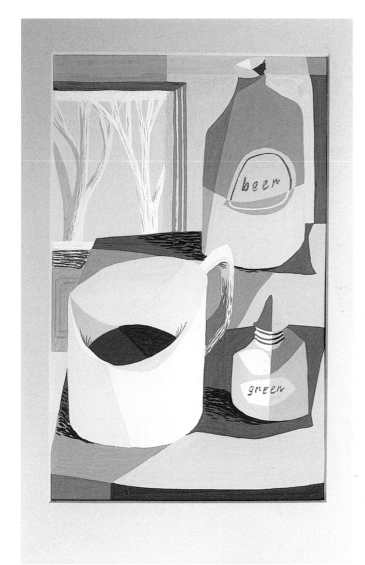

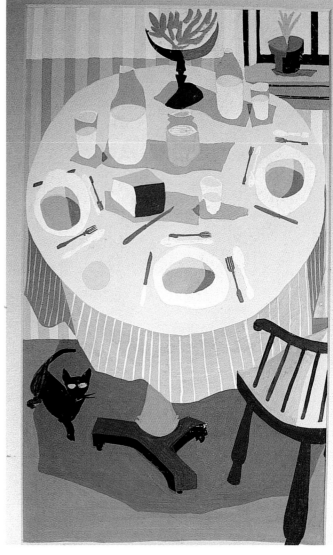

ABOVE LEFT AND RIGHT:
Still Life, 1946–47; gouache on paper;
20 × 12.5 cm (8 × 5 in.). One of the
works from his post-diploma show
for which he won a travelling
scholarship.
Collection Sheila Stewart

Table set for a meal, 1946–47;
gouache on paper; 24.5 × 15.5 cm
(9³/₄ × 6¹/₄ in.). One of the works
from his post-diploma show.
Collection Sheila Stewart

RIGHT: Textile designs, c1947
Artist's photo, collection Sheila Stewart

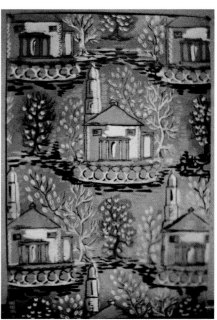

Boats, 1946–47; gouache on paper;
16.5 × 16.2 cm (6½ × 6¼ in.). One of the
works from his post-diploma show.
Collection Netta Cameron

Remembered as a quiet, reserved undergraduate, he already had anti-establishment views, was forthright in his attitudes and disapproved of the current teaching methods. He also began to share the socialist views of his girlfriend Sheila, a medical student later to be his wife. With a new Labour Government and a planned National Health Service, they shared high hopes of a new order. GSA gave him freedom and allowed him to think his own thoughts. Within a short time of starting his post-diploma year, he flourished and became quite a dominant force.

Allan Walton

Stewart's time at GSA coincided with that of one of the School's most interesting Directors, Allan Walton. He was at GSA for less than three years, from 1943 to 1945, but had a considerable influence on Stewart. Walton had been familiar with GSA before his appointment, because he had been joint assessor in textile design for the four Scottish Art Schools (Glasgow, Edinburgh, Dundee and Aberdeen) from 1940 to 1943. He had also known his predecessor, W. O. Hutchison, who had recommended him, in Chelsea during the 1920s. At that time the two had also known the School's architect, Charles Rennie Mackintosh.

Designs for a dining room, c1947. Possibly his post-diploma show or part of the exhibition of his work at the Edinburgh Festival.
Artist's photo, collection Sheila Stewart

Designs for an occasional room, c1947. Possibly his post-diploma show or part of the exhibition of his work at the Edinburgh Festival.
Artist's photo, collection Sheila Stewart

Walton had initially trained as an architect, then as a painter at the Slade, in Paris and in Newlyn, regularly exhibiting landscapes with the London Group. He also designed interiors, but is best known as a textile designer.

In 1931, with his brother Roger, he set up his own textile company, Allan Walton Textiles, at Little Green Dyeworks, Manchester. He was one of the most enlightened producers at that time, a rare individual who was both an effective designer and an effective art director. His screenprinted products were at the forefront of textile design, with artists – Vanessa Bell and Duncan Grant among others – commissioned to produce a wide range of designs, including abstracts. For this highly regarded work, Walton was elected a Royal Designer for Industry in 1940. He was also one of the original members of the Council of Industrial Design (CoID) set up by the Board of Trade in 1944 and was Chairman of the Training Committee.

Described by the press as tall, softly spoken and sympathetic, Walton certainly had a sense of style and was also droll and unstuffy. He had a passionate interest in design education, enjoyed the company of young people and regularly held tea parties for students in the Director's room. These were probably fairly formal affairs with male students in their habitual wear of suits or sports jackets, collar and tie, referred to by their surnames only, and female students addressed as 'Miss'.

The curriculum at Glasgow School of Art had remained virtually unchanged since Fra Newbery had established the craft studios in the 1890s. As a first step towards reorganising the Design School, Walton instituted a course in Interior Design that would form the central core round which the other design classes would be grouped. It was the intention to extend the Craft classes and build a series of workshops so that the students could gain a thorough knowledge of technical production. This, together with the study of design, should produce properly trained designers.

Despite Walton's optimism and enthusiasm, times were difficult for staff and students. In a letter of November 1943 from Mrs Gladys Harrison, head

of the Printed Textile department to the Secretary of the Board of Trade, endorsed by the Director, she explained the difficulties

> ... in obtaining coupon-free organdie and Battleship linoleum (used to make blocks to print). The organdie is impregnated with french polish and this screen is then used to allow the dyestuff to penetrate through as a filter in controlled and pre-arranged areas of cloth. One print may take two or three yards of organdie according to the number of screens employed. The Schools of Art in England have an allowance of white organdie for this purpose, coupon-free and I would be grateful for a similar privilege. The students have to give coupons for the material upon which they print and it is impossible for them to use coupons for organdie, too. I need 60 yards per annum of white, double width ...

Most importantly and in keeping with Bauhaus principles, Walton included his students in commercial projects. For example, he was involved, 1944–45, with the refurbishment of the Chancellor of the Exchequer's residence at no. 11 Downing Street. The task of designing the curtains was given to the textile students. The design selected was inspired by a motif on the plaster ceiling of the dining room at Sir John Soane's house in Lincoln's Inn Fields, London. It had a stripe and a repeat ivy wreath in green and gold, the motif outlined in brown. The design was printed on satin at GSA. Walton was very conscious of the surface quality of fabrics and liked the liveliness of lustrous textiles that intensified colour and reflected light.

Stewart was one of the students who worked on this project. Walton, who had an intuitive perception of a student's potential, encouraged Stewart's interest in textile design and was to be a lasting influence.

With a different educational system in Scotland from that in England and Wales, the four schools of art were independent bodies whose trustees were answerable to the Scottish Education Department, a largely co-operative, liberal and non-interventionist body. Walton was appointed as a representative of all four schools to a Special Committee on Technical Education set up by the Secretary of State for Scotland to make recommendations to the Advisory Council of Education in Scotland. The remit was to examine the prospective requirements of trade and industry, the provision for technical education in the universities and also the provisions, administration and finance of technical education in the various colleges, including the schools of art.

Walton recognised the division in England and Wales between the Technical institutions that were being developed at the expense of Art Schools, and the Art Schools where there was too much emphasis on hand craft and too little on the quality of design. During his short time in Glasgow, Walton was a vociferous advocate of the need for good design and of the importance of providing opportunities for the new generation of designers. He believed that designers should be as much artists as craftsmen and that it was the duty of artists to prepare for this new role.[2] In September

[2] *Glasgow Herald* report of a lecture to the Educational Institute for Scotland, December 1943

1944, in a letter to Stevenson's & Sons, Moygashel Mills, Dungannon, he wrote:

> Possibly Lord de la Warr mentioned that I am interested in design for textiles and the whole subject of the use of Artist Designers by the Manufacturer. I am fulfilling my present post to further these ideas.[3]

If the war had not happened, he would probably have been too involved running his textile business even to consider becoming more involved in education as Director of GSA.

He called for manufacturers to be more adventurous, suggesting to the Scottish Furniture Manufacturers Association that artists and sculptors with a sense of form should be invited to co-operate with designers and technicians in the production of new designs. In a lecture to the Publicity Club of Glasgow, he explained that the export trade recognised the importance of quality and that it was to the artist-trained designer that industry must turn to produce this quality product. This was a recurrent theme. In his lecture, 'Art and Industry', to the Royal Philosophical Society of Glasgow in 1944, he reiterated the importance placed by Government on the renewal of the export trade and emphasised the need to raise the status of the designer in order to raise the standard of design. This was to be a constant plea from the CoID but it had little impact. Most designers working inside industry were treated as little more than draughtsmen, reworking designs that sold well. The manufacturers continued to buy in more adventurous designs from established artists and independent designers. Walton advocated the establishment of a central college for industrial design to offer postgraduate art school training and a research station for design and industry.

After his return to London 1947–48, he was appointed the first Professor of Textiles in the reorganised Royal College of Art by Sir Robert Darwin, but his untimely death in 1948 before he could take up the post, robbed him of the opportunity to develop his ideas. Many years later, Robert Stewart was to develop a unique innovative postgraduate design course that put into practice some of Walton's ideas.

The Post-War Scene

The immediate post-war period saw the change from war to peace-time production. Both the coalition war Government and the Labour Government of 1945 recognised the importance of exports to the country's devastated economy. Design was seen as a way to ensure the desirability of these goods and an effective way to compete with other countries, especially the USA.

To develop an ethos of good design CoID and its Scottish Committee brought examples to public attention through exhibitions. In May 1944, *Design in Daily Life* had its first Scottish showing in Glasgow before travelling to Edinburgh and other Scottish towns. Glass, ceramics, textiles and

[3] Glasgow School of Art archive, Walton correspondence, Dir 10/1–16

items produced under the Utility scheme were shown. All the exhibits were pre-war except the Utility items.

Other exhibitions followed. In February 1947, *Modern Swedish Home, Its Furniture and Furnishings* opened in Glasgow. Among the 30,000 who visited in the twenty-one days of opening were groups of furniture apprentices, General Course art classes, art teachers and domestic science teachers, all of whom had special lectures arranged for them. The exhibition was accompanied by a conference, *Design for the Modern Home*, held in the Central Hotel, the first of six conferences to be sponsored by the Scottish Committee of CoID. The speakers were Basil Spence, Gordon Russell, Alastair Morton and Allan Walton who spoke of 'the longing to be free of manufacturers' restrictions and a need for imagination and inventiveness'.[4] Robert Stewart was one of the three hundred who attended this conference and his subsequent work demonstrates that he took Walton's words to heart.

CoID's governing body included representatives of the Board of Trade, the Ministry of Supply, the Exports Promotion Department and the Ministry of Education. Initially the major propaganda projects such as the 1946 *Britain Can Make It* exhibition and the 1951 Festival of Britain were London-based. The CoID governing body, which was self appointing, came to be regarded with suspicion by people like Stewart who saw it as part of the London establishment, dismissive of manufacturing cities like Glasgow which were regarded erroneously as culturally and aesthetically deprived.

However, the Scottish Committee does seem to have had some limited impact. It provided a furnished Scottish living room for *Britain Can Make It*, gave evidence to the Scottish Section of the Woollen Working Party and, following informal discussions with the Scottish Education Department, prepared recommendations on the training of industrial designers in Scotland. In 1947, the Scottish Committee made its first film, *A Question of Taste*, on dress and accessories aimed at schoolgirls, launched its first travelling exhibition and began to lay the foundations of a souvenir industry for Scotland.

To complement the *Britain Can Make It* exhibition held in London in 1946, in August 1947 the CoID Scottish Committee opened the *Enterprise Scotland* exhibition in the Royal Scottish Museum, Edinburgh. To maximise visitors, this took place at the same time as the first Edinburgh Festival of Music and Drama. Fourteen shops in Princes Street held complementary displays. The exhibition was popular, attracting 456,000 visitors (including 400 factory workers sent by a Glasgow firm) and resulting in orders from over 1000 buyers from twenty-eight countries. There was also a conference organised, *Hosiery, Presentation and Packaging*.

Enterprise Scotland was the largest industrial exhibition ever held in Scotland. 1000 manufacturers submitted 7000 items from which 3800 products were selected to represent forty industries. These included shipbuilding, sport, hosiery and knitwear, textiles, furniture, domestic utensils, solid fuel stoves, carpets, linoleum, printing and packaging, and leather. The aim of the

[4] *Glasgow Herald*, 10 February 1947

Cloth Hall, *Enterprise Scotland*, 1947.
Section designed by James Gardner and
Basil Spence; figures designed by Miss
Ethelwyn Baker.
*Design Council, Design History Research
Centre, University of Brighton*

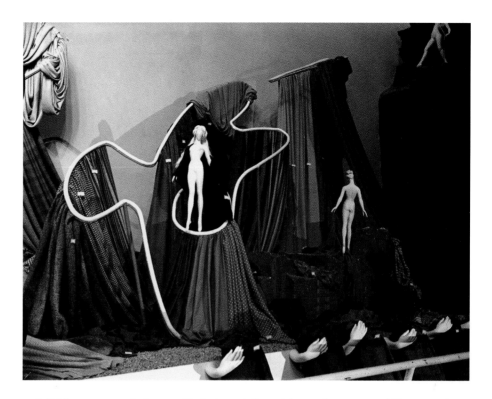

exhibition was to bring well-designed Scottish products to public attention, particularly those manufactured by new firms on the industrial estates, and to focus industries' attention on good design. Although the 'Made in Scotland' label generally stood for good workmanship it also carried the suspicion of a lack of originality. For example, traditional tweeds and tartans were much in evidence but there was a lack of new design, imagination and vision. There was also the fundamental problem that because of the emphasis on heavy engineering (at that time there were fewer light industries), there was a marked division between art and design, on the one hand, and industrial products, on the other.

With quantities of fabric and bright lighting, a carnival atmosphere was created by the designers James Gardner OBE MSIA and Basil Spence FRIBA FRIAS. The Scotland Today section had displays of textiles, printing, scientific instruments and other tools. The Cloth Hall also included designs by GSA textile students and by students from other Scottish art schools.[5] This student work was sought out by the Secretary of the Education Committee of the Rayon Centre, London, who was attending the Edinburgh Festival. He wrote to Harry Jefferson Barnes, the GSA Deputy Director, complimenting the Glasgow work as 'outstanding in design and execution'.

As in the case of *Britain Can Make It*, most of the exhibits in *Enterprise Scotland* were not available in the shops. In the accompanying publication *Pictorial Review of Enterprise Scotland*, Sir Stafford Cripps made clear the economic need for exports. Sir Thomas Barlow wrote about the CoID and

[5] Later, in 1952, Stewart was to work with Basil Spence designing a printed motif on grey satin for the seat of a child's chair designed on the theme of a swan by Spence for Princess Anne. *Glasgow Herald*, 10 July 1952

outlined the proposal for Design Centres to be established on a co-operative basis, with firms helped by Government grants. He pointed to the persuasive historical precedent of the Scientific Research Associations that had succeeded in meeting the nation's needs for advances in industrial research.

During the 1947 Festival, Stewart held an exhibition of his work in a church hall in Eyre Place in Edinburgh's New Town. The exhibition was designed by his friend Jack Lindsay who introduced innovative display methods: a false ceiling created with string, and X-shaped forms made from hardboard and lengths of wood 2 × 1 in. on which to drape the fabrics.

Although the Scottish Committee of the CoID had long-term plans to improve design through education, its short-term efforts were dismissed by people such as Robert Lyon, Principal of Edinburgh College of Art. In a letter to D. P. Bliss, GSA Director after Allan Walton's departure, he mentioned correspondence with Lady MacGregor of the Scottish Committee concerning the 1948 *Design for Modern Homes* conference, and commented:

> When the Council of Industrial Design begins to earn its keep and do something more than window-dressing, I shall have more confidence in the organisation than I have at present.[6]

Bliss obviously shared these views as later minutes of CoID's Scottish Committee record that in response to a suggestion that student designers should receive lectures on the work of the CoID, he said unenthusiastically that this would not be very useful.

It was not until May 1957, when the Scottish Committee moved to West George Street, Glasgow, that, with support and much of the basic equipment from Scottish industry, a permanent centre for exhibitions was established.

The Scottish Committee was widely criticised throughout its first ten years because it consistently failed to address fundamental issues, possibly because it had too few designers as members.

Robert Stewart left GSA in June 1947 and spent a year working for the advertising department of the Scottish Co-operative Wholesale Society at Morrison Street, Glasgow, which was a forward-thinking manufacturing and retail company at that time, one of the first in Britain to install computers in the 1960s. Vacancies were highly sought after as the company provided both good opportunities and sound training (with their own specialised courses and examination system). Manufacturing ranged from shirts and shoes to food products and sweets; there was even an abattoir.

SCWS furniture making was well regarded. Gordon Russell, the influential furniture designer responsible for Utility furniture, had worked with SCWS at the end of the war. He was commissioned to design a range of furniture for the society but unfortunately it was not commercially successful. The Co-operative Movement, uniquely representing manufacturer, retailer

[6] Letter dated 7 May 1948, Glasgow School of Art archive, Bliss correspondence, Dir 4

Studio label for SCWS, 1948; gouache on paper; 6 × 11 cm (2½ × 4½ in.). This was the first piece of commercial work as a studio employee.
Collection Sheila Stewart

and consumer, was founded on the ideal of social improvement and Russell suggested that it should also be committed to promoting good design. This was an opinion shared by CoID's Scottish Committee which organised a conference for the Scottish Co-operative Retail Societies in 1955.

Stewart was not with SCWS long enough to have any impact on the quality of the graphic design. He may, however, have been involved in preparing the advertising department's stand at the National Co-operative Exhibition at the Music Hall, George Street, Edinburgh, in May 1948, though nothing is known of his work for the society.

At the end of July 1948, Stewart took up his travelling scholarship and spent six months visiting France, Switzerland and Italy. In a letter to a friend, he said that he had never enjoyed himself so much, and 'You will appreciate what this means to me in the way of Art and believe me I have certainly had my eyes opened.'[7] Travel abroad had been restricted for so long during the war and afterwards that for young people, even those on a very restricted budget, the experience must have been exhilarating. In a report to D. P. Bliss, the Director of GSA, he wrote from Zurich that:

> Before leaving, I felt that the times were rather inappropriate for such a journey, but have since come to the conclusion that with conditions so variable, I am having a better opportunity of studying art and its reactions to circumstances. Paris where I spent my first few weeks, is an amazing city where poverty rubs shoulders with extravagance, and where existence seems to be hand to mouth ... My four weeks in Switzerland have in many ways been stimulating. Here for the first time I have seen a country unravaged by war, and the resulting high standard of living ...

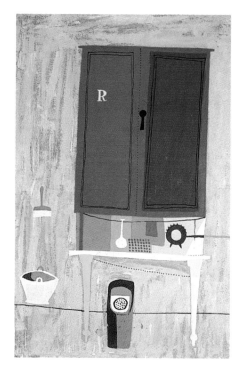

Kitchen cupboard, late 1940s; gouache on board; 52.5 × 37 cm (20¾ × 14½ in.)
Collection Sheila Stewart

During his six weeks in Paris, he spent time visiting the various galleries, studying the architecture and textiles, looking at bookshops, and making sketches and colour notes of designs. Although disappointed in the quality of printed textiles, much the same standard as in Britain, he thought the woven textiles he

[7] Letter to Netta Thomson, 26 November 1948

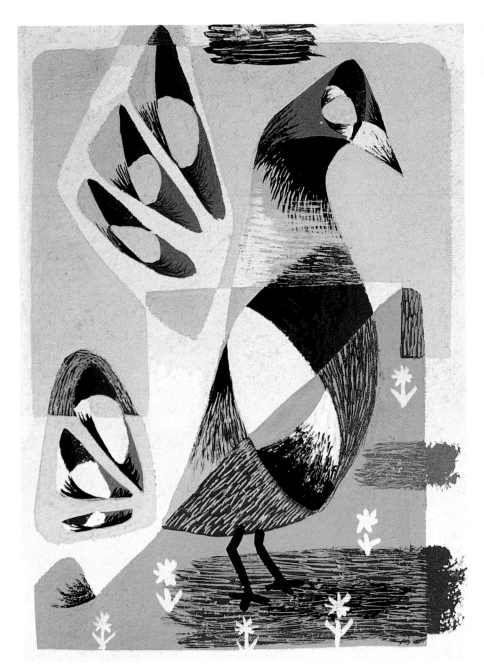

Bird design, August 1948; gouache on paper; 14 × 10.8 cm (5¹/₂ × 4¹/₄ in.)
Collection Sheila Stewart

saw in the showrooms of Rodier, Lesur, and Paris and Meyer delightful. 'Their colourings, and textures, are exciting and imaginative, and I would say ahead of Britain.' Book illustration and production also impressed him.

In Switzerland, a country he described as steeped in 'tradition and crafts-manship', he visited Geneva, Basle and Zurich, where he was impressed by the modern architecture that still retained traditional elements, with great attention paid to the detailing of windows, roofs and woodwork. In Basle he visited the Art Department of the University and in Zurich the Textilfaschule, both modern buildings with every facility for the students to work in perfect conditions. He was surprised to discover that the work produced by the students was inferior to that produced by their British counterparts.

Bob at the top of Milan Cathedral, 1948, on the journey provided by the travelling scholarship
Collection Sheila Stewart

Modern buildings in Italy he found '... simply atrocious. They throw up huge cold marble facades that would chill anyone and the interiors are mainly furnished with steel tubing. It's really desperate.' In Florence, he spoke to two of the leading architects, one of whom was designing a block of flats in Cairo for the Aga Khan. In a characterisic way he tried to argue his point about the severity of modern Italian architecture, but without success.

In contrast, he found the Italian scenery beautiful but impossible to describe, suggesting instead 'that you try to imagine yourself in the landscape of a Giotto.' He sketched in Venice which he thought picturesque but rather smelly, with unending bridges. On returning from a dance at 4 a.m, he was amused to see a milkman making his deliveries by gondola. Throughout his career, Stewart was to retain enthusiasm for Italian art and constantly recommended Italian design to students, with the comment that even when it failed it did so with panache. He particularly liked the way that the Italians questioned everything and crossed the barriers between art and design.

It was in Florence that he met the painter Joan Eardley who was also on a travelling scholarship from GSA. They shared an enthusiastic, energetic commitment to their work and, although they were in contact for less that two months, Stewart learned a great deal about painting and the painter's point of view that is apparent in his later landscapes.

While in Florence, he received a letter from D. P. Bliss inviting him to take charge of the Printed Textile department at GSA, as Mrs Harrison was leaving to take up a post at the Royal College of Art in London. Bliss was to remain a staunch supporter of Stewart and constant in his appreciation of Stewart's teaching abilities.

Stewart's working life was to be centred on the Glasgow School of Art. To be part of this creative institution provided him with a secure framework, freedom and stimulus, all of which he needed to flourish.

LEFT AND RIGHT: Sheila Harris and Bob Stewart, *c*1949 or 1950; Glasgow School of Art Ball
Collection Sheila Stewart

Birthday Card for Sheila, late 1940s or early 1950s; gouache on card;
20 × 15.2 cm (8 × 6 in.)
Collection Sheila Stewart

29

4

GLASGOW SCHOOL
OF ART 1949–84

Robert Stewart's arrival as a member of staff coincided with a period of revival in the fortunes of the Design School, previously regarded as the Cinderella of GSA. Douglas Percy Bliss, the Director, effectively continued the work begun by Walton to put the Design School on a proper footing with the appointment of new staff. Although from an academic and fine art background, Bliss had a real concern for design, and was ahead of his time in establishing a new industrial design department, one of the first courses of its kind in Britain. There was an upsurge of optimism as the new staff rose to meet the changing conditions in industrial design, despite cramped facilities and basic equipment. The new staff got on well and there was a close association throughout the 1950s, both at work and socially. There were lots of plays and cabarets for which Lennox Paterson wrote sketches, the families socialised and the wives often met up, with their children too. Stewart is remembered as being great company and good fun on these occasions[1].

Stewart married Sheila Constance Anne Harris in 1951, herself a remarkable woman who became the anchor for the family and Stewart's staunchest supporter. They moved to a flat in Oakfield Avenue, Glasgow, that became the venue for parties and was frequently visited by students. Although there was a tight budget, the flat was stylishly and distinctively decorated with his own printed curtains and a mural painted in soft colours by Stewart depicting birds perched among the leaves of stick-like trees. In 1952 Stewart became involved with a Stirling interior design company, Form & Colour, advising on colour schemes for factories, and he bought a small house in nearby Dunblane. The house was not ideal, it was in poor condition, in the main street next to a noisy pub. In addition, the distance made travelling to work in Glasgow difficult for both of them, necessitating an early start and breakfast on the train. Sheila had qualified as a doctor and was working in the Western General Hospital, Glasgow. They remained for less than a year in Dunblane, before returning to Glasgow to a large flat in Rosslyn Terrace in the west end that, like the flat in Oakfield Avenue, became a hub of activity and where they remained until 1961.

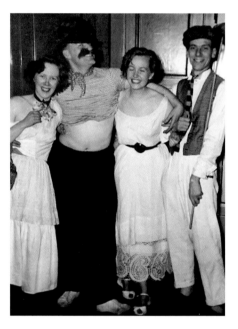

Bob and Sheila at a GSA fancy dress party, early 1950s
Collection Sheila Stewart

[1] Conversation with Dorothy Crawford, a fellow student and wife of John Crawford who taught ceramics at GSA

Oakfield Avenue, 1951/52. Bob made the table and created a pattern with inlaid, filed-down buttons; tablemats are printed with Bob's design based on barbed wire; curtain fabric is otherwise unrecorded; chairs are by Ercol.
Artist's photo, collection Sheila Stewart

Sheila in the Oakfield Avenue flat, 1951/52, with Bob's curtain design behind
Artist's photo, collection Sheila Stewart

From the beginning, Stewart's own work and his students were his priority and he acknowledged that such a commitment was selfish but essential for serious artists and designers if they were to achieve anything. His impact on the department was immediate, few students and staff having paid much attention to Printed Textiles until Stewart took over. He set his stamp on it and within a few years transformed it into the most vibrant in GSA. He created an informal atmosphere, was always known as Bob and although he was reserved, often preoccupied and not easy to get to know, he would chat if the

31

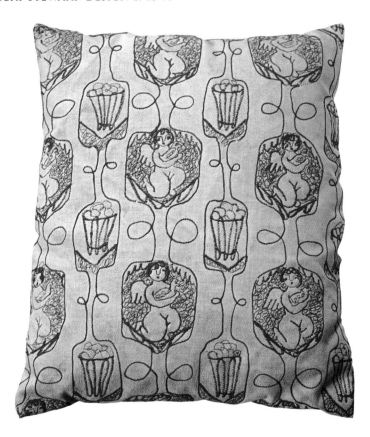

Cushion, c1950; machine embroidered on sailcloth; commissioned by John Noble, Ardkinglas
Collection David Sumsion

students were printing. He also established an ethos of hard work, setting an example by constantly being involved in his own work. Consequently the students benefited from his diverse interests and also the insatiable curiosity that made him open to situations whether it be tackling new design projects or dealing with students.

There was an influx of students immediately after the war, including many ex-servicemen and women with real experience of life and a keen sense of purpose. Such access to tertiary education was for many of them previously unattainable and an opportunity that exposed them to a very different experience that they relished. These were people who had worked closely with others in the war effort and because the Design School departments were in the same building (and cramped), they enjoyed camaraderie and the benefits of close collaboration. During the early 1950s the Printed Textile students used Interior Design's welding equipment and lathes. They painted doorknobs and turned attenuated wooden figures of laminated elm and plywood. These were like skittles or chess figures, ten to twelve inches high (25–30 cm), developed from Stewart's own work. Fascinated by techniques and the potential of machines, he first sketched the figures, the prototypes of which were turned by Jack Lindsay, a friend in Interior Design. Stewart then hand-painted them in bright colours. Later they were turned professionally in a workshop and sold by Elders, the most design-conscious furnishing shop in Glasgow. (It stocked only the best contemporary design including Liberty textiles.) In the 1960s, Elders commissioned Stewart to design a ceramic mural for the shop. The figures were also sold by Findlater Smith, stylish furnishers in Edinburgh's west end, the Scottish Crafts Centre and Liberty's.

OPPOSITE LEFT AND RIGHT:
Ailsa, 1954; hand blocked linen 28s.6d. (£1.42½) per yard, from Form & Colour, Stirling; 101 × 82 cm (39¾ × 32½ in.); illustrated in *House and Garden*, September 1954
Collection Sheila Stewart

Turned wooden figures, 1953/54; sold in various up-market shops
Artist's photo, collection Sheila Stewart

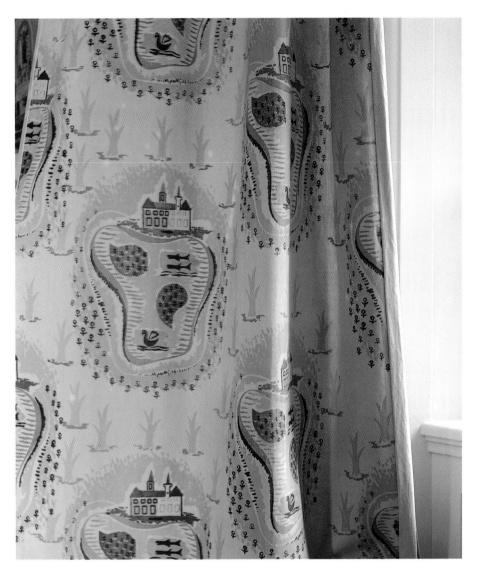

Curtain, c1950; screenprint on sailcloth;
commissioned by John Noble, Ardkinglas
Collection David Sumsion

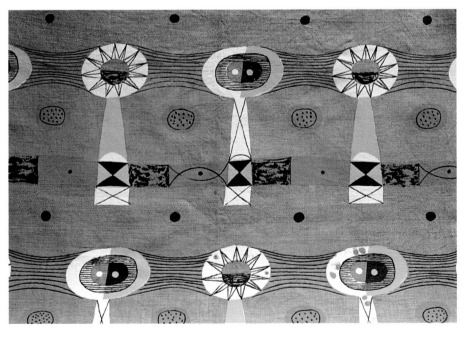

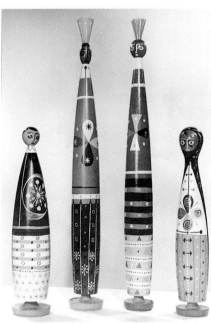

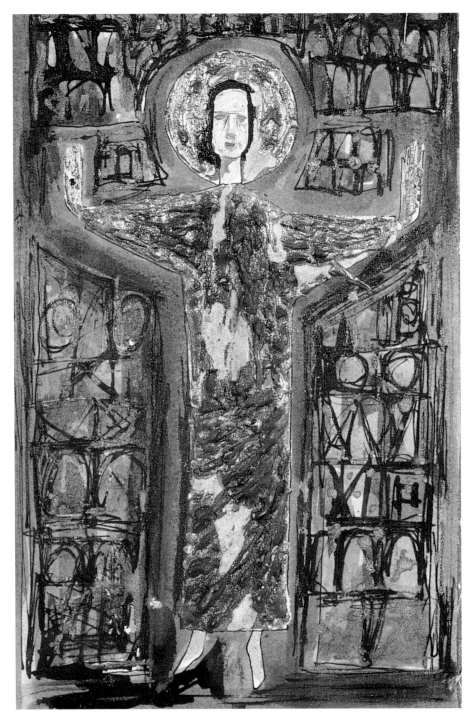

ABOVE: Machine embroidered panel, 1950;
one of three experimental designs;
24 × 12.6 cm (9½ × 5 in.)
GSA archive

LEFT: Design for an embroidered panel,
1955; gouache, ink and gold paint;
16.5 × 11.5 cm (6½ × 4½ in.)
GSA archive

The Embroidered and Woven Textiles department was also a source of inter-
est. There Stewart saw new experiments in machine embroidery and, quickly
becoming fascinated, he taught himself to use a sewing machine. His approach
to everything whether technique or medium was to develop a thorough under-
standing of its potential by first exploring and experimenting before embarking
on serious design, even if the final work were to be carried out by someone else
to his design. He was able to use the sewing machine with great facility as a
drawing tool and used it for his first private textile commission *c*1949/50. This
was for a furnishing fabric to cover a small settee for John Noble of Ardkinglass.

Cushion, 1951; designed by Stewart, worked by Kath Whyte; linen with cotton threads; commissioned by the Needlework Development Scheme for its Festival of Britain touring exhibition
GSA archive

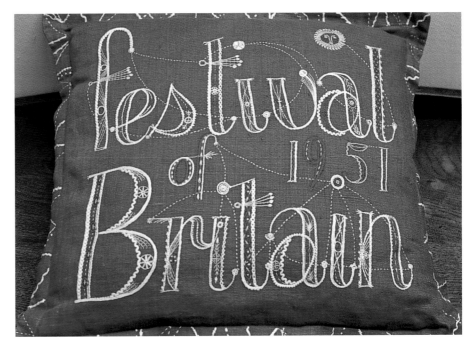

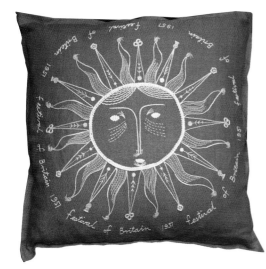

Cushion, 1951; designed by Stewart, worked by Kath Whyte; linen with cotton threads; commissioned by the Needlework Development Scheme for its Festival of Britain touring exhibition
By kind permission of the National Museum of Scotland

As fabrics were still rationed, he used sailcloth on which a repeat pattern of cupids was embroidered by means of a Schiffli or Irish machine. The commission also included two pairs of curtains, a pelmet and a window seat of sailcloth with a print design for Mrs Noble's bedroom. He was also commissioned by the Needlework Development Scheme (NDS) to design and work a folder of experimental embroidery on a domestic sewing machine and to create a small panel with two figures.[2] Stewart also produced several other embroidery designs for the NDS, that were worked by others. These include a cushion, 'Harold and Ephemia', worked by Doreen Sisson, a GSA student, in black embroidery on rust-coloured cotton, for the NDS exhibition at the Tea Centre, Regent Street, London, in 1954. This exhibition also included one of the Festival of Britain cushion covers and a tablemat designed by Stewart and worked by Sisson.

Students in the Design School occasionally collaborated on projects: for example, one competition involved working in small groups, one from each department. They had to invent the name of a country inn and design appropriate textiles, interiors and graphics. Staff also collaborated to produce their own work. Stewart first worked with Kath Whyte, Head of Embroidered and Woven Textiles, in 1950, to design a panel depicting the figure of Christ which she translated into silk, rough gold and sequins.[3] She gave him the finished panel and she kept his design. The following year, they again collaborated on two cushions for the NDS Festival of Britain touring exhibition in 1951. Stewart produced the designs and Kath Whyte translated them into thread and stitch. Staff also exhibited together. In 1953, Stewart, Whyte and Lesley Auld from Silversmithing exhibited in a crafts show at

[2] This panel, made in 1951, is now in the National Museum of Scotland, 1962.1076

[3] Last exhibited at the Collins Gallery, University of Strathclyde, 1980, its whereabouts are unknown.

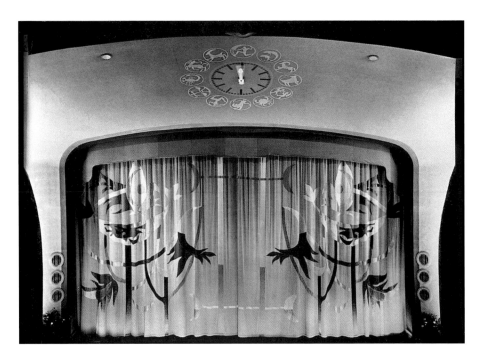

Proscenium curtains, Cosmo Cinema,
Glasgow, c1951; red cotton ground
Artist's photo, collection Sheila Stewart

Wylie and Lochhead's Glasgow department store. This co-operation continued throughout the 1950s and Misha Black commented that:

> This is a most enterprising and lively school, and one of its most outstanding characteristics is the unity and co-operation of its different departments. This is most noticeable among the departments of textiles, interiors, embroidery and weaving, and industrial design. These departments are of course naturally linked but only rarely is that link exploited as it is here.[4]

The Design School departments also exhibited together. 1951 was an important year for students and staff. During February, the Council of Industrial Design invited the Design School to exhibit at the Rayon Centre, Grosvenor Square. This was the first time any Scottish Art School had held an exhibition in London. Lindsay and Stewart arranged the exhibition which consisted mainly of printed, embroidered and woven textiles plus items from Interior Design. The exhibition was opened by Lady Semple and was well received by both public and press.

1951 was also the year that Stewart won his first major public commission. A competition was set by Mr Singleton of the Cosmo Cinema, now the Glasgow Film Theatre, for proscenium curtains. Stewart's design, which he submitted together with a model made by Lindsay, was successful.

Printed Textile students' work also featured in the private buyers' lounge at the Scottish Industries exhibition at the Kelvin Hall in 1954. The students were given a free hand and produced vividly coloured designs that included printed curtains of white towelling and an impressive 10 ft by 6 ft (305 × 183 cm) wall panel based on Clydeside shipbuilding, designed by Peter Perritt and boldly printed with almost fifty different colours.

Peter Perritt's Diploma Show, 1952.
Perritt later became Head of Textiles at
Manchester College of Art.
GSA archive

[4] Assessors' Report, 1956

Wall panel; signed: Stewart 1953; screenprint on linen; 132 × 111 cm (52 × 43³/₄ in.). A similar wall panel by Stewart was illustrated in *House and Garden*, June 1954, selling price £25. *Collection Sheila Stewart*

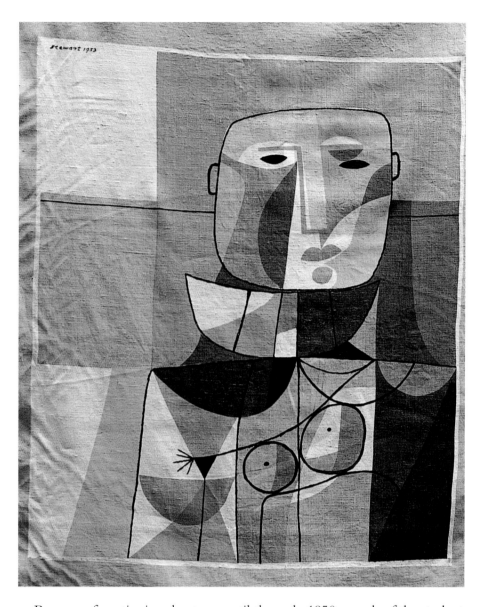

Because of continuing shortages until the early 1950s, much of the student work was in monotone which in itself set a challenge encouraging the students to solve the problem of creating rich effects with a single colour. The appointment of a print technician, Bill Balmer, helped the work of the Printed Textile department, as did a large process camera (that could do half tones). This was installed for the production of wallpaper but was to benefit both wallpaper and fabric design and led to a greater understanding of the relation between them. Margaret Stewart won a Royal Society of Arts travelling scholarship for a wallpaper design, and attracted attention from the trade. Continuing improvements in the vitality and standard of work produced by the students was praised by the external assessors Grace Lovat Fraser and Edward Bawden and encouraged Stewart to put forward a proposal to the Director to improve the facilities of the Printed Textile department.

The proposal was the result of reading a report issued by the Silk Centre that was awarding considerable grants and scholarships to some English colleges, but mainly to the Royal College of Art. It had been suggested that

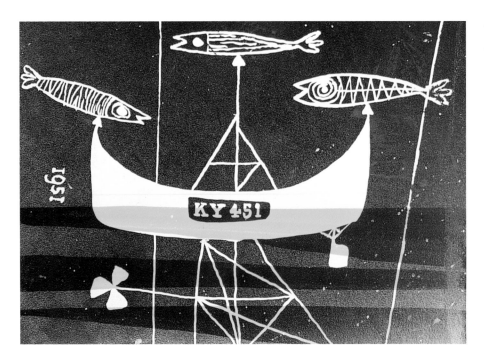

Textile design, 1951; paper negative with
yellow ink; 12 × 16 cm (4³/₄ × 6¹/₄ in.)
Collection Sheila Stewart

GSA students could also benefit. Stewart was always aware of developments elsewhere and conscious of the need to improve the standard of teaching and quality of the GSA experience of his students. Of these, ten were specialised textile students and thirty-five part-time students. Stewart was also aware that although the Printed Textile department provided the most advanced course in Scotland, it had a long way to go before it could provide students with the technical training that would satisfy industry. Most of the Glasgow students had joined the teaching profession, but as there were now fewer posts he saw the options as either to reduce the number of students or improve the training in order to provide students for industry.

Although the basic Printed Textile course changed little in the first few years, the scope of work undertaken by the students widened. Stewart took students to visit various factories. Among others, these included Ferguson's, Carlisle, which was a vertical factory encompassing all aspects of textile practice, also Edinburgh Weavers, Edinburgh Tapestry Company, Donald Brothers and, later, Bute Fabrics. The students who were full-time in the Printed Textile department still attended the Royal Technical College's Fibre Science department to learn about fibres and their properties. They continued to sketch in the botanic gardens on Thursday and on Friday worked these into finished pen and ink drawings. From the technician they learned to make screens by stretching cotton organdie, secured with drawing pins, coating them with gelatine and blocking or painting out the background with French polish, finally fixing the printed colours by wrapping the fabrics in newspaper and steaming them, a tedious process with variable results.

Stewart proposed a revised curriculum to improve the efficiency of the printing and suggested that the Monday lectures on weaving at the Technical College should be replaced by lectures on dyes, printing pastes, discharging processes, pre-treatment and after-treatments.

Stewart making screens
Collection Sheila Stewart

His report addressed the widespread criticism of industry that preferred the 'works-trained designer' to the School of Art graduate because of the former's appreciation of the relationship between the design and all phases of production. Stewart proposed that each student should have the practical experience of producing one or two prints by each of the methods commonly used in industry, taking the fabric through all stages of production. In this way, the students would be more knowledgeable and more able to co-operate fully with clients. For example, they would be able to specify after-treatments that would give character to the print, but which it would be impossible to show on the colour sketch. He did not request quantities of elaborate equipment, conscious that the course should not become a 'Textile Printers' apprenticeship, but he was also aware of the drawback of some schools with elaborately equipped departments where students handed over the finished sketch to technicians and had no further contact with their designs until presented with the finished print. An integral part of the scheme was the development of a postgraduate course to make the new facilities available to all Scottish students. He also suggested a visit to Manchester and the Royal College of Art, London, to obtain accurate costs, and to Zurich 'in order to check up on the schools where I first conceived an ambition to see such a development in Glasgow.'

The Director put forward a plan to the Board of Governors and the Scottish Education Department which was accepted and the Printed Textile department was extended and re-equipped. No matter what other distractions or techniques the students were involved with or encouraged to pursue, they each had to produce eight printed lengths. One of these was done as a Diploma test answering a design brief, producing the design, working out the

Preparations for GSA Fashion Show, 1952; backdrop designed by Stewart who also made and installed a mobile of bird forms. The triangular pattern on the right and the fruit below were developed as textile designs.
Photographed for Picture Post, *by kind permission of the Hulton Getty Picture Collection*

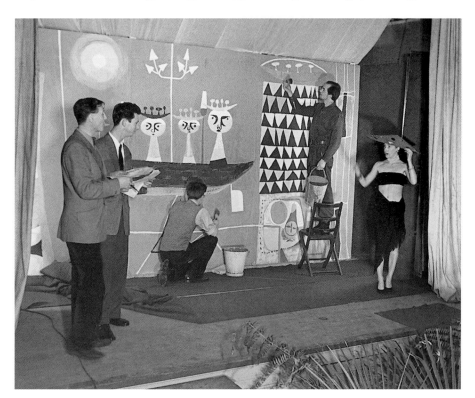

repeat and completing the colour separations within a specified time of two weeks. Help was given only at the printing stage by the technical demonstrator. The changes were an undoubted success and, within two years, two leading industrial firms applied to the School for advice on printing methods and equipment.

However, the relationship between industry and art schools was still ambivalent and graduates were often disappointed when they experienced industrial working practices. For example, Sheila McQuistan was the first student from the department to work in industry. On a selling tour of manufacturers with her portfolio of designs in 1953, she was offered a job in Whitehead's studio in Rottenstall, Lancashire. Despite Whitehead's being a well-established company that produced many interesting designs, she quickly found the work extremely frustrating as there was little freedom to design or to be creative. She was usually asked to rework or produce new colourways for existing commercially successful designs. The company, like so many others, failed or refused to appreciate the capability and potential of young graduates, preferring to buy in their more innovative designs from established, mainly London-based, designers and well-known artists.

This continued to be an issue throughout the 1950s and in 1960 the Scottish Committee of the CoID organised a conference for members of the Carpet Industry who were experiencing difficulties in recruiting design staff for their studios. The Committee circulated an agenda to the Scottish Art Schools on the training of designers for the industry. Bliss, after consultation with Stewart and staff in other Schools, replied on their behalf. Bliss pointed out that although the industry claimed to be the largest employers of designers in Scotland the industry had never shown interest in art school graduates and that the industry had never seemed artistically alive. He suggested that the reasons for the difficulties in interesting young students in Industrial Design was that they did not experience it at school and it lacked the glamour of painting. He said, 'The trouble about Scottish Industry is, first, that it rarely realises that it needs Design and, second it never pays enough.'[5] He also pointed out that faced with a choice of employment, graduates would prefer teaching to industry which offered no security, longer hours, shorter holidays, less pay and mechanical uncreative work. Although he concluded by expressing his willingness to co-operate by organising part-time courses if the carpet firms did something to interest students, he insisted that, more importantly, the firms needed highly paid Art Directors responsible for staffing their studios and capable of controlling a design policy. However, the conference seemed to resolve nothing and the problem continued.

In 1955, Bob Finnie, a post-diploma student, was appointed to replace Bill Balmer. Stewart and Finnie made a good team, with Stewart's infectious and enthusiastic but mercurial and abrasive temperament and Finnie's more pragmatic, steady approach and attention to detail. The appointment of Chuck Mitchell as Stewart's assistant in 1964 added considerably to the team. Mitchell,

[5] Bliss correspondence, June 1960, 'Carpet Design and the School of Art', Glasgow School of Art archive, Bliss papers, June 1960, Box 1

Rosslyn Terrace flat, late 1950s; the three designs 'Rock' are signed: Stewart 1957. They were illustrated in *Motif 2* and produced as a textile design by Donald Brothers, Dundee.
Collection Sheila Stewart

who shared an enthusiasm for work, was talented and a larger than life character; although often outrageous, he was a sincere person and, like Stewart, worked intuitively. Both he and Finnie were devoted to Stewart and despite offers of jobs elsewhere, Mitchell remained in Glasgow possibly to the detriment of his own work and career. There was an air of excitement about the Printed Textile department which continued to make technical developments and grow over the years, but within considerable physical and economic restraints. One ingenious solution to the shortage of space was the acquisition of a spiral staircase from a submarine, the Otranto, at Faslane that was of the exact dimensions necessary to allow maximum use of the space available above the darkroom.

By the mid 1950s, there was a buzz about GSA's Printed Textile department which, by the end of the decade, was seen as the place to be in GSA. The department was regularly singled out by assessors and the Diploma shows consistently praised:

> The designs of the senior students in the printed textiles department rank with the best produced anywhere in the world by professional designers and are clearly the result of exemplary and imaginative instruction … some work is in advance of marketable possibility. This is to be commended in students' work.
>
> The technical standard of the screen printing is exceptionally high and the examples of other crafts by textile students, the exquisite flower drawing, and the brilliant arrangement of the display complete an exhibition which would be outstanding if shown in any capital city.'[6]

[6] Misha Black contribution to Assessors' Report, 1955

The department was also stimulating press interest. For example, an article in the November 1954 issue of *Design*, a propaganda journal launched by the Council of Industrial Design in 1949, examined the textiles being produced by the students. It noted that there was a freshness and individuality in the drawing and an interest in abstract design, although this was accompanied by a new interest in natural forms fostered by Stewart. The article also noted that:

> … Where abstract shapes have been used they have been ordered and controlled to cover the cloth in a rhythmic manner and with a dignity not always apparent in this idiom. In these examples there are strong indications of that increased humanity, that intimate sensitivity which has been lacking in much recent work in this field and elsewhere and for which so many are now searching.[7]

But how did Stewart achieve this and what was it about his method of teaching that produced such spectacular results? When the students joined the Printed Textile department he asked them to create designs from their drawings. At first they had no idea what he was asking them to do and no basis on which to evaluate their own efforts. This is the paradox of learning to design, for it is a difficult subject to talk about and an understanding of the essential elements of designing can best be learned by the students doing it, even although at first they do not understand what they need to learn. In other words it is learning by doing and is a form of self-education, the most effective kind of education. Although sometimes students intuitively recognise a good design they do not necessarily understand the reasons why it works, but gradually they learn the grammar of design through exercises in line, shape and colour. Through personal research and dialogue with Stewart, his students learned not just about the design process but about themselves.

His doctrine was based on an understanding of the visual relationships between point, line and plane of which he was a complete master. He was incapable of making a mark that did not work or was in the wrong place, similarly with colour he could put exactly the correct amount of an opposite colour in exactly the right hue beside a colour that you would imagine could not possibly work. Cosgrove believes this unerring ability came from

> … a complete understanding of and belief in the work of Maurice de Sausmarez and those whose work in Leeds during the 1950s led to *Basic Design: the Dynamics of Visual Form*.* While some of this was core to the two-year art and (but mostly) design course, it was the way that Bob *used* the underlying principles each and every day in teaching and making work that mattered (albeit at a sophisticated level), plus of course Klee's *Thinking Eye*. A difficult man to typecast.[8]

[7] 'New Textiles from the Glasgow School of Art', *Design*, November 1954, pp 28, 29

* available from A & C Black

[8] Jimmy Cosgrove in a letter to the author, July 2002

Initially, there were only six students in each year of the Diploma course, but later, even when student numbers rose, Stewart treated them as individuals. He did not teach formally and never held group tutorials, but would talk to individuals as they worked. For him, education was to do with ideas and values and he had the ability to respond to individual students and get behind their personalities. He placed great emphasis on sketch books and would search them for the individual mark making and character saying, 'I want to know what makes you tick.' These sketch books, or visual diaries, often aroused more interest and admiration among the assessors than the textiles themselves. For example, Robin Day's assessment in 1962 stated that 'they were extraordinarily rich in the raw materials of textile design and were evidence of Mr Stewart's quite uncanny gifts for teaching.' From his study of their sketch books, Stewart would devise ways of enabling and encouraging students to develop their self-expression; he always had points of reference and sources of inspiration for them, sometimes suggesting they look at the work of the most unexpected of people. He had an ability to see the potential in his students' work and to tempt people onto thin ice, to take risks and extend themselves, ensuring that they learned about their capabilities for themselves. However he was always ready to rescue them if they looked like going under. He was confident in his judgement and his critiques could at times be hard as he was brutally honest, but in aesthetic matters his judgement was invariably right and the students respected his opinions and wanted his approval. He was available to give advice but did not pontificate, encouraging students to think for themselves and develop experimental ideas. He also felt responsible for his students' work and on occasions would be waiting for them in the morning saying, 'I've been thinking about your work on the train this morning.' He was generous in spirit towards his students and, in helping them to make the most of their work, he went to extraordinary lengths in helping set up Diploma or Degree shows, altering the space or putting up tension wires.

The effectiveness of such teaching depends on good communication between student and tutor and this is not always easy, as there can be ambiguities and vagueness as well as difficulties in expressing visual things that are difficult to put into words. Such problems can lead to misunderstandings, but Stewart could paint a vivid verbal picture pointing out things that the student had not thought of, or could suggest a range of alternatives by sketching on a separate piece of paper, rarely if ever on the student's drawing. He would question the student about aspects of the design or might direct attention to problematic parts of the work, however the final decision was very much the student's. Occasionally he would push the student's work in a particular direction after the design had been produced. This sometimes resulted in work that was over-directed and markedly showed his influence, particularly in colour choice, but the intention was to help the student towards an individual way of 'looking' even if the work suggested otherwise.

Neither was Stewart's course static, he kept it alive and dynamic by varying the emphasis from year to year. Through this variety and his fresh approach, he encouraged students to develop a critical eye and was inventive

in the practical ways he enabled them to make informed decisions in evaluating and developing their work. He used interesting visualising techniques: for example, if a student had printed a design and felt it needed something more but was unsure if an additional colour was the answer, Stewart would recommend the cutting-out of a shape in paper of appropriate colour to lay on top. He thought it essential for students to investigate the weight, surface texture and draping qualities of the fabric to be printed before embarking on design work. If a student was stuck, he might be taken to a nearby department store to look at the surfaces of textiles for print. These may appear fairly obvious things to do but, even today, they are not often employed. Stewart would project slides of images onto a white toile if a fashion textile was required, a common technique today, but unusual then. Of great concern was the quality of mark; to demonstrate to the student the importance of how this was interpreted from design to print, he would make several different exposures of a pencil drawing with a process camera. These different tones would then be superimposed to give a really sensitive print that expressed the subtlety of the original drawing.

Despite his initial reservations about teaching there can be no doubt that Stewart became an inspirational teacher, particularly to those on the same wavelength, but sometimes he influenced students too much in trying to make them see things his way. He did not suffer fools and overwhelmed some and it could be difficult for those who had a different stance. Occasionally this resulted in major rows with those students determined to go their own way. For example, Stewart was passionate about drawing and there were many arguments with students about photography versus drawing with regard to textiles. Stewart worked intuitively and was too opinionated to work things through in an objective way and those who took a more intellectual approach rather than responding intuitively often found him frustrating. Visual aspects and beauty were more important to Stewart who was anti-theoretical; he was not interested in historical aspects and disliked irony, retro design and punk. He liked students who would tackle anything and approach it with the right attitude, but he had no time for those who played safe and any student with an interest in design history had to be self-motivated, as there was no encouragement within the department. However, even those who had a difficult time, such as Lin Gibbons who felt the course lacked intellectual rigour, later recognised that he laid important design foundations and that struggling against him was character forming. Through this conflict and reaction to his ideas, Lin Gibbons developed a determination and tenacity that enabled her to become an international award-winning graphic designer and President of the Chartered Society of Designers.

Some of these difficulties were resolved in 1973 with the appointment of Jimmy Cosgrove, a student of Stewart's (1967–72) who had gone to GSA after a career in telecommunications. He counterbalanced Stewart's reliance on intuition, as he took a more intellectual approach and one of his major contributions to the Printed Textile department was to articulate the educational aspects of the course for assessments and for students. He also introduced

Activities Week, 1975; screenprinting in Sauchiehall Street, Jimmy Cosgrove is on the right.
GSA archive

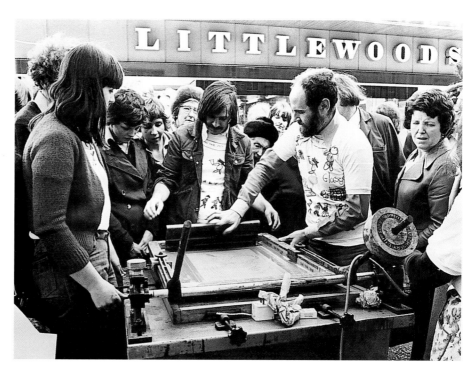

photography to the department and later succeeded Stewart as head of Printed Textiles before becoming Head of First Year and Deputy Director.

Stewart, like Bliss, saw the course as affording an appreciation of pure design that could be applied to any specific purpose. He wanted students to leave with a well-developed personal vision that he saw as the fundamental building block and a belief that anything can be interesting if you work some of your own inspiration into it. The next step could be built on that foundation in whatever area the student could find work. There was no business training, or firm guidance on how students should go on and make a living as designers, consequently during the 1950s some students were left feeling rather lost at the end of the course. However, by the 1960s, through specific projects for industry during their fourth year, students were exposed to real-life situations and given some experience of a possible career.

Through the breadth of his scope and his enthusiasm for design, he attracted students to textiles who had not even considered the subject and, unusually, there were always many male students in the Printed Textile department. On completion of the introductory two-year General Course, students had to choose a specialist department and Stewart offered them freedom and exciting, dynamic personal intervention. Peter McCulloch, a student from 1953–57, was not interested in textiles but wanted to do both jewellery and ceramics, which did not go down well with other tutors. Stewart did not consider this a problem and set up a kiln in the Printed Textile department in order to print tiles. McCulloch went on to design textiles for Edinburgh Weavers, BEA (British European Airways), Hull Traders and regularly for Heal's. He later set up the MA Textiles section at Birmingham, and became a consultant to the United Nations, lecturing in thirty countries.

Jock McInnes, a student from 1962–67, was interested in fine art and expected to join the Painting department, but instead was attracted to Printed

ROBERT STEWART: DESIGN 1946-95

Textiles, not because he was interested in design, but because the Painting department was steeped in tradition and Impressionism, whereas Stewart was wide ranging and open to new ideas. He was the only member of staff during the mid 1960s prepared to take on modern painting issues and open up the area of abstraction to students. McInnes knew he would find what he wanted in Stewart's department, which at that time was more like a mixed media department and also fulfilled the role of a printmaking department. Although McInnes, of necessity, learned about repeat pattern and printing design, more importantly he learned from Stewart's 'ways of seeing', looking at things in two dimensions and with concern for the aesthetics of shape. McInnes was also able to explore screenprinting, following the example of Andy Warhol and many of the American Expressionist artists; he was able to splash things onto canvas and experiment with a squeegee. McInnes went on to teach in the General Course, introducing screenprinting to first-year students and has subsequently become a very successful painter. Similarly, during the 1960s, John Macfarlane who was interested in the theatre was encouraged to join the department and flourished under Stewart's teaching, winning a Leverhulme Travelling Scholarship for 1969. He is now an internationally renowned theatre designer working with ballet, opera and drama companies in countries such as Denmark, Germany, Switzerland, Austria and the USA. There were also other students who, though in other departments, were interested in what was happening in Printed Textiles. For example, Jackie Parry from Sculpture was attracted to the educational experience of the textile students and did a postgraduate year with Stewart, later teaching on his MA course.

Success in attracting students with diverse abilities was recognised in 1964 when Humphry Spender, of the School of Textiles at the Royal College, and Robin Day were assessors. Bliss recorded in the annual report that:

> Despite Mr Stewart's modesty, the three Design Assessors once again singled out his section as the liveliest in the school. Indeed I have known no Design Assessor in the sixteen years that Mr Stewart has worked with me who did not sing his praises. He has been called the best teacher of Printed Textiles in the country. Mr Robin Day in his report shrewdly observes that 'the textile school itself seems to attract some of the most graphically talented students in the College. In this department one gets the general impression of talent and vitality and one feels in some cases that it is almost accidental that the channel of all this is to be fully directed at the design of textiles.' He goes on to say that 'the most interesting and promising work in this department is in the portfolios of drawings and studies of the students, or in paintings and other forms of expression.' Certainly the three post-Diploma students in this section devoted their fifth year not to textiles but painting! Nevertheless the assessors were delighted with this work, awarded them each the highest verdict; and even bought some of their exhibits.

Later there were students who worked in even more diverse areas such as etching and engraving sheet aluminium murals, etched, printed and kiln

Stewart with students of 1968–1970;
John Macfarlane is on the left.
GSA archive

fused glass works, posters, ceramic decoration and even caricatures. Although Stewart's main passion was surface design on any product, his appreciation of fabric, the surface quality, how it draped and moved, the quality of weave as well as the decoration applied, was second to none.

Work exhibited in Diploma shows helped influence a student's choice of department, as did presentations by the heads of departments to the second-year students. Malcolm McCoig, a student from 1959–64, remembers that the head of painting, William Armour, talked down design, declared that he would let Rembrandt speak for painting and left. Stewart followed, making a passionate plea for design, and ended by throwing down lengths of printed cloth including work by students. McCoig, of course was hooked and eventually went on to become Head of Textiles at Gray's School of Art, Aberdeen.

Design School staff also taught on the introductory General Course and Stewart, like his colleague Kath Whyte, would often identify talented students and try to persuade them to join his department. In this, there developed a friendly rivalry between the two. But success breeds success and competition was fierce to join the Printed Textile department. Stewart, who could be arrogant about his students' achievements, was disappointed if the new applicants were not of a high enough calibre. However, he was also ready to put himself out on a limb and took all the students who were not readily pigeonholed and encouraged them to develop their diverse interests. Some of these students, such as Macfarlane and McInnes, would already have a strong intuitive understanding of the direction in which they wanted to go. This made them interesting as individuals as they had probably demonstrated that they were prepared to take risks to allow this development to be recognised. It also meant that they had a tendency or potential that Stewart could work with and encourage. This contributed greatly to the dynamism and diversity of the

Printed Textile department, as did the postgraduate students he attracted who, he believed, made an important contribution to the life blood of a department.

Stewart and some of the other Design tutors, but none from the Painting School took an interest in Section V of the General Course. This was a randomly selected experimental group of ten students, a cross-section that included some who had done other things before becoming students or had a different educational background. Known as the 'Inventors' Club' under the tuition of Ted Odling, a Magnus Pike figure, they followed a different curriculum that gave them an introduction to a wider variety of disciplines than those following the traditional standard course. There was a Bauhaus influence, they studied Itten's colour theory whereas the General Course did colour wheels; they built geodesic domes with an architect while the others studied perspective and made drawings of plaster casts. Odling set interesting weekend projects, e.g. each student had to build a ping-pong ball machine in balsa wood, in which it took a certain time for the ball to drop, or to make a forgery by taking a familiar object and subvert it by recreating it with personal symbols. The aim was to encourage imagination.

Stewart set these students drawing exercises that were all about observation and seeing. He produced an enormous palm leaf, allowed them one minute to look at it. Then they had to paint it on large sheets of paper with a two-inch brush and black paint. On a huge sheet of paper he would made a mark in paint with a four-inch brush, then each student in turn would add a mark to build up a composition. The students were rather in awe of him and 'on their toes' because his department had such a good reputation and he was known to expect a great deal from his students.

Stewart's life and his work were inseparable and his students were a crucial part. As a major designer of national importance during the 1950s, he is unusual in that he continued to teach throughout his career. His ability as an educator largely stemmed from the way he reacted totally and with infectious enthusiasm to his passion of the moment, whether this was the discovery of a new artist or writer or stemmed from his own work. This often had the opposite effect on some colleagues who tired of such enthusiasm and reacted against it. Stewart enjoyed the stimulus of young people, liked them for their ideas and constantly urged discussion and debate about art and artists, about design and about all aspects of the arts. When students visited London to see exhibitions, this was not intended to focus on textiles but to open their eyes to the wider art world. However, he became angry when students looked at magazines of contemporary design as he disliked trendiness. He thought that all the glossy journals and magazines should be removed from the library because they were a distraction from the fundamental issues of design and that students would inevitably be influenced by them and regurgitate what they saw, which would produce pedestrian results. He wanted them to do original work that was unconstrained by the commercial requirements of the moment, as Walton had encouraged.

He was also concerned with beauty and could not tolerate ugliness in his students' work. He believed that they must experiment and explore their art and their own abilities to the utmost. To help them to do so he wanted to

Danny Ferguson's 'The Bored of Studies';
70 × 100 cm (26 × 39¼ in.); Stewart is
third from the left.
GSA archive

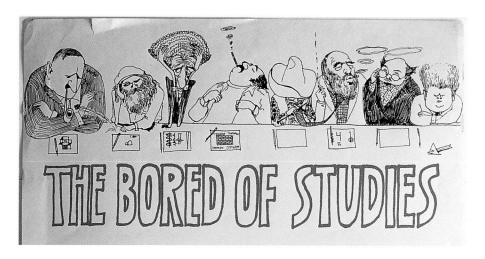

control what outside sources his students were exposed to. He introduced them to graphics, film makers, artists, philosophers and composers such as Mahler that most had never heard of. He would lend them books, later these included Ivan Ilich's *De-Schooling Society*, Theodore Roszak's *The Making of a Counter Culture* and works by E. F. Schumacher. He introduced them to other subjects such as interior design and brought in an architect to teach the students architectural drawing. And there was inevitably music, whether in GSA or his own studio at home. Always a keen dancer, during the mid 1970s he became passionate about Scottish country dance and on Friday afternoons the studio was cleared and he brought along someone to teach the students who went along for a laugh. Mitchell and Cosgrove joined in, too. This was not the kind of earnest de-stressing exercise that might be considered today, but was simply for fun and a way of forging the students together. But the students didn't always go along with his ideas. In the late 1960s, he tried to set up a discussion corner in the GSA studio with comfortable chairs, but the students resisted this move. This emphasis on discussion was partly to create a unified, co-operative group, but it was also his way of working out his own ideas and exerting control.

To further extend the students' experience from the mid 1950s, he organised annual week-long drawing trips to Ross and Cromarty in the north-west of Scotland during the Easter holidays. Although painters had practised in this way since the nineteenth century, Printed Textiles was the only GSA department to do so at that time and individual students from other departments occasionally joined them. The accommodation in the National Trust Adventure camp at Balmacara was in wooden huts on a former anti-aircraft site. It had the advantage of being cheap but the conditions were primitive, the floors were often wet in poor weather, the toilets were outdoors and the water supply was frequently covered with ice. It was a week in which barriers between the students were broken down. They cooked their own meals, sometimes of salmon or sea trout freshly caught, or rather poached from nearby rivers and lochs by Chuck Mitchell, an excellent fisherman. For most of those who chose to go, this was their first exposure to wild landscape, it was a visual expedition with inspiration from real experience. For many that experience was life-changing.

Stewart was always first up in the morning, preparing for the day's work, cutting card in different shapes and had often produced some work to show the students before breakfast. The weather at that time of year was invariable atrocious with sleet, snow or rain, yet everyone worked intensively outside, all day. Each morning driving around places such as Plockton, Sheildaig, Torridon, Applecross and Glenelg, the students would spread out and work quickly, studying the wider landscape or details of lichen and other natural forms. Stewart and Mitchell were passionate about this activity and brought the landscape alive for the students. After an hour or two, they would move to a new site, returning to spend time after the evening meal looking at the day's work and discussing it over a drink, often shared with the local postman who enjoyed socialising with them. In this way, students learned how to take things from what they saw and develop them further. Later, there was fun and inevitably late nights, but Stewart needed sleep and would not tolerate disturbance either of his sleep or his creativity and concentration during the week. Everyone returned with quantities of work and an exhibition was held in the Mackintosh museum at GSA with Stewart trimming and mounting the students' work for the exhibition.

The results of the Easter trip provided the students with inspiration for months and many developed ideas drawn from the landscapes in textile designs. In Kintail there was little else to do except work, although they did attend local dances in the Achamore Village Hall, at Plockton and at other villages. Although

Students sketching at Plockton, c1966.
Photographs from the Easter visits to Balmacara are rare because the emphasis was on drawing and cameras were rarely used. This image was taken from a short film.
By kind permission of Bob Finnie

Landscape, late 1960s; Procion on paper;
dramatic, atmospheric paintings such as
this often resulted from visits to
Balmacara.
Artist's photo, collection Sheila Stewart

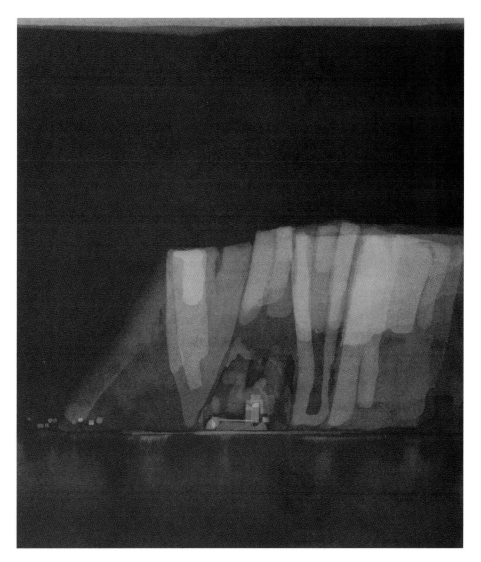

in 1967 the more comfortable Cargill Hostel in the grounds of Culzean Castle
in Ayrshire was established, the textile students continued to visit Wester Ross
for a few more years, also staying at Letterfearn, Loch Duich and Morvich.
Students from Aberdeen joined them after three of Stewart's former students
had gone to work at Gray's. As a result, Stewart attracted postgraduate students
from Aberdeen and one, Mary Duncan, went on to work with Ted Odling in
Section V. During the rest of the year, too, there were exchanges with other col-
leges. The visit to Edinburgh resulted in a rather drunken race along Princes
Street between students in prams, and when Edinburgh students visited
Glasgow, the students raced each other along Sauchiehall Street to the
Underground station, with student-built coffins. Aberdeen also exchanged vis-
its between textile departments that were decorated for the occasion.

The students of the four Scottish schools of art had more formal contact
through promotional activities such as combined exhibitions of work.
Enterprise Scotland set a precedent in 1947 and *Scotland '67*, sponsored by
Simpson's of Piccadilly, brought them together to draw attention to various
aspects of Scottish industry and design. Stewart, however, although enthusias-
tic in earlier days, expressed serious doubts about the value of more frequent

exhibitions. He questioned their purpose and the motivation behind them, pointing out the danger of promoting the importance of a college, a particular course or boosting sales, that could result in losing sight of the main purpose, namely broadening the knowledge and experience of the student. He pointed out the huge expense involved which he believed could be better used in purchasing new equipment or in financing additional activities for students or, even more importantly, might be invested in postgraduate courses in whose development he was taking an increasing interest.[9]

In 1971 began the innovative Activities Weeks that broadened the experience of the students and opened out GSA to the wider community of the city. Tony Jones, a mercurial enthusiastic Welshman, then a young lecturer in the Sculpture department, and the dynamic Scot recognised some form of Celtic fellow feeling and Jones' friendship became important to Stewart. They fuelled the first Activities Week and subsequently invited Joe McGrath, David Hockney, the industrial designer Kenneth Grange and Dr Magnus Pike, and organised debates such as Glasgow Plus or Minus which examined city planning within Glasgow. Stewart was interested in the visiting artists and intellectuals and their points of view. At least one, Professor Roszak stayed with the family at Loch Striven. Later, Cosgrove was to be a very active and energetic supporter and took on much of the organisation, inviting speakers such as Bruce McLean, Ian Brakewell, Kevin Coyne, Peter Blake and George Melly.

Changes in Education

In October 1963, Bliss sent Stewart and Kath Whyte to the Schools of Art in Manchester, Birmingham and Leicester to assess the impact of the new DipAD system. On his return, Stewart reported that although the results were uneven the overall impression was one of 'renaissance'. The work of Manchester was of a very high standard based 'purely on drawing and vision, an excellent springboard for any department'. He also noted a good Liberal Studies Department, although he had little sympathy with such studies and later came into conflict with GSA's department. He was much impressed by the approach in Leicester where staff and students were working 40–50 hours per week and new buildings, equipment and staff were being provided. Here he found remarkably fluent and heated discussions between staff and students and noted, 'It seemed that staff and students alike were sharing some educational experience. When I thought a little of Glasgow, I feel that we are a decade behind. Naturally it is the final results which count in the long view, but this feeling which came from Leicester will stay with me for a long time.'[10]

Bliss, who recognised the abilities of Harry Jefferson Barnes (who was to be his successor), recognised that changes in education were inevitable. On his retirement in 1964, he commented that Barnes' time as Director would

[9] *Facet 1*, Glasgow School of Art, February 1968, p. 31

[10] Bliss correspondence, Glasgow School of Art archive

be vital to the School and so it proved. It was a time of significant academic development and expansion but not without its difficulties. There was the debate among the Scottish Schools whether to go along the route of the Council for National Academic Awards (CNAA) degree system that operated in England. Harry Jefferson Barnes was concerned to retain the School's independent status but argued that the change was necessary in order that Scottish students should not be disadvantaged in Britain and Europe. There was resistance from several members of the academic board, notably Stewart and Dugald Cameron, head of Product Design. Although they had a different approach to teaching and their own work, they nonetheless both recognised the practical difficulties in establishing the assessment criteria for the grading of an honours degree, particularly in fine art. Stewart 'was afraid that if the proposals were accepted repercussions would follow and people like himself would be brought into line.'[11]

It was ironic that at a time when more examinations were being introduced into the Art and Design Schools, Architecture was reducing them. There were lengthy discussions and heated arguments about the changes and Harry Jefferson Barnes had problems in persuading the heads of departments to toe his line. During this difficult time he had a tendency to divide and rule to achieve what he wanted which was to safeguard the position of GSA as one of the largest and most important monotechnics in the UK. He hoped that the Scottish Art Schools would form a loose confederation of equal partners doing similar work and awarding similar qualifications to prevent their being swallowed up into larger local polytechnic groups as had happened in England and Wales.[12] Unfortunately there was no united alternative Scottish proposal from all four schools. This undermined any resistance and the degree system was implemented in Glasgow. But CNAA was anxious that the best characteristics of Scottish art education should be preserved. In his book on art education, in a chapter entitled 'Grasping the Thistle', Robert Stroud mentions that:

> The Scots …who believe that their courses had preserved some good old fashioned virtues which had been thrown out by the supposedly trendy colleges south of the Border. It would be wrong to pretend that there was not an element of truth in this allegation. The CNAA visiting teams, on the other hand, though they found some exceptionally good work being done in the Scottish colleges – the textiles department at Glasgow springs to mind as producing some of the best work in that area anywhere in Britain – considered that many of the courses were too heavily craft-based, with not enough emphasis on the intellectual contents of the programme, and the students studies were too closely directed, so that there was insufficient encouragement for personal exploration and development.[13]

[11] Minutes of a meeting of the Board of Studies, GSA, 26 April 1972

[12] Annual Report, GSA, 1971

[13] Robert Stroud, *A Good Deal of Freedom, Art and Design in the public sector of higher education, 1960–1982*, Council of National Academic Awards, 1987, pp 165–178

This had been Allan Walton's criticism of English Colleges in the 1940s. However Stewart and some others continued to have strong reservations and doubt about whether CNAA panels could understand the Scots experience and take the Scottish art educational strategy into account.

Degree courses were begun in 1975 and the increased paper chase created by accountability on all fronts as art education moved to a university system caused Stewart problems. He loathed administration and paperwork, he believed that it was 'doing' that mattered and would regularly pick up the morning mail and dump it in the waste bin saying that if he started to go through that lot, he'd never talk to a student.[14] This inevitably caused bureaucratic chaos, but he refused to conform and was determined to swim against the tide because he felt he had to fight the fact that education was becoming more rigid. He simply wanted to be allowed to carry on teaching in the way that he had always done. Yet despite these problems and his reservations, CNAA was fairly benevolent. Importantly for Stewart, it gave him the opportunity to set up what for him was the ideal teaching situation, a Master's Degree course in Design. Although the long-term vision was to establish a Scottish School of Advanced Studies in Art and Design, it was recognised that until the new degree system was well established this was not a feasible development. It was in 1978 that Stewart initiated an experimental extended postgraduate Diploma course that was submitted for CNAA approval and eventually granted MA status. Stewart was appointed Head of this course which was unique in Britain. His intention was to bring together the very best students from different disciplines – textiles, graphics, jewellery, murals, interior and product design (called engineering design in England) – in order that they could develop and enrich their individual specialist areas through the cross fertilisation of dialogue with their fellow MA students, with himself and with the head of their own undergraduate specialism. In other words, he wanted to engender an attitude of intellectual enquiry to run parallel to the visual awareness and enquiry that would enable them to design in a lively intelligent way. To this end, the students were continually posed new challenges by Stewart. For example, he suggested to Clare Cameron who was designing table linen that she should also design a table; when he saw a student with 'tissue paper crushed up in a bowl, which looked superb, I got him to make silver that looked like that.'[15] As well as their own specialism, students worked in other disciplines and also on joint projects. They were allocated different departments, a mural student had to design and make a ring in a week and she set a mural project for a jeweller. The group visited and studied the Caledonian Hotel in Edinburgh before working together to design cutlery, furniture, textiles, interiors and mural decoration appropriate for this setting.

Such group projects depended on close co-operation which was successfully developed during the first two years, when the students were all Glasgow

[14] Information from Sheila Mackay, former student and colleague on the MA Design course at the GSA

[15] Minuted conversation about the MA Design course between Malcolm Thwaite and Stewart, 6 August 1979, Glasgow School of Art archive

graduates. However, there was a problem during the third year when there was conflict among the strong personalities within the group. There was also a basic problem in that it was difficult for Product or Engineering Design students to integrate properly as they approached their work in a fundamentally different way. Although the work produced during the first two years was outstanding, the course was criticised because it lacked definition and control and needed to develop a core element appropriate to all disciplines. Despite these setbacks, the course was improved and went from strength to strength attracting graduates from an even wider range of disciplines, including photography, fine art and planning. Stewart's belief in the course was vindicated in 1983 when the CNAA examiners stated that, had it been possible to award an MA with distinction, they would have done so to several students. The course was very much identified with Stewart and was known among the staff by the shorthand term 'BSC', Bob Stewart's Course.

Bob and Sheila Stewart with one of their dogs, 1990s; the family enjoyed pets and at one time had a Pyrenean mountain dog and seven cats.
Collection Sheila Stewart

Stewart was a paradox in that, although he was anti-establishment, he also desired recognition of his work by that same establishment, not simply for personal reasons, but in appreciation of the importance of design about which he continued to be passionate all his life. His work as a designer was certainly recognised by Harry Jefferson Barnes. In addition to his MA post, in 1980 Stewart was appointed Head of the Design School which he accepted for a two-year period. Subsequently, the new Director Tony Jones appointed him as his Deputy. Despite the recognition of his long service and of the contribution to the School's reputation that this appointment brought, it was not a happy time for Stewart. On the one hand, he had a widely acknowledged, hugely successful career as a teacher when his students regularly won the Newbery Medal (for best student in the School), and during a ten-year period his textile students won five Leverhulme scholarships in competition with the rest of Britain, and some won international acclaim. On the other, his inability or unwillingness to adapt to the continuing changes in education and administration and the inexorable involvement in internal politics, which he loathed, brought profound anxiety, anger and frustration that was increasingly expressed in fierce arguments with his colleagues, including those who were close and valued supporters. Also during this period a lifetime's smoking habit caught up with him and he became ill in 1983 and was forced to retire through ill health the following year.

5

EDINBURGH
TAPESTRY COMPANY,
THE DOVECOT STUDIOS

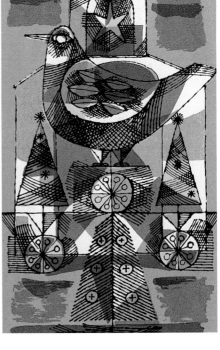

Christmas card, 1954–57; screenprint on
card; 15 × 11.5 cm (6 × 4½ in.)
Collection Margaret Beck

Uɴᴛɪʟ ᴛʜᴇ 1980s, heads of departments taught four days each week and were
expected to continue to work in their own particular field and pursue their own
creative activities or undertake courses of study to improve their academic or
technical qualifications without interfering with normal teaching duties.
Throughout his teaching career, Stewart energetically pursued his own studio
practice, the experience of which fuelled his teaching. He may well have remem-
bered a lecture given by D. P. Bliss, a brilliant lecturer, to colleagues and students
on his appointment as Director in 1946. It was full of encouragement and sup-
port, but also included a warning to those who taught to beware that if they did
not continue their own creative work it was likely they would lose their zest for
their subject, becoming merely wage earners and therefore bad teachers.[1]

During the late 1940s and early 1950s, Stewart was intensively developing
textile designs. He sold six designs to Morton Sundour[2] and went on a selling
spree in 1950. In his own words, 'I did my salesman bit, carrying my case round
all the best London stores. I learn't a lot – all students should do it. I was kept
waiting for hours and then they wouldn't even look at my wares.' A visit to
Liberty's, with abstract patterns, paid off in the end. The buyer who was used
to selling chintz told Stewart to take that rubbish away. 'I'm afraid I lost the
place, replied in good Glasgow tongue and swore I'd never enter their doors
again.' He went straight to another shop but Mr Stewart-Liberty himself asked
him to return.[3] A fruitful relationship followed. Stewart supplied designs to
Viyella over many years and also designed both printed and jacquard woven
textiles for Donald Brothers, Dundee. This contact between the department
and the company had been established by Allan Walton who knew Frank
Donald and stayed with him when an assessor at the Dundee School of Art.

Stewart also became involved in a commercial venture at the Edinburgh
Tapestry Company when Harry Jefferson Barnes, then Deputy Director of
GSA, and John Noble of Ardkinglas took over its running from the Bute

Christmas card, 1954–57; screenprint on
card; 20.2 × 12.6 cm (8 × 5 in.)
Artist's photo, collection Sheila Stewart

[1] Glasgow School of Art archive, Bliss papers, Box 4

[2] Information supplied by Sheila Stewart – these designs have not yet been identified

[3] *Glasgow Herald* interview, 18 October 1980

Christmas card, 1954–57;
screenprint on card;
12.6 × 20.2 cm (5 × 8 in.)
*Artist's photo, collection
Sheila Stewart*

BELOW: Card, 1954–57;
screenprint on card;
11 × 19 cm (4¼ × 7½ in.)
Collection Sheila Stewart

family in 1954. In an attempt to ensure its survival under the crippling imposition of 66⅔% purchase tax on tapestry, Noble suggested bringing in Stewart to develop a range of more affordable well-designed quality goods to increase cash flow. Stewart who enjoyed flexibility in his work and liked to start things off and get them going, reduced his teaching to two days each week and worked two days at the Company's Dovecot Studios, Edinburgh. The company is most commonly referred to as the 'Dovecot' from the ancient building in the garden.

There was a print table at the Dovecot and he invited one of his graduate students, Margaret Stewart (no relation), to work with him. She printed his

Leaves tablemat, 1954–55; signed: Stewart; screenprint on blotting paper; 28.5 × 34 cm (11¼ × 13¾ in.)
Collection Margaret Beck

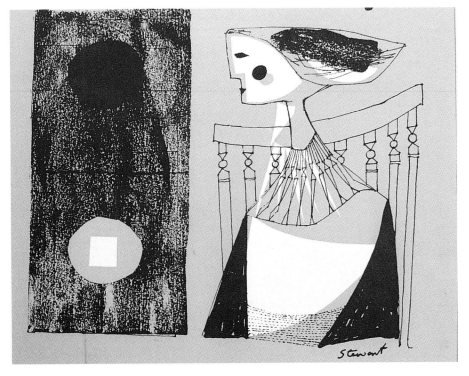

Abstract tablemat, 1954–55; signed: Stewart; screenprint on blotting paper; 28.5 × 34 cm (11¼ × 13¾ in.)
Collection Sheila Stewart

Abstract tablemat, 1954–55; screenprint on blotting paper; 28.5 × 34 cm (11¼ × 13¾ in.)
By kind permission of Mount Stuart Trust Archives Collection: Edinburgh Tapestry Company, 1912–2000

Houses tablemat, 1954–55; signed: Stewart; screenprint on blotting paper; 28.5 × 34 cm (11¼ × 13¾ in.). This design was produced in a variety of colourways and also used as the design for a Liberty scarf.
Collection Sheila Stewart

designs but also did her own. They produced printed cotton cushion covers of which there were four designs in various colourways, Christmas cards in eight designs and tablemat designs printed on blotting paper as well as card (eighteen designs including shells, fruit, men in boats, a cockerel, fishermen, gardeners, buildings and abstracts). The mats sold in sets of six for 5/9d (29p) and could be produced at a rate of 600 to 675 sets per week at most. There were also printed linen tablemats; Sheila Stewart stitched and frayed the edges and lent a hand to pack goods when an order was sent out. It has to be remembered that Scandinavian design was very influential at this time; doilies,

tablecloths and anti-macassars had given way to simpler uncluttered interiors with plain wooden tables and furniture.

Margaret Stewart and Robert Stewart were really starting this part of the company from scratch and experimenting with different applications of screenprints. For example, printing on ceramic napkin rings was tried but was not developed and thin plywood was curved and made into fruit bowls. Pieces of parquet flooring composed of jointed strips of African teak backed with Rexine were printed, given a matt finish of resin-bonded lacquer and sold as heat-resistant tablemats in eight designs. However, most successful was printing on tiles. At first the tiles were silk-screened, but later transfer prints were used. Eventually thirty designs were produced, including birds, trees, classical heads and a knight on horseback. A series illustrating historic buildings was designed for the National Trust for Scotland by Barnes. The tiles were for interior use and could be ordered in special colours for fireplaces, bathrooms and kitchens. Special editions limited to fifty tiles of any one design were introduced and sold framed as small works of art for wall decoration. A long tray for keeping teapots or dishes warm in front of the fire was made from fine mild steel rod supporting four tiles, and pairs of tiles for oil and vinegar were mounted in wrought iron. In addition, a tray with a simple plain wood frame holding six tiles in a choice of two five-colour designs was available.

Although it was never the intention to undertake the whole range of silk-screen printing normal to commercial art studios, there were plans to produce a range of decorative papers for bookbinding. In addition, cards were printed and Stewart began to produce editions of high-quality screenprints in brilliant

Whalers tablemat, 1954–55; drawing; 28.5 × 34 cm (11¼ × 13¾ in.)
Collection Sheila Stewart

60

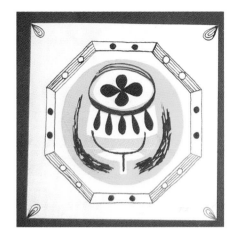

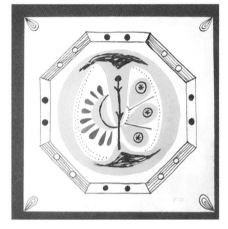

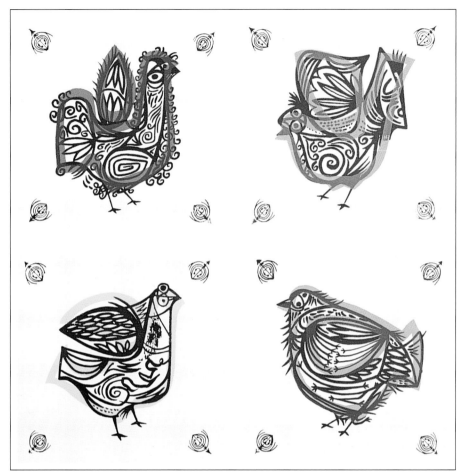

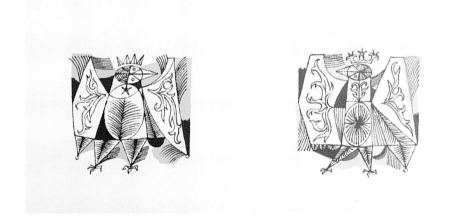

ABOVE: Set of tile designs, 1954–57;
screenprint on paper; each 12.7 cm
(5 in.) square
*Mount Stuart Trust Archives Collection:
Edinburgh Tapestry Company 1912–2000*

ABOVE RIGHT: Set of tile designs, 1954–57;
screenprint on paper; each 12.7 cm
(5 in.) square
Collection Lady Alice and Janet Barnes

RIGHT: Pair of tile designs, 1954–57;
screenprint on paper; each 12.7 cm (5 in.)
square
Collection Lady Alice and Janet Barnes

colours. Each edition was limited to 40 prints measuring 22 × 17 in. (56 × 43
cm). An innovation of Stewart's was printed linen mural panels that he began
producing in 1951. These one-off designs were intended to introduce colour
to decorate home or office schemes and, by 1953, he appears to have con-
centrated on Cubist inspired heads in clear, bright colours, priced by size at
£2 to £3 per square foot.

There was also a range of designs available for printing lengths of textile,
and although the company did not plan to produce textiles on a large scale
they were interested in printing textiles for particular schemes, especially

where it might be appropriate to use abnormally large motifs of design which could not be found in manufacturers' normal ranges. It was suggested that these designs could be customised to suit particular schemes. Stewart had samples of these designs printed, but it seems likely that they were produced at GSA as Margaret Stewart did not print lengths at the Dovecot Studios.

During August 1955, Stewart spent a week visiting potential customers in London, which he described as '… a week such as I have never known before'.[4] First he visited Liberty's where he met Paul Roake, the general manager, Stewart-Liberty and Mrs McClelland the buyer. She asked him to design and print some plain tablecloths and napkins that she would supply ready-made. His goods, particularly the tablemats, had an enthusiastic reception and, after bargaining, a £200 order was agreed for blotting paper mats on condition that they were sold to only one or two other stores, but not the John Lewis Group. In addition, the Dovecot was commissioned to design and print Liberty's Christmas card.

Next he went to Woollands, Knightsbridge 'where within seconds the whole floor was littered with our goods and Elgin plus directors, sales staff and public were going into raptures. The effect is impossible to describe and was slightly embarrassing.' Woollands, too, was particularly impressed with the tablemats and requested exclusive rights in the Knightsbridge area. 'I said, no, I really must see Harrods down the road. The fun now started with Elgin and directors and after some haggling they decided to make it £200 and share rights with Liberty. I agreed. This altogether took half an hour and I was like a sponge at the end. Never in my wildest dreams had I thought the day would come when I could successfully play one firm against another. … When I described things on the floor, it so happened that a director of Ebbots of Croydon was there and next day he 'phoned Elgin to say that he wished to contact me and place an order for £50 of paper mats. Both Woollands and Liberty agreed.' Woollands were also interested in purchasing designs for lengths of textile the following November as they were about to enter that market. As a result of these orders, promotions including special window displays were arranged. However, at the Dovecot, it meant that there were 14,000 mats to print and the question of whether to employ additional assistance to complete the order. Ultimately, Bob Finnie was brought in to do the colour separations and to help with printing during the GSA summer holidays. Stewart wrote to Barnes,

> My feeling about pulling in odd helpers is frankly against them. I see no reason to spend our small profit on others when I have 3 days unused … I think it also silly to work a full-time summer in preparation for the best buying season and revert to part-time work. My impression now is that if we do not take up this chance now we never will do anything.
>
> Ian Hepburn for whom I now have a great regard is even more adamant on this point. He admits he has never known a week like it, and I myself have battled for years for just such a position and am naturally reluctant to withdraw now.

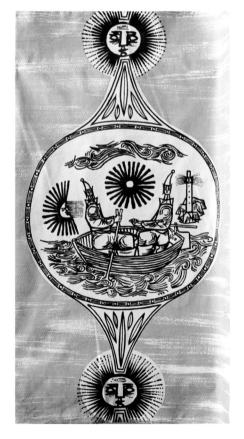

Fabric sample, 1954–55; screenprint on linen; 93 x 136 cm (36½ x 53½ in.) The central oval design was also used on tablemats in a variety of colourways. *Collection Sheila Stewart*

[4] Undated letter from Stewart to Harry Jefferson Barnes. I am grateful to Lady Alice and Janet Barnes for allowing access to Sir Harry's Edinburgh Tapestry Company correspondence.

Fabric sample, 1954–55;
screenprint on linen;
80 × 132 cm (31 1/2 × 52 in.)
Collection Sheila Stewart

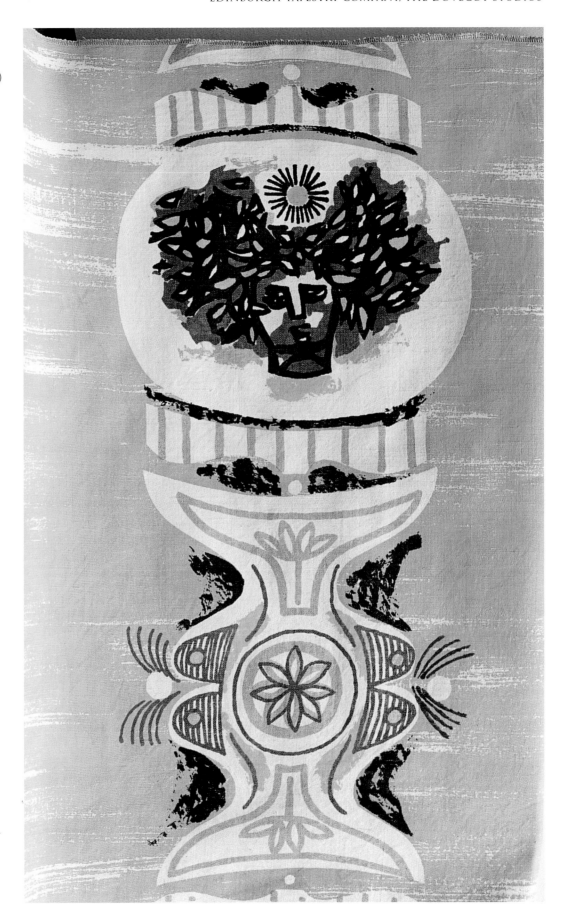

Ian Hepburn, a former Glasgow interior design student of Henry Hellier, and now a salesman and designer with Alten Products who supplied light fittings, furniture and accessories, had accompanied Stewart each day. They were obviously stimulated by each other's company as Stewart reported

> I don't think we got a good night's sleep all week as we got so excited about ideas. Ian was very excited about basing furniture on the wood mat principle and I must say that I can hardly think of anything else.

As a result of their discussions and the success of this selling trip Stewart put the following proposal to Barnes:

> Let things go till Xmas and clear up this welter of work. Immediately after this bring things to Cardross (on the west coast) for a start to be made no later than March for summer sales. Bring in more capital, ask Hepburn to join our section and get started on furniture right away. A start would be made sensibly on tables, etc. He would bring his work to us and continue selling. We have between us all the contacts for good publicity and sales in London. We would expand our co-operation to make things such as small cigarette boxes, trinket boxes, etc. In other words to make as finely and as beautifully as possible, objects made today which would be as graceful as the papier mâché objects of last century. In the case of furniture it would be to slowly find a grace and elegance of beautiful craftsmanship which is lacking in contemporary furniture today. This does not entail desperately expensive articles if properly planned.
>
> All this, of course, is to be built round printed 'alamac', and I feel that we could establish a school of furniture as elegant as the Italian and as well made as the Danish, but have a different character.
>
> I think the idea is wonderful and not to consider it would be sheer folly. It is all very well being artistic and patronising the arts, and you will no doubt know what I mean by this, but it may well be that what is all the time below one's nose can prove as valuable.[5]

This letter expresses the spontaneous enthusiasm with which Stewart reacted to new ideas and opportunities and also his concern with quality and beauty. The following May, Harry Jefferson Barnes accompanied Stewart on his next sales visit to Liberty's where he met Roake who subsequently wrote to Mr Tyrell of Saunders Ltd, Salisbury, Rhodesia, recommending the products, particularly the blotting paper mats and cards.

Unfortunately, Stewart's ideas proved too ambitious for the Dovecot at that time, possibly because of the constant perilous financial strain of supporting the tapestry workshop and the effort necessary to bring in commissions for tapestry, which was the main focus of the company. Whatever the reasons, the furniture plans were never realised although the mats and other goods continued to be sold through Liberty, Woollands and Browns, Kingston-upon-Thames, as well as in Inverness and Fort William, through Crafts

Six sample fabrics, 1954–55. Each length has the design name and 'Stewart Scotland' printed in the selvage.
Artist's photo, collection Sheila Stewart

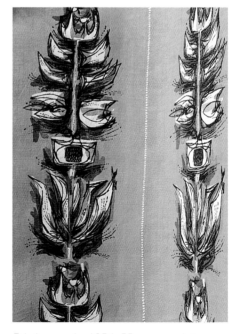

Fabric sample, 1954–55; screenprint on linen; 84 × 133 cm (33 × 52³⁄₄ in.)
Collection Sheila Stewart

[5] Ibid.

64

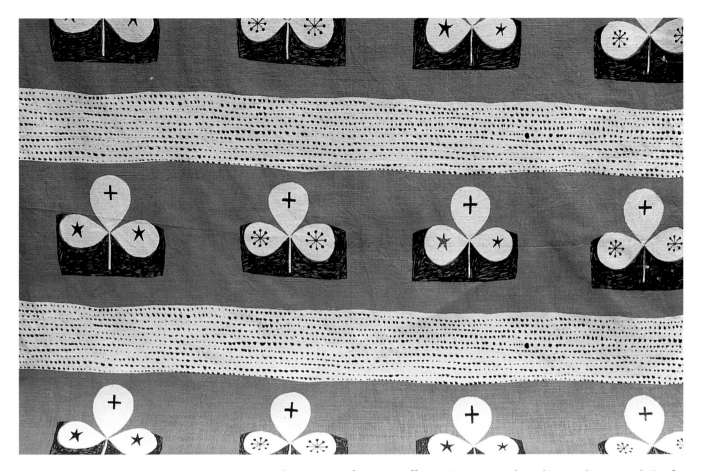

Fabric sample, 1954–55; screenprint on linen; 70 × 85 cm (27½ × 33½ in.)
Collection Sheila Stewart

Council contacts of Harry Jefferson Barnes, and in the newly opened Crafts Centre at Acheson House in Edinburgh's Canongate.

Margaret Stewart left in 1957 and Tom Shanks was asked by Barnes to take over responsibility for printing in order to allow Bob Stewart to return to full-time teaching. He remained for eight years, at first in Edinburgh, then in Glasgow; in 1961 the printing operation was transferred from the Dovecot Studios to a room at the top of a blind manufacturing factory in Bellgrove Street, Bridgeton. This accommodation was supplied by Moira Meighan who had taken over the family business and was a lively force in the cultural life of the city. However, tile production returned to Edinburgh three years later and Edward Powell from GSA took over the printing. Equipment had been acquired by 1961 for the intended printing of wallpapers, but this never developed. John Noble recognised that Stewart was an exceptional designer and wanted to give him his head, but the operation was too small a concern to be a financial success. Barnes saw the need to produce more ordinary commercial goods.

Stewart, who now wanted time to develop his own work further, returned to full-time teaching although he continued to work to commission for commercial companies. For example, he designed a colourful range of cast-iron cookware decorated with vitreous enamel glaze for Lane and Girvan that was illustrated in the 1958 *Studio Yearbook of Decorative Art*. Later he was again to have a working contact with Ian Hepburn who went on to work with ICI, when Stewart was enlisted to work with Bri-nylon. By the late 1960s, Stewart had almost abandoned textile design which he thought a young man's game.

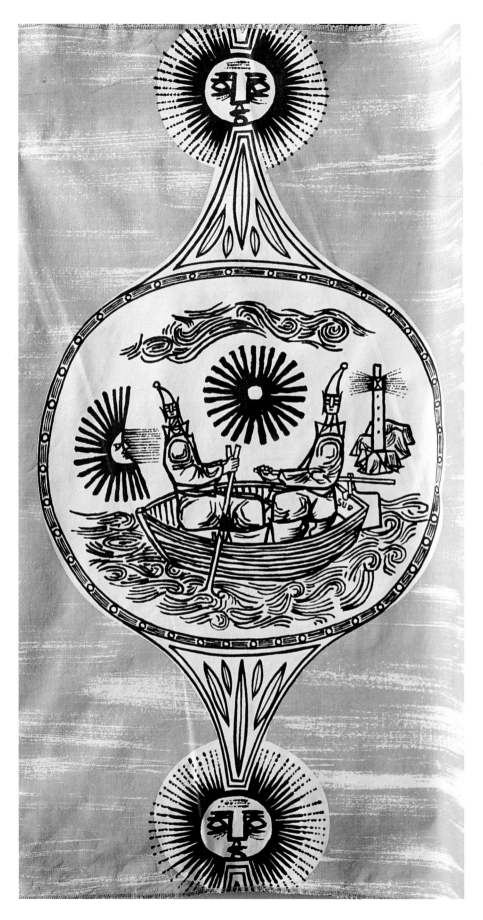

Fabric sample, 1954-55 (see p. 62)

6

TEXTILES

Mary Schoeser
Former Liberty archivist, freelance archivist, historical textiles adviser, curator and author

Textiles: 'the strong present tense'
We must set up the strong present tense against all the rumours of wrath, past or to come. So many things are unsettled which it is of the first importance to settle – and, pending their settlement, we will do as we do. … Expediency of literature, reason of literature, lawfulness of writing down a thought, is questioned; much is to say on both sides, and, while the fight waxes hot, thou, dearest scholar, stick to thy foolish task, add a line every hour, and between whiles add a line. … Thou art sick, but shalt not be worse, and the universe, which holds thee dear, shall be the better.

T HESE WORDS BY Ralph Waldo Emerson are possibly best known to historians and practitioners of the decorative arts through their citation in *Writing & Illuminating, & Lettering* by Edward Johnston*, a father of modern calligraphy as well as directly and indirectly of much that was new in both commercial letter forms and wood- and lino-engraving in the first half of the twentieth century. Although there is, therefore, a connection to Robert Stewart's work through lino-block printing, which he learned as a student, it is the allusion to calligraphy that is more pertinent here. Stewart's 'lines' were not written but were equally communicative. His designs worked by providing what has been dubbed 'metaphorical appreciation', important because 'the individual needs an intelligible universe, and that intelligibility will need to have some visible markings.'[1] Despite the fact that a relatively small proportion of his textiles of the 1950s can be firmly identified, it seems clear that these were only occasionally entirely non-figurative or abstracted floral forms, which were the mainstay of pattern design in this period. Instead they drew from an *oeuvre* that was consistently humane, dealing often with the human form, face or features. This focus on humanity was expressed through a visual vocabulary embracing ancient, mythological or imaginary beings, or other widely understood evidence of human enterprise, such as fish and boats. By exploring such imagery, Stewart tapped into cultural iconography representative of individuality, risk-taking and idealism that were, on the one hand, particularly Scottish and socialist and, on the other, universally understood.

* available from A & C Black

[1] Mary Douglas and Baron Isherwood (eds), *The World of Goods: towards an anthropology of consumption*, (1976), published by Routledge, London, 1996, p. vii

There are several other reasons why the opening quotation should bring Stewart to mind, among them his own battles with illness, his tenacity and his doing as he would do. Less obvious is the way in which it suggests two other calligraphers, both also influential teachers. One, Donald Jackson, used the same passage in relation to the other, Irene Wellington. Here the parallel plays out in the latter's creative and sustained forwarding of the ideologies of her mentor, Edward Johnston, and Stewart's similar contribution to the perpetuation of the legacy of Allan Walton, who died in 1948. Already mentioned is the embodiment of Walton's pro-active and multi-disciplinary approach in Stewart's modification of his undergraduate courses and, later, in postgraduate training. Further, in addition to the contact provided to the Dundee textile firm, Donald Brothers, it is more than likely that Walton's approval of Stewart's student designs opened the door to the group of firms controlled by the Morton family (originating in Ayrshire, just south of Glasgow) and the initial purchase of six designs for the Morton Sundour range in 1950. Walton had been personally acquainted with Alastair Morton, whose particular interest was the Morton company's upmarket subsidiary, Edinburgh Weavers (established in 1928), for whom Walton's firm had undertaken hand-screen printing.

It is difficult to gauge Stewart's subsequent contribution of designs to Sundour and, in all likelihood, to Edinburgh Weavers. This is not only due to the movement and dispersal of records[2], but also because the USA and Canada were for much of the 1950s the principal markets for these fabrics, almost exclusively so in the case of Edinburgh Weavers. The same was the case for Donald Brothers' fabrics, which were distributed by wholesale companies such as Jofa Inc. of New York and decorator-designers such as Dan Cooper, whose New York-based operation showcased many high-quality British fabrics, including the influential work of Ethel Mairet and her Ditchling workshop, Gospels. While in both Britain and America there were institutionally backed initiatives to recognise the designers of products such as textiles, this seldom pertained when fabrics were imported into the Americas. In these instances the need to establish brand recognition took precedence, and few of the British textiles illustrated in American journals name the individuals responsible. Whatever their professional encounters, Morton's stint as a course assessor in 1961 meant that he was certainly to become familiar with Stewart's work, and even by 1960 Stewart spoke as if from extensive personal knowledge when he described the former as 'both a designer and a business man', going on to urge that 'the need of today was for competent Art Directors of his calibre who could be trusted by the executive and were capable of catering for foreign markets, local trade and design developments'.[3]

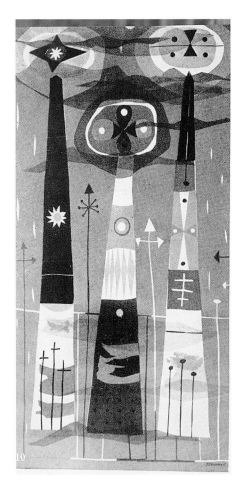

Screenprinted panel, 1952; 122 × 61 cm (48 × 24 in.); illustrated in *House and Garden*, December 1952
By kind permission of Condé Nast

[2] Edinburgh Weavers was established, as its name implies, in Edinburgh, but moved to Carlisle in 1932. It and other Morton companies were purchased by Courtaulds in 1964 and some records were held in their London design library until 1999 when Courtaulds itself was taken over by Sara Lee. The majority were then lodged in the V&A Archive of Art and Design. At the time of writing these records were in the process of being listed by Archive staff.

[3] 'Material re Conference for Scottish Carpet Industry 24/6/50', account of Second Discussion Period that was opened by Robert Stewart, Glasgow School of Art archive, Box 1, v

On the same occasion, a conference on the Scottish carpet industry organised by the Council of Industrial Design, Stewart ably defended the textile training at GSA, pointing out that 'he himself was a practising designer who ran a business in addition to his teaching commitments' and adding that he 'specialised in design of a high order and found that there was a ready market for his products'. He felt compelled to add, in typically blunt fashion, that 'some of the thinking expressed at the conference seemed to him to be at least ten years out-of-date.' The progressive thinking he referred to had been epitomised by Walton and clearly outlined in John Gloag's influential volume, *Industrial Art Explained*, first published in 1934. It was revised in 1945 and in that form was in its second edition by the following year, having become widely circulated among designers and design students. One entirely new chapter entitled 'The Designer and the Future' would not only have provided backing for Stewart's remarks had he chosen to cite it, but would also explain why, without a shred of irony, Stewart referred to himself as a decorator. Gloag himself used the term 'industrial decorative art', which

> covers the creation of decorative patterns, and the choice of colours and texture, for such things as pottery, textiles, wallpaper, and domestic glass. This branch of industrial art comes more directly under the control of fashion than any other; it is more susceptible to the variations and idiosyncrasies of personal taste, less influenced by functional requirements and affords more opportunities to the type of creative mind that excels in the invention of decoration, for the artist's freedom is limited only by the need for studying the processes whereby his patterns are ultimately reproduced.[4]

This and Gloag's following reference to Roger Fry's essay on art and socialism provide a framework for a fuller understanding of Stewart's independence of mind, own small-scale manufacturing and determined condemnation (and personal avoidance) of commercial studio practice in which

> many skilful men and women...copy and combine ornamental motifs from which vitality has long departed, motifs which were once fresh and lively and applicable to the needs and taste of contemporary life.[5]

Underpinned by an assured use of line, Stewart's designs of the 1950s have that 'strong present tense' characteristic of only a handful of British 'decorators', among whom the most comparable is Lucienne Day. Her work, which is well documented,[6] had a similar breadth, encompassing in that decade just under 100 documented designs, mainly for furnishing fabrics but also for dress cloths,

[4] John Gloag, *Industrial Art Explained* (1934), second edition published by George Allen & Unwin, London, 1946, p. 203

[5] Ibid. pp 203–4, making reference to Roger Fry, *Vision and Design*, published by Chatto & Windus (Phoenix Library), London, 1928 and the essay within first published in 1912

[6] See Jennifer Harris, *Lucienne Day: a career in design*, published by the Whitworth Art Gallery, Manchester, 1993, and see note 8

carpets, wallpaper, table linen and porcelain. Stewart was undoubtedly more prolific. The some 130 designs across all media accounted for to date represent only part of his output during the 1950s. In addition, his work spanned an even greater range of objects, in part because he was in many cases, as at the Edinburgh Tapestry Company, directly involved in their manufacture. Records for small studio-based production rarely survive and Stewart was no exception in leaving it to later generations to piece together evidence of his own design practice. Nevertheless, even in the absence of his own accounts, it is clear from other sources that he designed furnishing fabrics, scarves, cushion covers, tablemats, tablecloths, printed wallhangings, proscenium curtains (for Cosmo Cinema, Glasgow, c1951, see p. 36), embroideries and tapestries, as well as his wooden skittle-like figures, ceramics and graphics. In addition, he may well have designed wallpapers, since this product was hand-printed in his own department at GSA.

The absence thus far of any evidence of carpet or lace designs is somewhat surprising given the proximity of major manufacturers of these loom-made textiles, but it does appear to be an area Stewart left to other designers. Certainly, a criticism levelled at the Printed Textile department in Alastair Morton's 1961 course assessment was that

> It was noteworthy that virtually all textile designing was for furnishing prints. There were no designs for jacquard woven fabrics and few for tweeds. Furthermore, there were no designs at all for carpets, lace or knitting, all of which are important Scottish industries.[7]

With hindsight it seems clear that Stewart preferred – many would say wisely – to design for processes that he himself could carry out. This self-limitation is implied as advice to designers in the statement from Gloag's book quoted above and equally evident in Stewart's subsequent contribution to the knitting industry nearby in the Scottish Borders in the form of *printed* imagery. To the layman this distinction is difficult to discern, but within the textile trade itself there is a fundamental division between constructed textiles (among which are carpets, Jacquard weaves, laces and knits) and surface decoration, meaning the added elements that are printed or embroidered onto an existing cloth. The distinction rests in the much more direct relationship between the design and production of surface decorations and the far more complex process needed in order to translate designs into constructions. For example, the sole known use of a Stewart design for Jacquard weaving, 'Don Quixote', produced by Donald Brothers in 1956 had to be adapted first by an in-house designer to accommodate the precise restrictions placed on widths of repeats, and then by a specialist weaver's point-paper draughtsman to create the instructions needed for this particular loom-technology. In contrast, handwoven tapestry required only scaling-up of the design. Tapestry was the only form of constructed textile for which Stewart designed directly and it is telling that he understood that particular technique.

[7] Alastair Morton, *Adjudication for Diplomas 1961: design and crafts*, typescript in Glasgow School of Art archive, p. 3

Don Quixote (detail), 1956; Donald
Brothers; jacquard woven cotton;
48 × 24 cm (18³/₄ × 9¹/₂ in.)
Collection Sheila Stewart

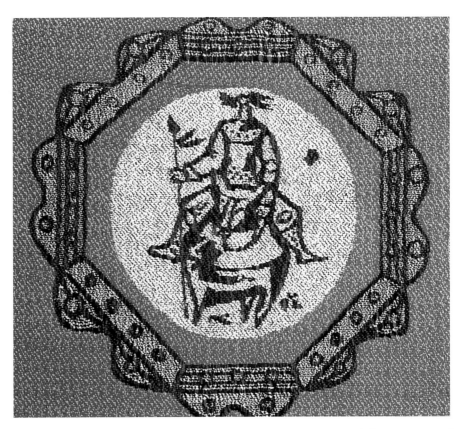

Stewart's combined skills in drawing and making thus created the intertwined platform from which he launched into a variety of surface-designed textiles. By the early 1950s he had already established a recognisable style based on human forms, conventionalised into skittle- or chessmen-like shapes, or faces, rendered into moon, sun or mask-like images. Lively, informally placed clover leaves, spirals, triangles and circles were often details within patterns or, occasionally, the basis for simpler, more abstract designs. Like Lucienne Day, he was accorded the compliment of spawning imitations, even if he did not himself design the handful of currently unattributed David Whitehead furnishing fabric patterns bearing similar elements. Stewart's students helped to disseminate his seemingly rapidly sketched approach. (Day herself was later to comment as a GSA assessor that the high standards were 'very greatly due to the quality of the teaching, as much perhaps as to the ability and application of the students themselves'.[8]) Equally, Stewart's work was illustrated frequently in periodicals of the day, contributing significantly to the taste for the contemporary and its increase during the 1950s. One example is a 1953 survey of then-present and future developments in the design of furnishing textiles, which in part summarises another recognisable and more long-lived aspect of Stewart's style:

Design will not only vary the colour proportions in unexpected ways but can give the available colours a new style and meaning, and even become a substitute for colour. A shift of interest from colour to drawing is becoming

[8] Lucienne Day, *Adjudication for Diplomas 1960: design and crafts*, typescript in Glasgow School of Art archive, p. 2

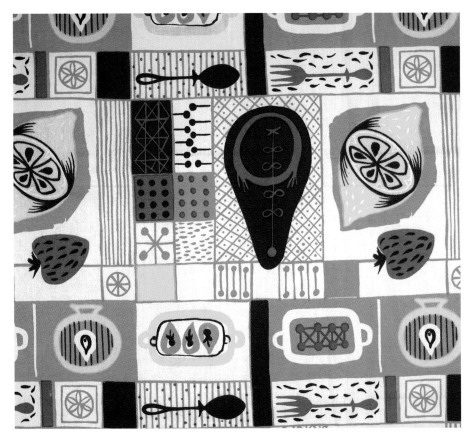 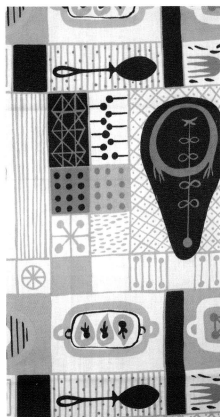

noticeable lately in many ranges. We find colours used as no more than sup-porting tints to purely linear designs; prints being marketed which are simply drawings in black line on a pure white ground. Though these are extreme cases any discussion of trends in print design, now and for some time to come, is inescapably a discussion of theme and motif and the way things are drawn, with colour as an obviously always important but nevertheless secondary consideration.[9]

Fruit Delight, 1951; Liberty of London; 32.4 cm (12³/₄ in.) repeat; published in *Decorative Art: the Studio Yearbook of Furnishing and Decoration* 1952–53, p.287
By kind permission of Liberty

The two concluding images accompanying the article are 'Fruit Delight' and 'Masks' by Stewart, both first produced by Liberty in February 1951 and described as two of 'three in the confident new range from Liberty'.[10]

For much of the 1950s, the major coverage of Stewart's output was accorded him by virtue of his association with Liberty. Known for its Tudor-style building on Great Marlborough Street, London, Liberty was then – as it is now – in reality two businesses, the shop and the wholesale division, created to supply both its retail sibling and other customers and granted independent status in 1946. The wholesale division had been concerned mainly with textiles since 1922, when Liberty purchased the printwork complex at Merton on the river Wandle (opposite the site of the Morris & Company printworks), with which it already had an association some thirty years old.

[9] James de Holden Stone, 'Curtains in the Breeze', *Studio* 146:1953, p. 49

[10] Ibid., p. 50. The third textile is 'Books' by Jacqueline Groag; all three illustrated on p. 51; the text itself appears to have been written in late 1952.

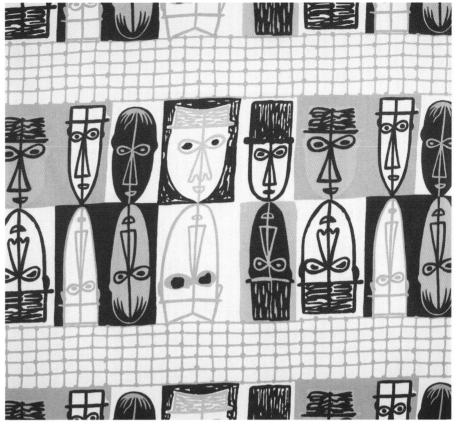

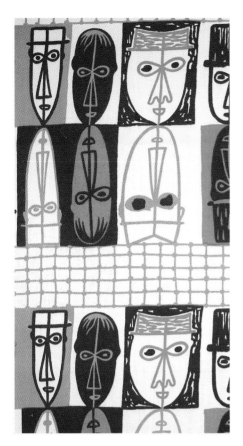

Masks (also called Altierie), 1951; Liberty of London; 29.3 cm (11½ in.) repeat
By kind permission of Liberty

In the 1950s, hand-block printing was still a speciality at Merton, which also undertook hand-screen printing, then a relatively new technique that had been only gradually introduced in Britain during the 1930s. Mechanised printing with engraved copper rollers and, later, rotary screens, was commissioned from outside suppliers, as were all woven cloths. The shop had the first choice from new ranges developed by the wholesale branch, but was never obliged to take all, or any, on offer. Conversely, the shop could procure from elsewhere textiles that were not part of the wholesale range. However, despite these flexible options, in the late 1940s both sides of the business were still known for the delicate small floral designs developed well before the war and known both as Tana Lawns (from the fine-quality cloth on which they were printed) and, as a now-generic term for this style, 'Liberty look' patterns.[11]

For Stewart, an important change in Liberty policy had been a decision of the board in mid-1946, that younger consumers would 'become the customers of those shopkeepers who show most enterprise in catering for their taste. Each department should therefore carry a percentage of goods that are contemporary in feeling.'[12] It was within this context that the cousins Hilary Blackmore and Arthur Stewart-Liberty 'made their influence felt. They were as full of enthusiasm as their great-uncle, the original

[11] See Susan Meller and Joost Elffers, *Textile Design: 200 years of patterns for printed fabrics arranged by motif, colour, period and design*, published by Thames & Hudson, London, 1991, p. 86

[12] Liberty Board papers, cited in Alison Adburgham, *Liberty's: a biography of a shop*, published by Unwin Hyman, London, 1975, p. 125

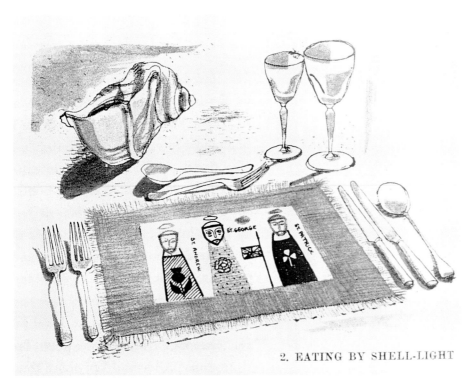

2. EATING BY SHELL-LIGHT

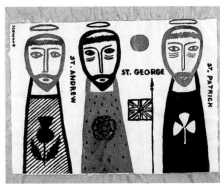

Patron Saints, 1951; designed to mark the Festival of Britain; published in *House and Garden,* September 1951
By kind permission of Condé Nast

Arthur Liberty, but their enthusiasm was for their own contemporary style.' They are credited with bringing in Eric Lucking in June 1946 to revolutionise the window displays and in 1949 allocating space for the Young Liberty section of the shop, with a young buyer independent of other departments (as all buyers were) but drawing fashion and accessories, including scarves, from other sections. Further,

> By adopting the modern technique of an advisory Design Committee, the Company was able to keep abreast of the best that was being produced both at home and abroad in printed fabric design. It was realised from the first that fabric design could be made the bridge between the old and the new, and therefore the traditional prints for which Liberty's had so long been famous were combined with the most advanced designs.[13]

Prominent among these were designs by Robert Stewart, although his contribution goes largely unrecorded in the several published histories of Liberty.

Stewart's first contact with Liberty, in 1950, came at a propitious time, when the shop had just established a modern furniture department. Planning for the following year's Festival of Britain was already well advanced, and Stewart's contribution to the shop's Festival souvenirs were two designs, each with three figures, one of Beefeaters and the other of patron saints. Another design survives but its production is not recorded. Of the three-figured patterns, however, much more is known. Both appear to have been produced as tablemats and kits for cushions in 'tapestry' – that is, needlepoint – 'trammed ready for working with wools to finish.' And both designs, together with 'Fruit Delight' and 'Masks'

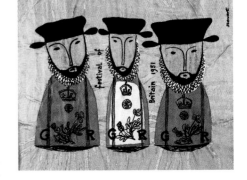

Beefeaters strike off, 1951; Liberty of London; designed to mark the Festival of Britain
By kind permission of Liberty

[13] James Laver, *The Liberty Story*, published by Liberty & Co., London, 1959, p. 54

King Cole, 1951; Liberty of London
30.5 cm (12 in.) repeat
By kind permission of Liberty

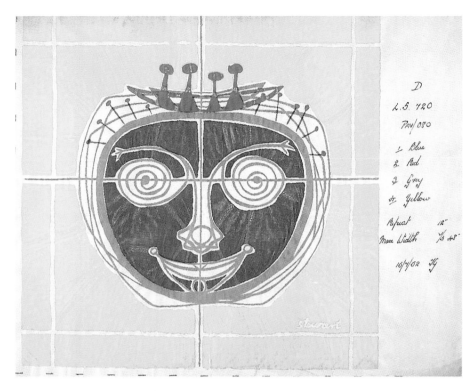

(designs for furnishing fabrics), were sold not only in Liberty's own shops in London and Manchester (which existed from July 1905), but were available from a number of sources across the country, including Wylie & Lockhead in Stewart's own Glasgow.[14] Not surprisingly, the furnishing fabrics continued to be produced, but even the Beefeater tapestry, with its reference to the 1951 Festival removed, was still available in December 1952, when it was one of five items designed by Stewart that were included in the Liberty Christmas catalogue.

Aside from its own shops and outlets within other stores, an important vehicle for Liberty was its mail-order business, and this catalogue hints at the way in which Stewart contributed to the 're-branding' of the company as a purveyor of contemporary style. Prominent on the cover are two of his hand-painted skittle-like wooden figures. Within are some dozen textiles, most of which are plain (Scottish mohair wraps and Suffolk rush mats, for example) or traditional (such as the boxed Paisley-patterned silk tie and handkerchief set, most probably printed at Merton, or Chinese hand-embroidered silk mules). The only strikingly contemporary textiles are three by Stewart, among them a triangle-patterned cushion and the Beefeater tapestry kit, with the latter shown next to a Beefeater egg cosy clearly indebted to the tapestry design. The third item was a wooden-legged waste-paper basket covered in 'Masks'. Neither Stewart nor the designer of the waste-basket, F. J. de Rohan Willner, was credited in the catalogue. However, Stewart's signature is incorporated in the designs for both of the Festival patterns, as well as the triangles cushion and four other Liberty cushion/tablemat designs, all of which were first produced in 1952 ('Towncrier', 'White Coils', 'King Cole' and a design now known as 'Three Suns'). In a subsequent

Beefeaters needlework kit, 1952;
Liberty Christmas catalogue
By kind permission of Liberty

[14] Among these were Brights of Bristol; Goodacre, Nottingham; Howell, Cardiff, Johnson, Leicester; Thurman & Malin, Derby; Trevor Page, Norwich; and Wolfson, Leeds.

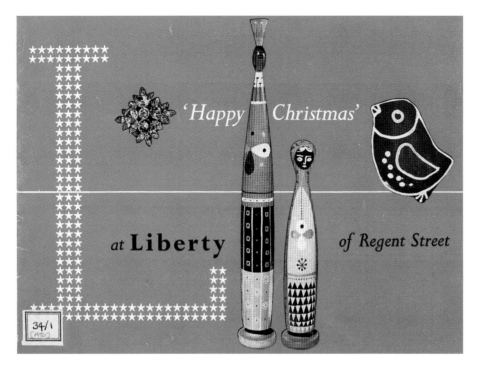

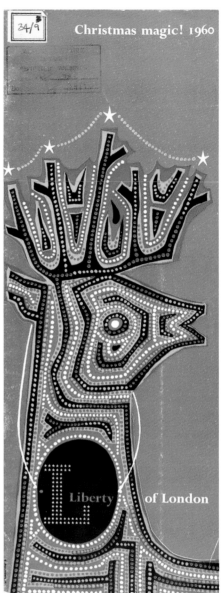

Christmas catalogue, Stewart's contribution had risen from one-quarter to one-third. Against a greater selection of mohair wraps and rush mats, six of the 19 textile-related items were by Stewart. There are three cushions ready-made from 'Keir', 'Macrahanish' and 'Raimoult', a brass-legged waste-paper container covered with 'Sun Man', a work box covered with the same (and foam padded to serve as a seat) and a workbag or 'tote' made from 'Macrahanish' but described so as to suggest that the fabric design might vary. Stewart again is not named.[15]

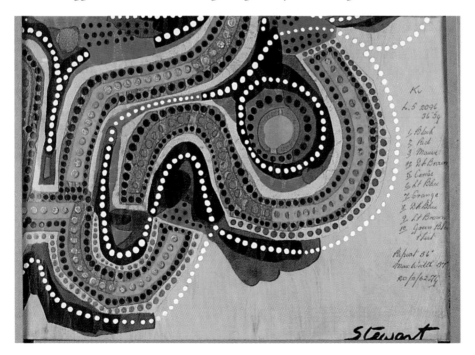

THIS PAGE AND FACING PAGE:
Liberty's Christmas catalogues of 1952 and 1960 (also a drawing)
By kind permission of Liberty

[15] This catalogue dates from 1953 or 1954, the earlier date suggested by the inclusion of Coronation spoons.

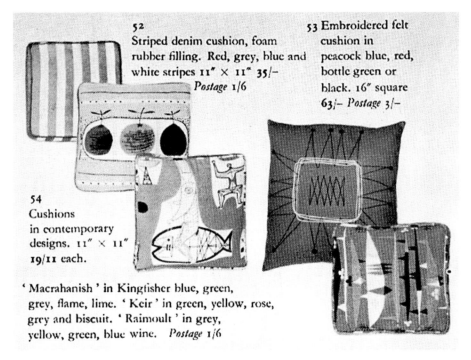

52
Striped denim cushion, foam
rubber filling. Red, grey, blue and
white stripes 11″ × 11″ 35/-
Postage 1/6

53 Embroidered felt
cushion in
peacock blue, red,
bottle green or
black. 16″ square
63/- *Postage 3/-*

54
Cushions
in contemporary
designs. 11″ × 11″
19/11 each.

' Macrahanish ' in Kingfisher blue, green,
grey, flame, lime. ' Keir ' in green, yellow, rose,
grey and biscuit. ' Raimoult ' in grey,
yellow, green, blue wine. *Postage 1/6*

57
Leather waste
paper holder
16″ × 6″ 55/-
Postage 3/-

58
Waste paper container,
in printed linen—
Contemporary design.
Brass legs. Lime green
or peacock blue.
13½″ high, 7″ diameter
45/6. *Postage 2/6*

62
Linen work box, with
foam rubber top to form seat
17″ × 11″ £5. 15. 6.
Posting charges forwarded on request

76
Workbag,
in Liberty material.
In chartreuse,
red, grey or blue.
Approx :
13″ × 9″ × 7″
45/-. *Postage 2/-*

77
Letterclips,
covered with
coloured leather
0/6 each. *Postage 1/-*

Nevertheless, by at least 1954, Stewart was regarded as the leading figure in the creation of contemporary textile designs for Liberty. This is underscored by the fact that he was one of only a handful of designers allowed to sign the cushions and scarves sold in the shop; others among the scarf designers were the Parisian couturiers Balmain and Givenchy (or, more likely, their staff). It is a point confirmed by Day herself:

> While respecting Lucienne's desire to remain independent, Tom Worthington [of Heal Fabrics] became increasingly concerned about her working for Heal's competitors. The issue came to a head after Lucienne was approached by Liberty, asking her to design a linen dress fabric to celebrate the Coronation in 1953. The resulting pattern, Tudor Rose (also known as Coronation Rose), led to a request from Arthur Stewart of Liberty for a furnishing fabric; this elicited a screen-printed linen, Fritillary (1954), a striking composition based on butterflies. Subsequently, Tom Worthington came to an arrangement with Liberty, whereby Heal's agreed not to commission designs from Liberty's designer, Robert Stewart, as long as Liberty stopped working with Lucienne.[16]

This compliment to Stewart coincided, sadly, with a period during which designing was – in his own words – 'a thing I have not had time for this year because of the department...'.[17]

Stewart's contacts with Liberty were already complex. Of the fifteen known designs supplied between 1950 and 1954, some – those for cushions,

[16] Lesley Jackson, *Lucienne and Robin Day: pioneers of contemporary design*, published by Mitchell Beazley, London, 2001, p. 80

[17] Letter from Robert Stewart to D. P. Bliss, Glasgow School of Art archive, 13 July 1954, p. 3

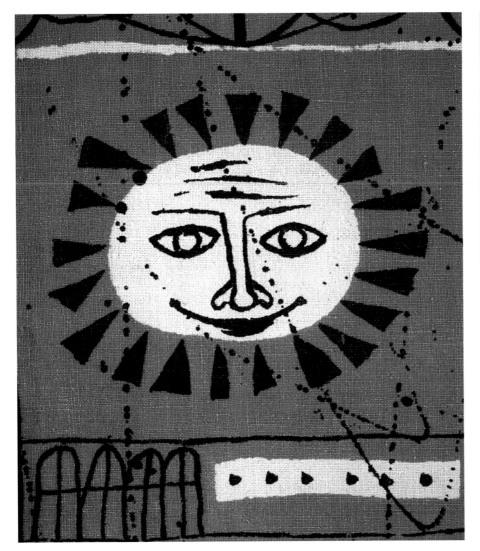

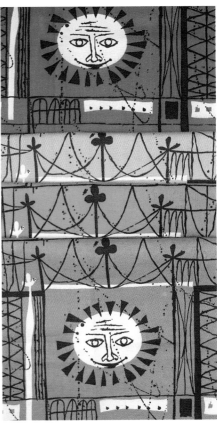

Sun Man, c1953–54; Liberty of London;
also printed on linen in grey
By kind permission of Liberty

boxes and waste-paper baskets – were clearly commissioned by the furniture department. Others were noted as initiated under the 'miscellaneous' code, representing a department that originally encompassed Japanese fans, screens and lacquerware but later appeared to be responsible for items such as tablemats and coasters.[18] Further, it seems likely that the fabrics coded 'C', for furnishing lengths in the records of the wholesale division, had all been transferred from the furniture department. Certainly 'Sun Man', 'Keir', 'Macrahanish' and 'Raimoult' were being sold by the Liberty shop at least as early as the year prior to their introduction into the Merton hand-screen printing records in 1955. (The remaining fabric in this group is 'Applecross', listed as printing at Merton from late February, 1955.) These may have been initially sub-contracted to commission printers such as Barracks in Macclesfield, which is known to have supplied Liberty on occasion, or they may have been printed by or for Stewart himself and supplied directly to the furniture department. By this time his work with the Edinburgh Tapestry

[18] This information courtesy of Anna Buruma, Liberty Archivist, whom I would like also to thank for assistance with interpreting the wholesale company's records.

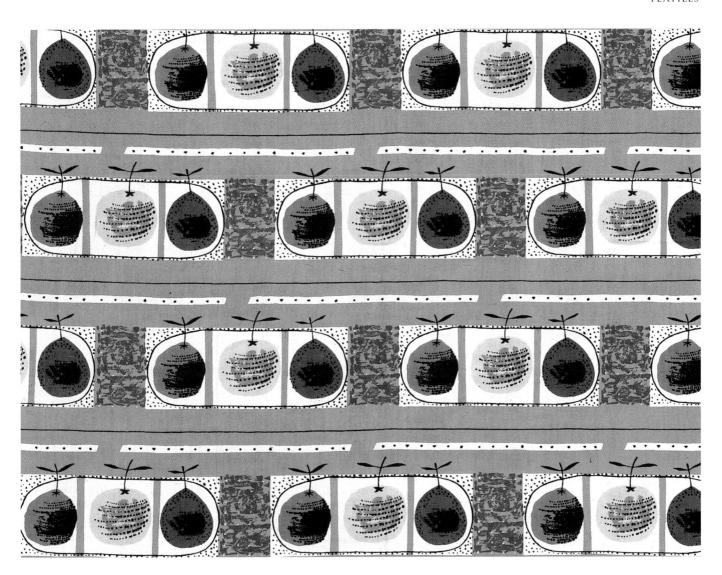

ABOVE: Keir, c1953–54; Liberty of London; 44.5 cm (17½ in.) repeat
By kind permission of the V&A Picture Library

Keir design, c1953–54; Liberty of London; gouache on paper; 36 × 53.2 cm (14¼ × 21 in.). A note in pencil in Stewart's hand at the bottom left states 'Design C still not happy about this part'
Collection Sheila Stewart

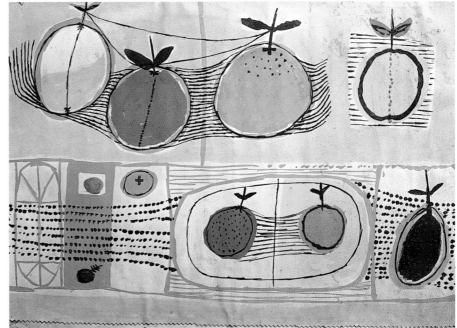

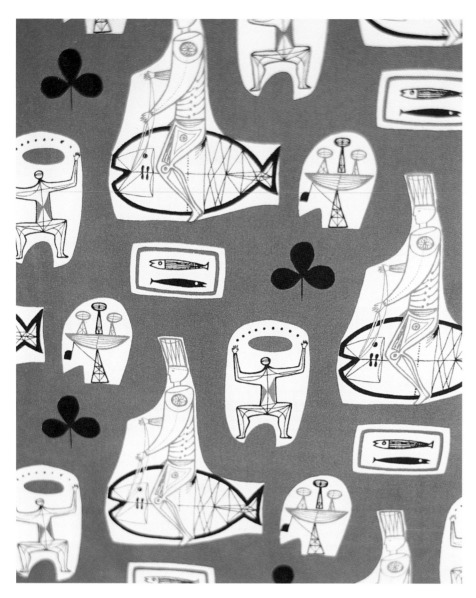

Macrahanish, 1954; Liberty of London; roller printed cotton, 38 cm (15 in.) repeat. Various spellings of this design's name occur in Liberty's records and publicity and in subsequent literature, although the place itself, known to Stewart, is Machrihanish. Published in *Fifties Furnishing Fabrics*, 1989, plate 21, also in *Austerity to Affluence: British Art and Design 1945–1962*, Plate p.35
By kind permission of the Fine Art Society

Company (ETCo) had begun and a photograph (see p. 64) of a group of six printed furnishing fabrics of this period demonstrates that by one means or the other, Stewart was initiating his own production. Two correspond to surviving designs bearing the Edinburgh Tapestry Company logo, yet the remaining three with clear selvedge legends indicate that he was also promoting his own brand, 'Stewart Scotland'.

To complicate matters further, one of the ETCo. paper designs bears a close resemblance to an unattributed Liberty design entered into production in late 1955, as does another entirely different surviving ETCo. sample length and a further Liberty design of the same date. Both of these in the Liberty records are marked to record their earlier production elsewhere or by a technique other than screenprinting as, in fact, are all the other Stewart designs for Liberty furnishing fabrics. At the very least, something of Stewart's independence of mind is already becoming evident. Flattering though the concept of a 'Liberty's only' designer might seem to some, it was clearly not his intention to become fettered to one client. As early as January 1954,

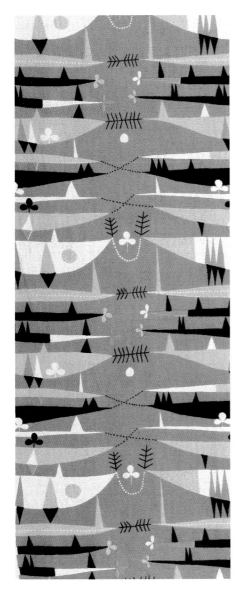

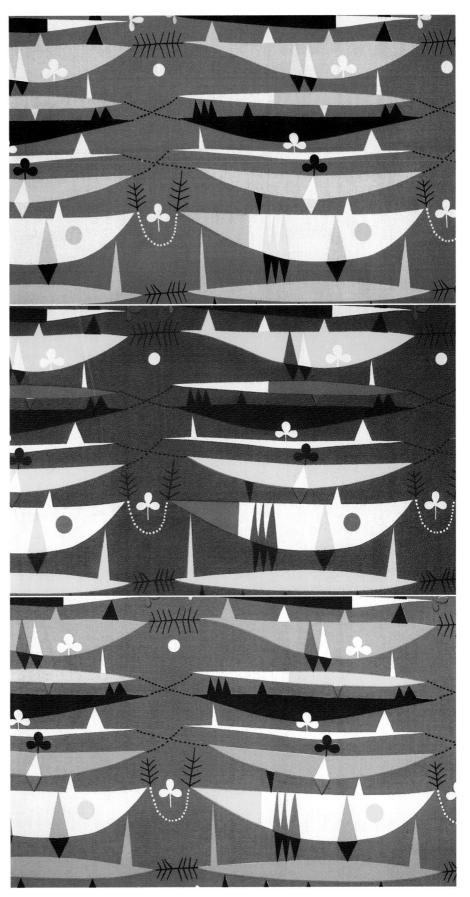

ABOVE: Raimoult; Grey/pink colourway
*By kind permission of the V&A Picture
Library*

RIGHT: Raimoult, 1955; Liberty of London;
66 cm (26 in.) repeat; three colourways
By kind permission of Liberty

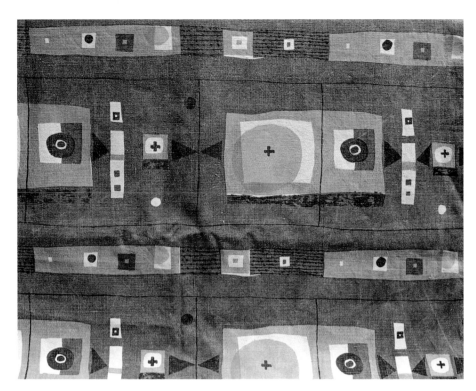

Applecross, c1953–54; Liberty of London;
29 cm (11½ in.) repeat on linen
Collection Sheila Stewart

Donald Brothers had begun producing Stewart's 'Kelpie', although this was at first for Jofa in New York and therefore not competing directly for Liberty customers. However, all was soon to change. In June of the same year *House & Garden* ran a full-page feature on Scottish design that was particularly eye-catching because it was in colour, a feature not yet so commonplace as to go unnoticed. Stewart's hand is everywhere: in a wall hanging singled out above the room set and, within it, his tiles and tablemats designed for the Edinburgh Tapestry Company and a length of 'Kelpie' draped over a coffee table. The designer of the linen tablemats and fabric length is not stated (whereas Stewart *is* credited for his wallhanging and tiles) as if, perhaps, to cushion the blow to Liberty. However, 'Kelpie' was now being manufactured under the Old Glamis label – Donald Brothers' own brand – and was available from, among other locations, Elders of Glasgow, the most contemporary among that city's retailers and also a stockist of Liberty fabrics.[19]

That Stewart continued to enliven the image of Liberty is nevertheless confirmed by several facts, among them their promotion of his designs. 'Macrahanish' received considerable press coverage during late 1954 and 1955 and now often was accompanied by an acknowledgement of Stewart as the designer. For example, this fabric together with Stewart's skittle-like figures were featured in the Liberty room set illustrated in the prestigious *Decorative Art: The Studio Yearbook of Furnishing and Decoration* of 1955–56. If this was intended to dissuade Stewart from working for competitors, it had no effect. His work continued apace for the ETCo. and Donald Brothers were producing at least two more new designs by 1957. Meanwhile, Liberty

Un-named design based on barbed wire, c1951–4; possibly Edinburgh Tapestry Company. This design was also printed in a grey/white colourway and the design was produced commercially as a ceramic tile for the Edinburgh Tapestry Company.
Collection Sheila Stewart

[19] *House & Garden*, February 1956, pp 46–7

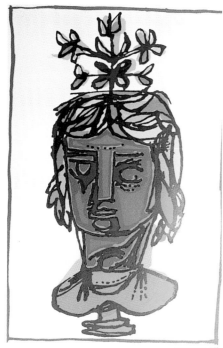

Detail of a female head from a textile design, 1955; Edinburgh Tapestry Company. Together with a male head this design was printed as a cushion cover in various colourways. Published in *Motif 2*, p.52, 1959

RIGHT: *House and Garden* December 1954: 'Kelpie' from Donald Brothers, printed in black and white, is draped over the table on which are two tiles and two tablemats by Stewart for Edinburgh Tapestry Company. Under the table are another two tiles. 'Kelpie' was printed in fourteen colourways.
By kind permission of Condé Nast

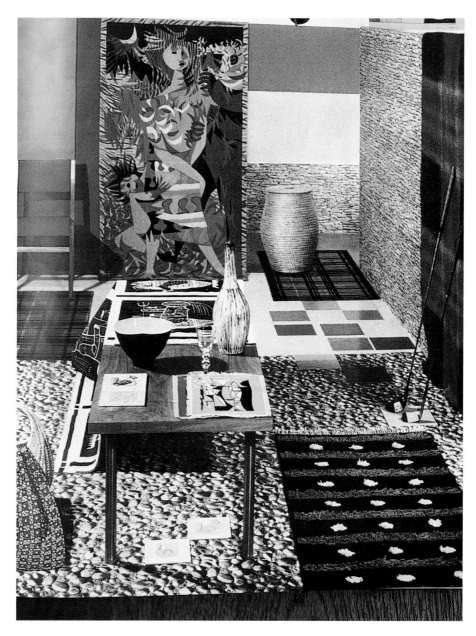

introduced his 'Mirage' design as part of their 1956 Young Liberty range, emphasising the Liberty name and not the designer's; other designs of the same year appear calculated to evoke his style. The result was inevitable. Thereafter, no new Stewart designs were entered into the Liberty wholesale furnishing fabric ranges.

Relations with other departments seem to have been unaffected. In 1954, 'King Cole' had been re-designed by Stewart for cambric cotton scarves, and a number of further scarf designs, possibly produced elsewhere, are thought to have been taken up by the shop in the mid- to late-1950s, although no direct evidence for this has been found. Nevertheless, he certainly produced a design for the 1960 Christmas catalogue cover and six scarf designs were among those that entered into hand-screen printing at Merton between June 1961 and February 1962. Among the latter is a design similar to the Stewart image decorating the cover of *Motif 2* in 1959, and his strong and

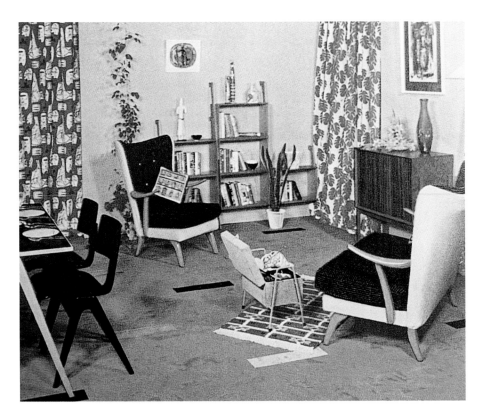

Liberty room set, 1955
Decorative Art: The Studio Yearbook of Furnishing and Decoration, 1955–56

current links with Liberty are made clear in the text. Acknowledging Stewart's beginnings as a designer and printer of textiles, the writer Robert MacGowan went on to comment that

> it is in this field that the general public have seen most of his work. These textiles were commissioned by Liberty's of London and are available in Great Britain; textiles commissioned by Donald Brothers are available in the American market.[20]

This quotation, if accurate, suggests that a compromise, in the end, had been reached between Donald Brothers and Liberty, and as a result the designer and his first major client were reconciled. At any rate, all the scarves carried Stewart's signature. The same quotation also underlines the longevity of Stewart's contribution to the Liberty ranges. Indeed the scarf design already mentioned, together with another consisting of four sets of concentric circles, went on being printed as Liberty scarves – a fashion item notoriously sensitive to rapidly changing tastes – until September 1966.

Stewart's involvement with the Edinburgh Tapestry Company was, however, to have effects beyond those of his commercial relationships. He had been right to foresee the freeing effect of time away from the demands of teaching, and his work evidences a series of changes from late 1954–57. There is an almost immediate shift away from his vocabulary of the previous period and toward epic themes and abstractions in which the use of broad,

[20] Robert MacGowan, 'Robert Stewart: design and drawings', *Motif 2*, Shenval Press, February 1959, p. 53

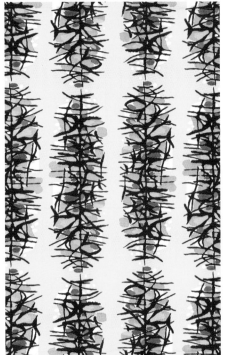

Mirage, 1955; Liberty of London; roller printed cotton, 38cm (15 in.) repeat, also printed in pink; published in Herbert Read, *Art and Industry*, 5th edition, 1956, p.177
By kind permission of the V&A Picture Library

Seraphim design, 1957–58; Donald
Brothers, Dundee; pen and ink on paper;
30.5 × 28 cm (12 × 11 in.). The printed
design had figures overlaid with blocks
of colour and was available in four
colourways.
*By kind permission of the Heriot Watt
University Archive Records Management
and Museum Service*

BELOW: Rock, 1957–58; Donald Brothers,
Dundee; printed in black and white and
also black and white overlaid with blocks
of duck egg blue. The figure on the right
was illustrated in *Motif 2*, p.59, 1959.
See also photo of Rosslyn Terrace flat,
page 41.
*By kind permission of the Heriot Watt
University Archive Records Management
and Museum Service*

Lion Head scarf, c1961; Liberty of London;
screenprint on silk ; 91.5 × 94 cm
(36 × 37 in.)
By kind permission of Liberty

dominant outlines is soon combined with intense areas of texture, as if heavily smudged or angrily scratched into the design's surface. These qualities exploited the unique capabilities of screenprinting, just as subsequent designs played with the lyrical, swift placement of line courted by the lithographer's stone or the 'fractured' surface areas obtained through monoprinting, both of which he began to explore by about 1957. Such printmaker-like marks set the tone for the Donald Brothers' designs of 1957–58 and the later Liberty scarves. They were by the early 1960s to become an element in the repertoire of surface designers,[21] and there is no doubt that Stewart's work of the mid- to late-1950s played some significant part in this trend, particularly once his work was featured so prominently in *Motif 2*, in 1959. (This was not just 'any' magazine, but an innovative and covetable item in its own right, published sporadically over a period of eight years and in limited numbers by the Shenval Press.)

There is a long tradition of influences flowing from printmaking to textiles that is self-evident but despite that, not fully documented. Even less understood is the opposite exchange, between textiles and printmaking. Stewart stands as evidence of the latter, and his example is particularly useful

[21] For example, Lucienne Day produced the inky monoprint design, 'Cadenza' for the 1962 Heal's range, a trend in her own work that started very tentatively in 1958, but was not fully developed until 1961.

Square spots, c early 1960s; scarf design;
Liberty of London
By kind permission of Liberty

RIGHT AND BELOW: Profile Head scarf, c1961;
Liberty of London; screenprint on silk.
This was available in other colourways
including pink and tan with black;
91.5 × 94 cm (36 × 37 in.)
By kind permission of Liberty

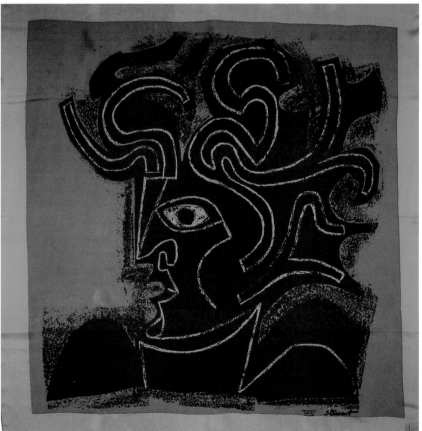

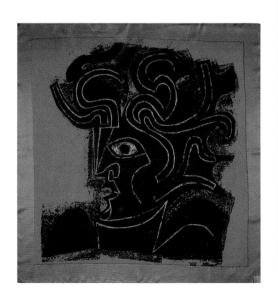

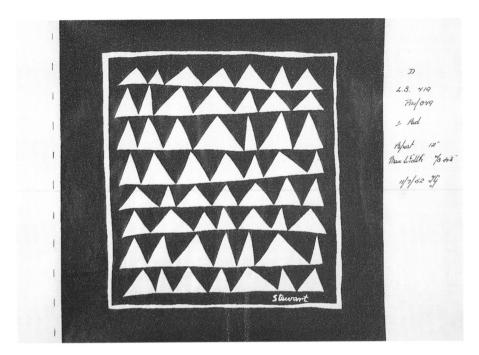

Triangles, c early 1960s; scarf design;
Liberty of London
By kind permission of Liberty

since his early training, so thoroughly grounded in textiles, is evident in his sensitivity to textures when printed on paper. The few images and remaining examples of his tablemats made of blotting-paper are especially rare testimony to his direct exploration of the relationship between the character of the substrate (paper or cloth) and the marks placed upon it. They also typify his innovative approach to function itself, and may well mark the beginning of a trend – in the British Isles at least – that today gives us a myriad of taken-for-granted printed paper towels, napkins and other similar products. (In his own day, they were recommended 'to keep in reserve and use when you've a premonition that the party will be a messy one, or to save tablecloths from the onslaughts of untidy carvers.'[22])

As Stewart was able to control more fully the multi-media use of his designs, and as his style matured, it was natural that his interests would broaden and he would leave textile designing to the next generation. As he himself put it, textile design 'was more suited to younger men'. It certainly required considerable energy simply to travel to sell designs; travelling from Glasgow to London to do so was itself a day's journey by car or by train. Some firms, of course, came to Glasgow, particularly as the Printed Textile department's reputation grew. One such firm was Gayonnes Limited of London, which was known for its support of young designers and by at least as early as 1952 was producing patterns by GSA students.[23] It seems likely that Gayonnes also purchased designs from Stewart, but the same could be said of at least a dozen firms which produced ranges including designs following his lead or, even, designed by his own present and former students. Of Stewart himself, it has been said that some of his designs were produced by Hull Traders Limited of Lancashire, where innovative

[22] 'Talking Shop', *House & Garden*, February 1956, p. 82

[23] 'Scottish Influence at B[ritish] I[ndustries] F[air]', press-cutting from *Barratt's*, 14 May 1952, Glasgow School of Art archive; the student was Sylvia Chalmers.

Spirals, *c* early 1960s; scarf design;
Liberty of London
By kind permission of Liberty

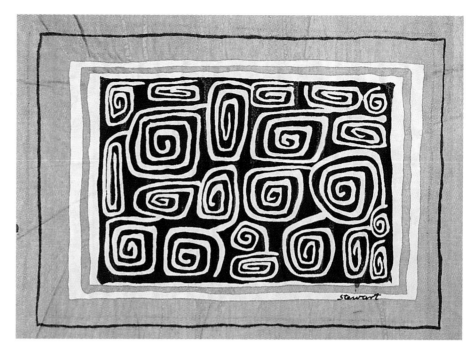

screenprinted textiles were both designed and commissioned by Shirley Craven from 1960–72. If so, this may forever remain a mystery, for there are to date no known archives surviving from the firm itself, nor any account of its history, save its now-legendary contribution at the leading edge of British Pop products. (Hull Traders marketed Bernard Holdaway's 1966 range of cheap, expendable, brightly coloured 'Tomotom' furniture.) It is perhaps possible that Hull Traders also marketed Stewart's ceramics which may account for the confusion.

In many ways it does not matter that many Stewart designs are now lost. His impact on the field of printed textiles is clear enough, bringing above all a feeling of improvisation to the fore. His textile work of the period from *c*1950–60 expressed an ingenuity that circumvented a series of barriers, from the restrictions still imposed on supplies in the early 1950s, through the retailers' desire to 'capture' a particular designer as their own and on to the refusal to see himself hemmed in by media-based boundaries. Through it all, the doorways he constructed for innumerable students were his constant focus. In this he epitomises many fine teacher-designers who never achieved lasting fame but who made an incalculable difference.[24] It seems a perfectly right monument to his real successes that, at the peak of his career in the mid 1970s, the old deal struck between Heal's and Liberty's that seemed to 'set the cat among the pigeons' for Stewart himself, should be repudiated by the recruitment by Heal's of his students, Peter McCulloch, Adrianne Moray Ferguson and Karen Macdonald.

[24] Another was Dora Batty, see Sylvia Backemeyer (ed.), *Making their Mark: art, craft and design at the Central School, 1896–1966*, published by Herbert Press, London, 2000 (available from A & C Black). This book also contextualises the earlier work of D. P. Bliss, the influence of Edward Johnston, and the dissemination from *c*1910 of Noel Rooke's 'white line' style of block printing, in which Stewart was trained.

7

FASHION

Robert Stewart responded enthusiastically to the changing needs of both his students and commerce. Through visits to English colleges, he was aware that changes in education made closer links with industry even more imperative and set about developing contacts that would provide interesting opportunities. By the 1960s, there was greater emphasis on youth fashion in shops and magazines and, as there was no fashion department in GSA, the students were encouraged to explore different areas such as fantasy clothes and fashion illustration as well as fashion textiles. The GSA's annual fashion show provided a show case for the work and was an important event. From the early 1950s, it was organised and run by the Printed Textile department students, although in the 1970s it was taken over by the Student Representative Council.

In 1964, Stewart was approached by British Nylon Spinners, a subsidiary of ICI, who wanted to make their fabrics more attractive to manufacturers. Each of the Printed Textile students designed and printed a length of Brinylon in powerful vivid colours. The lengths were made up into garments in London for a promotional catwalk show to which all the students and staff were invited and given hotel accommodation. This was the first of several such collaborations. However, as a letter from I. J. Hepburn of ICI Fibres to the Director Harry Jefferson Barnes suggests, such projects were not always straightforward nor without their tensions:

> Can I please at this point ask you to officially thank Bob Stewart, for his good work on our behalf and his continued enthusiasm despite having to deal with 'Philistines'. That we have remained friends throughout our various projects must say something for both characters.

Barnes replied:

> It will give me very great pleasure to thank Robert Stewart 'officially'. When people work as hard as he does, with such enthusiasm, they often fail to get the thanks they deserve because people imagine it is all great fun. As you will appreciate, he is certainly one of the most dynamic and useful members of our staff...

In November 1965, Stewart was invited to London for two days to discuss a new student project with the Fabric Development Manager of ICI Fibres. As a result, in January 1966, the students were asked to design fabrics for men's

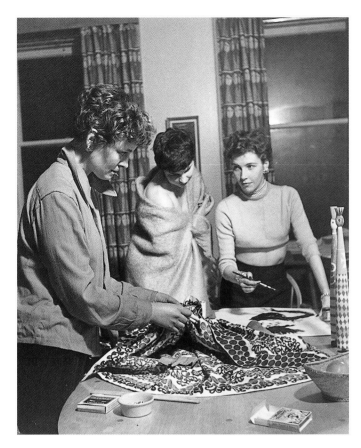 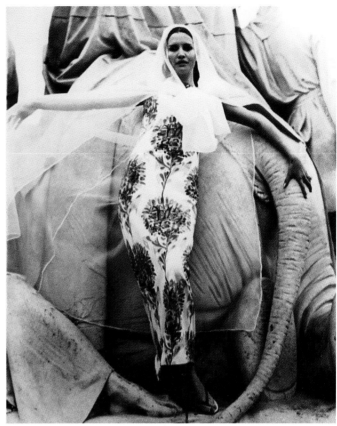

ABOVE: Students preparing for the fashion show in the Stewarts' flat, 1952. Two turned wooden figures on the table and related curtain design.
Photographed for Picture Post, *by kind permission of the Hulton Getty Picture Collection*

ABOVE RIGHT: Evening dress fabric designed by Stewart, 1965/66; flower print in pinks on white Bri-nylon, exhibited at the Weft Knitting Exhibition
British Nylon Spinners press photo, GSA archive

shirts. Michael Edser, a designer, provided the students with a limited colour scheme based on Paris trends while ICI provided the fabric and technical information. This formed the basis for the printed designs. ICI saw the resulting fifty designs at the rough stage and considered the designs impressive enough to select twenty-three for discussion with shirt manufacturers who were invited to choose eight, each by a different student. These were then printed by the students who were each paid £10. The Playton company made up these textiles to Michael Edser's designs for display on ICI's exhibition trade stand in February at the Weft-Knit Presentation. The shirts were subsequently displayed in each of ICI's area offices during March and April. ICI proposed putting the remainder of the designs into the form of a book to be shown to the fashion trade, so that anyone interested could contact Robert Stewart to produce a design. The fashion trade received the prints enthusiastically; Heathcoat bought two designs from Stewart and Knitcraft Hosiery also contacted him with the promise of commissions for the autumn.

GSA had been selected for this pilot project because of the good relations established with Robert Stewart and because he could provide the quality of print required and had 'proven to be extremely competent and enthusiastic'. As a result of this success, ICI wanted to take things a stage further in 1966–67 and plans to establish two £500 scholarships for one year's post-diploma study in nylon at GSA were discussed. British Nylon Spinners were to supply the fabrics and dyestuffs. The scholarships would be open to all British art schools. ICI proposed to pay Stewart a fee of £500 per annum for working with these students and to cover his expenses for visits to London

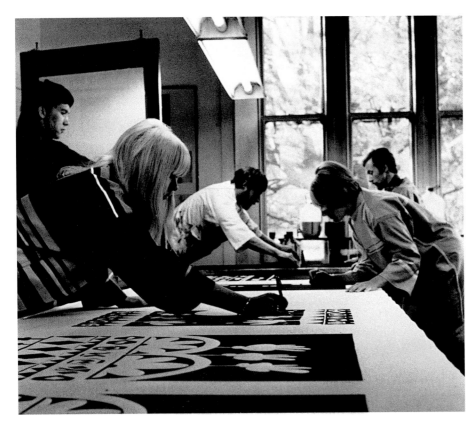

Students working at the print tables wearing their smocks. Chuck Mitchell is printing in the background. This photograph appeared in the *Guardian* article, 10 October 1966.
GSA archive

for discussions with the Marketing Department. It was intended to present the students' work to the trade at a special presentation which would become an annual event in their London showroom. The long-term aim of this proposal was to raise the general standard in Britain without lowering the manufacturing profit margin. Unfortunately this was never implemented because of the organisation's change to trade as ICI Fibres.

Central to the success of the Printed Textile department's fashion projects was the appointment in 1963 of Julius Tescher, an experienced applied organic and colour chemist, who introduced new dyes and considerable expertise to the department. Tescher had been principal chemist in a Viennese textile printing company and had then run his own textile works from 1933 to 1938, when he emigrated to England and continued to work in the textile industry. Although based in Glasgow, officially he was appointed to work with all four Scottish art schools – in effect he only worked with Glasgow students.

This expertise was reinforced in 1965 with the appointment of Anne Stevenson, a former student who had spent a postgraduate year studying fashion at Farnham, and of a City & Guilds trained pattern cutter, Ivor Laycock. Their appointments stimulated new fashion projects that started with garment shapes for which suitable prints were designed. In 1966, students were asked to produce simple T-shaped smocks that would be worn everyday in the studio. Most of the prints were bold, vivid and geometric and featured in an article in the *Guardian* where they were described as the 'boldest and most imaginative in Britain'.[1]

[1] Fiona MacCarthy, 'Heads Above Smocks', *Guardian*, 10 November 1966

Fashion drawing,
mid 1960s;
gouache on card;
25.5 × 20.3 cm
(10 × 8 in.)
Collection
Sheila Stewart

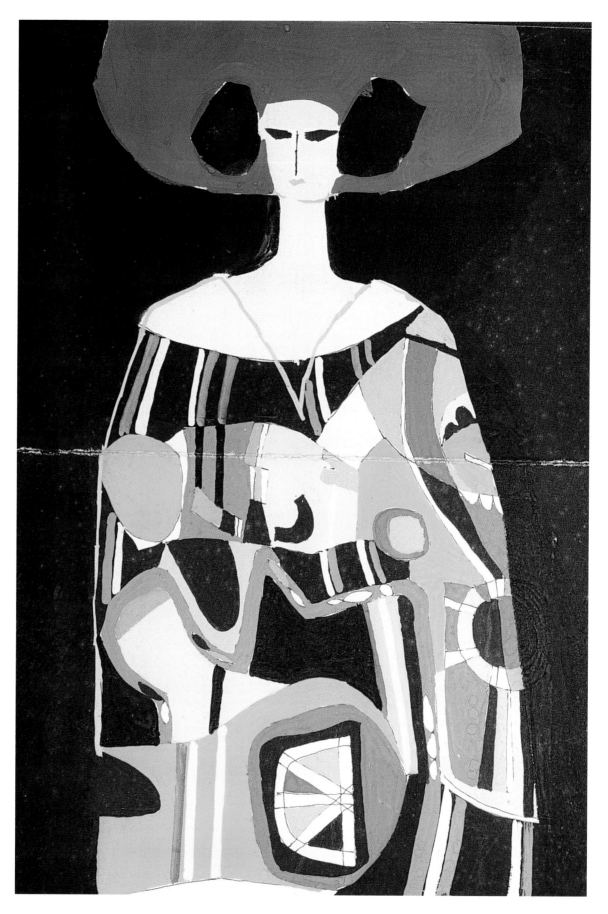

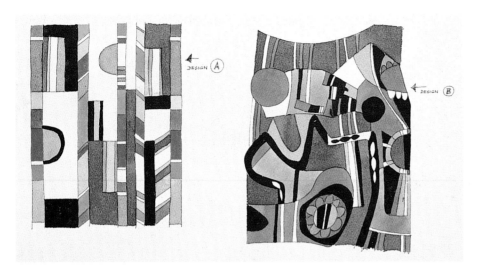

Fashion drawing, mid 1960s; gouache and ink on card; 26 × 37.5 cm (10¼ × 14¾ in.)
Collection Sheila Stewart

One of the difficulties with more complex dress shapes was ensuring the correct scale of pattern and Stewart would often lay the page of a fashion magazine, which had the garment cut out, over the students' work to encourage consideration of scale and the effect of draping the fabric. He consistently encouraged students to design with the end product in mind, such as laying bed linen designs on a bed to see the effect both on the vertical and horizontal. Students were also given exercises in which a restricted range of carefully chosen colours was used to demonstrate that colours can be made to work together in any combination. Students were also encouraged to enter national fashion competitions.

Visits were made to various manufacturers. Early in 1967, a chance remark by Stewart resulted in the department's most exciting fashion project. He and a group of students were visiting Pringle of Scotland in Hawick to see the process of making fully fashioned knitwear, when Pringle's difficulty with

OPPOSITE ABOVE: Undated fashion drawing, mid 1960s; a note in Stewart's hand in the margin states 'Not good drawing but the first'; 26 × 37.5 cm (10¼ × 14¾ in.)
Collection Sheila Stewart

OPPOSITE BELOW: Fashion drawing, mid 1960s; ink on board; 26 × 37.5 cm (10¼ × 14¾ in.)
Collection Sheila Stewart

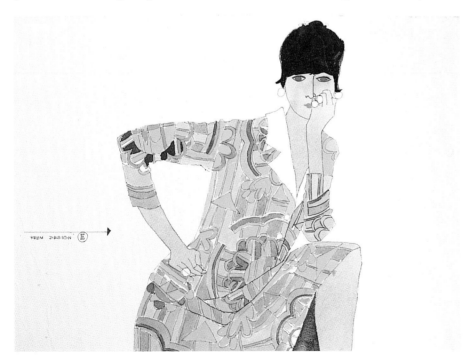

Fashion drawing, mid 1960s; ink and gouache on board; 26 × 37.5 cm (10¼ × 14¾ in.)
Collection Sheila Stewart

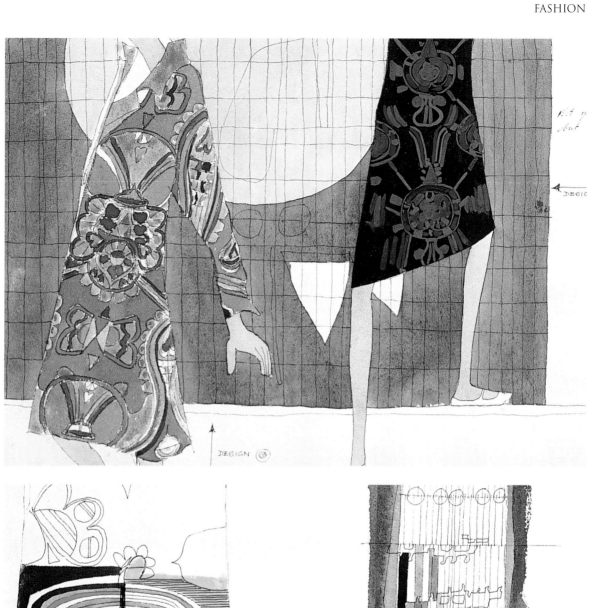

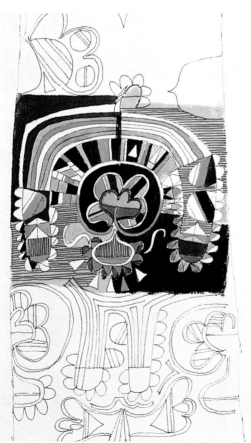

printing cashmere was explained. In 1955, Pringle had collaborated with a printing company in Staffordshire and although the results were technically excellent, aesthetically the designs were disappointing and inappropriate to the material as screens already employed for printing silk lengths were used. Subsequently, Pringle contacted an Italian printer who was achieving good results, but there were again difficulties. Finished garments had to be unpicked so that they could be pinned out flat for printing; they were then sent to Italy and returned to Hawick for finishing. Pringle had no control over the designs and were not satisfied with the quality of the printing. There were delays caused by difficulties with Italian customs, and the cost of the work, plus duties, made the process prohibitively expensive. Stewart suggested they should do the printing themselves – it had been one of his ambitions since 1950, when printed cashmere of indifferent design and print quality first appeared on the market, to perfect the process. He believed it was possible with the help of his staff and students. Pringle were sceptical about the suggestion, but Stewart pointed out that they already had two of the prerequisites of a screenprinting plant (the dyehouse and wet-finishing department) and that setting up tables and training printers would be straightforward. A small adjacent empty mill became the screenprinting department.

Following discussions between Harry Jefferson Barnes, GSA Director, Stuart Beaty, Pringle's Design Director, and Robert Stewart, an agreement was reached that the Printed Textile department undertake to help Pringle set up a new screenprinting department, advise on technical matters and supply designs – for this a consultancy fee would be received. Although Pringle were convinced that there was some mystique about the process, Julius Tescher who had printed on cashmere in Vienna was confident that it was straightforward. He had simply to find a dyestuff compatible with cashmere and formulate it with the required thickeners and catalyst. He selected an acid dye used in normal wool printing and extended the range of dyes held in the Printed Textile department to suit Pringle's needs. Various print tests were carried out at GSA as the staff were not familiar with the material. It was important that they invest in the correct equipment from the start, in order to meet the demands of the production schedule.

The best mesh count for screens was selected, that was open enough to pass enough dye through, but fine enough for the mesh to hold the design detail. Tests were done with squeegees to determine which blades were most suitable. For example, a soft and blunt blade will give maximum dye coverage, a hard and sharp blade the minimum. To print a large area of intense colour may require several passes of dye with a blunt squeegee to achieve the necessary penetration and intensity, but if the design includes an area of fine detail in the same colour this will certainly flood and thicken. Therefore a separate screen is needed for the fine detail even although it is the same colour. There was no-one to do the colour separation until a primary school janitor who formerly worked in the textile industry was found, with the necessary skill to produce them in gouache on paper. Once this basic research was carried out the printing was straightforward and presented few problems.

One of the first printed cashmere jerseys, designed by Alex Gourlay, Pringle, 1967. The design was based on reflections in water.
Collection Alex Gourlay

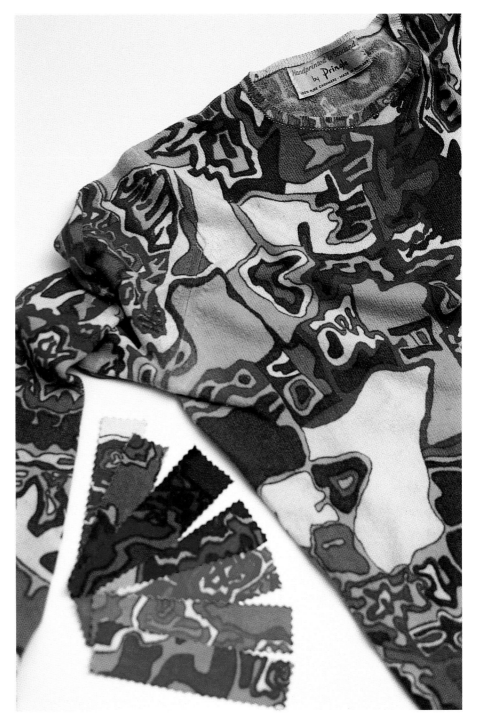

This was only one part of a much larger project involving the whole Printed Textile department with several aspects of the project being developed simultaneously. For example, screen preparation rooms were being designed and set up at Hawick with equipment for stretching, coating, exposing, developing and barrier-coating, although initially this work was done in Glasgow. Printing tables were installed as were the necessities for the after-printing processes such as steaming (to make the dye fast) and finishing (to wash away the excess dye and thickeners). There were other constraints to consider such as printing on the irregular shape of the 'kippered' sweaters, which had their side and underarm

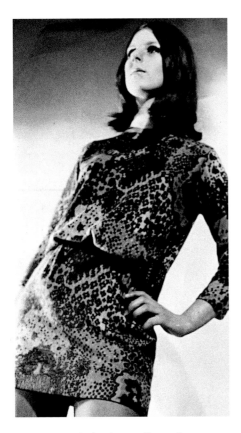 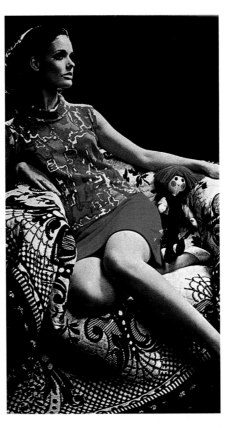

FAR LEFT: Printed cashmere dress, shown at the GSA annual fashion show, 1967
GSA archive

LEFT: Pringle fashion advertisement
Courtesy Pringle, collection Alex Gourlay

seams unstitched to allow the garment to lie flat for printing. The knitted fabric was of uneven thickness and had a tendency to stretch in all directions, even between the application of successive screens. Eventually after much interaction – arguing, rejecting, compromising and inventing – final solutions were reached.

At the same time as technical matters were being considered, the students were asked to prepare a design as part of their Diploma Examination. The design suitable for a fully fashioned cashmere sweater was to be in no more than five colours and, in addition, the students were to provide an alternative colour scheme. The design was to be all-over in character and to repeat across the garment three times (i.e. sleeve, body and sleeve), the repeat join occurring at the top of the sleeve. Although the design would be printed on a flat garment, it would be seen in the round when worn. Pringle wanted to produce a range of floral, geometric and paisley pattern influenced designs and Bob Finnie went to Paisley Museum to study original Paisley shawl designs. Stewart thought that Pringle could and should select adventurous designs, but Stuart Beaty was bound by the constraints of the fashion market and believed that designs could not be imposed on customers, that only through a gradual and possibly lengthy process of education could they be encouraged to move in a new direction. It was agreed that at least for the first season there would be no radical departure into unfamiliar design areas.

An important aspect of the design process was the test printing being done in Glasgow to get the feel of the fabric and the 'look' of the colour on cashmere. In contrast to Pringle's staff who handled cashmere every day and took it for granted, there was among staff and students at the school 'a greater

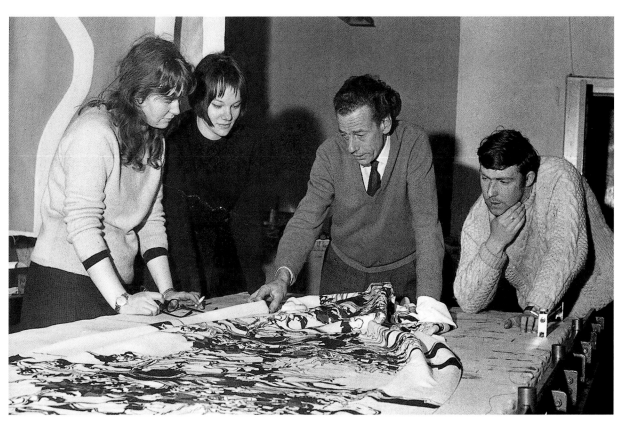

Stewart and students at the print table discussing a fashion fabric. This photograph appeared in *Drapery & Fashion Weekly*, June 1969.
Collection Sheila Stewart

reverence for the soft whiteness of the cashmere and a strong desire to use this quality as a design element by playing off areas of white against areas of print.'[2] The first 24 prototype designs printed on cashmere sweaters by students were shown to Pringle's customers and met with a varied response. Some welcomed the new approach, others were critical and thought the designs 'ultra-refined'.

The project was completed in just five months, a printed dress went into production and the sweaters were sold to the home market at £16 19s 6d (£16.95). The first commercial collection was launched at a fashion show held behind closed doors. There was great commercial interest and Tescher was even approached by *Paris Match* and asked about the process, but everyone involved had signed a secrecy agreement with Pringle. The collection was a success and although there were already cashmere sweaters on the market, with designs either hand-block printed in London or screenprinted in Italy, none of these had designs that were conceived in terms of fully-fashioned knitted sweaters. The prints were well received because of their freshness.

> Unlike standard commercial work, the students' designs had an immediacy of appeal which stemmed from a sense of real creativity compared with what is too often in the commercial studio becomes simply the results of the daily nine-to-five grind. The student work looked fresh and exciting, the other merely tired, contrived and recipe-ridden.[3]

[2] Description of the project by Stuart Beaty, Design Director, Pringle, *Facet 2*, June 1968, p. 22
[3] Ibid.

After the initial project was completed, Pringle printed their own sample garments from screens prepared from designs purchased from a collection submitted by GSA students in December and June each year. The students worked to Pringle's brief, considering not just the needs of the home domestic market but also the export market that accounted for 60% of their products. Requirements varied considerably: America looked for bright prints, the German taste was for more sombre colours while some customers preferred garments suitable for evening wear. This provided scope for the students and the Printed Textile department became a source of design ideas.

At the beginning of the project, Stuart Beaty believed that 'as our two bodies work together and exchange information a useful state of affairs will arise where Pringle are looking to GSA for a fresh design approach and the students in turn would have the opportunity of having their designs proved in the practical world of commerce, which can be both exciting and salutary.'[4] So it proved and in this project there was something for everyone to become excited about; everyone, Stewart, his three assistants, four technical staff and more than twenty students, gained from the experience and were greatly motivated. Students whose designs were chosen for commercial production were paid the full commercial rate. On graduating, one student was offered a full-time post with Pringle. The Printed Textile department also received a grant from Pringle which was used to fund student visits and projects. The department also gained considerable kudos from widespread press coverage that led to approaches from other companies such as Goujon (Paper Togs) offering lengths of non- woven fibre free of charge and suggesting a design exercise with the department.

Stewart had begun to supply designs to Viyella in the 1950s and continued throughout the 1960s. Although he never pursued a wider personal design involvement in fashion, he was interested enough to make fashion drawings and develop colour ideas for his own interest.

[4] Letter to H. Jefferson Barnes, 21 February 1967, Glasgow School of Art archive, Box 11

GRAPHIC DESIGN

In the 1990s, large design consultancies were developed to provide services in all areas of design, but forty years earlier Stewart presaged this trend: his interests ranged from textiles, ceramics and graphics, to exhibition layout and presentation. This was unusual, but he was very much of his time in having an idealistic approach to design. Whereas today the term 'design' has in many ways become devalued through its use as a marketing ploy or symbol of questionable quality, during the 1950s there was a more idealistic attitude to design that still acknowledged its social responsibility and relationship to people. Accordingly, Stewart applied his usual problem-solving procedure, bringing the same concentrated attention to detail for each project, whether for commercial mass production, special limited editions or one-off works.

Having produced graphic designs for the Co-op and other companies such as Ferguson Brothers of Johnstone, and the cover of Colville's of Motherwell house magazine for May–June 1948, Stewart continued his interest in graphics alongside that in textiles and ceramics. For example, he designed all the packaging and publicity material for his range of ceramic kitchen storage jars. He also frequently played with designs, developing them in different ways for different media, e.g. during the 1970s he produced geometric designs based on circles that were used for both posters and tapestries.

Design for the cover of Colville's house magazine, 1948; gouache on card; 14 x 10.8 cm (5½ x 4¼ in.)
Collection Sheila Stewart

FAR RIGHT: Design for the Scottish Crafts Centre, mid 1950s; gouache on board; 37.5 x 26.5 cm (14¾ x 10½ in.)
Collection Sheila Stewart

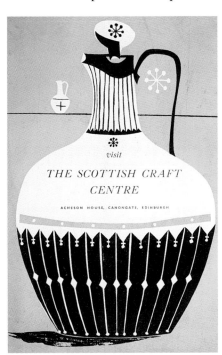

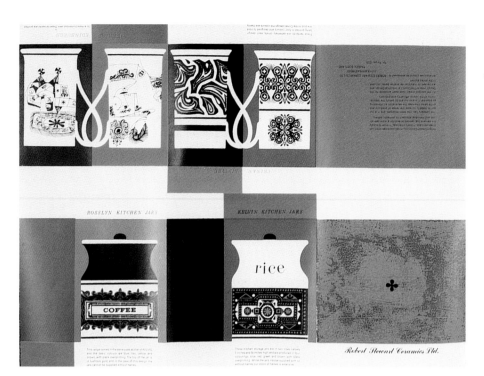

Publicity brochure for Robert Stewart
Ceramics, 1960
Artist's photo, collection Sheila Stewart

Stewart's graphic design was worked in mixed media and, just as with his work in textiles or ceramics, it always remained fresh, never descending to clichéed imagery. When he was asked to rework Charles Rennie Mackintosh's designs that surrounded him in the School, he was reluctant to do so. Nevertheless, the results had Stewart's own stamp and were always contemporary designs of their time, not pastiches, whether they were book covers, posters or official stationery, such as the School's letterhead and degree certificates. Yet in this aspect of his work, we can again observe the contradictions that run throughout his work. Although he loved techniques, he believed in an intuitive approach; in the discipline of graphics, we can see his complete technical control of the medium, often applied to playful subjects in an apparently spontaneous way.

Stewart had a surprisingly wide knowledge of developments in the design field internationally and, while he did not advertise it, he would regularly visit the library to study the latest journals on graphics or interior design or to select a book related to some visual problem or idea on his mind, but just as likely related to a student's work. He introduced his students to *Graphis*, the International Journal of Graphic and Applied Art, that in the 1950s included articles on a wide range of subjects including fine art as well as graphics. Most of his students had never thought of looking at graphics magazines.

They also saw Stewart designing and printing invitations and posters for School functions such as farewell dinners for the Governor Robert Begg and at the staff retirements of Kath Whyte, Lennox Paterson and David Donaldson among others. Portrait posters for individuals were simplified graphic portraits that apart from capturing a likeness also gave a sense of the character of the individual. The poster images have a quality of clarity and Stewart's considerable ability to place design elements on the page was fully exploited in this medium. In addition, he produced posters for local events

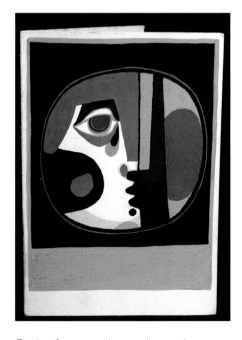

Design for a greeting card; gouache on
card; 20.2 × 12.5 cm (8 × 5 in.)
Artist's photo, collection Sheila Stewart

Design based on Mackintosh's weather-
vane on the GSA building, late 1950s;
pencil and gouache on board;
75 × 54.6 cm (29½ × 21½ in.)
Collection Sheila Stewart

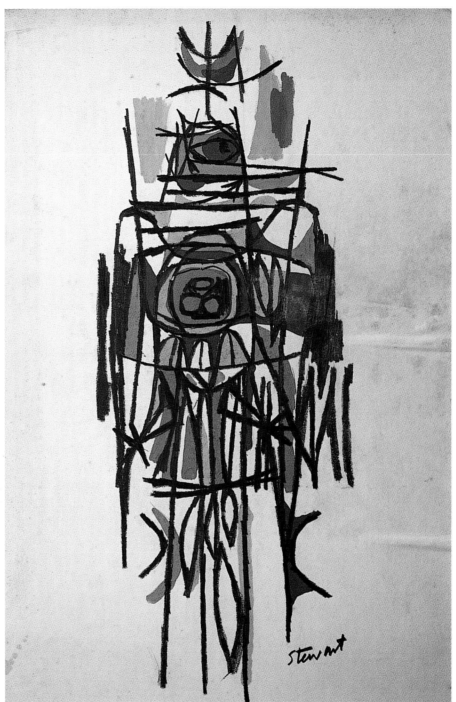

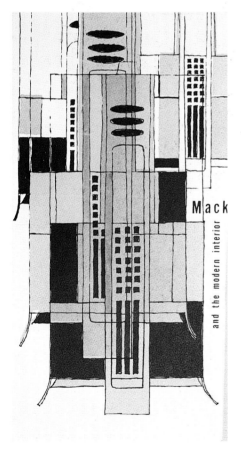

Invitation: *Mackintosh and the Modern
Interior*, screenprint on card;
20.4 × 10.8 cm (8 × 4¼ in.)
Collection Sheila Stewart

such as the Glasgow International Fair in 1959 which included a Royal
Ballet Season at the Theatre Royal, a series of films at the Gorbals Film
Theatre and an exhibition of Modern Art held at the Kelvingrove Art
Gallery. With the introduction of the first Activities Week in 1971, posters
became even more important and ambitious. A board was erected annually
outside GSA and featured an 8 × 4 ft poster that had been printed in sec-
tions in the Printed Textile department where, by this time, one floor had
been given over to paper printing. Many of these posters such as those
for Joe McGrath, Bob Godfrey and Cedric Price were powerful images.

103

Christmas card, 1950s; screenprint on card; 16.5 × 33.5 cm (6¹/₂ × 13¹/₄ in.); designed for Mr Singleton, Cosmo Cinema, Glasgow
Collection Sheila Stewart

Christmas card, 1950s; screen-print on card; 16.5 × 33.5 cm (6¹/₂ × 13¹/₄ in.)
Artist's photo, collection Sheila Stewart

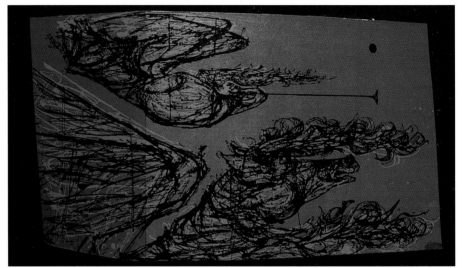

Family Christmas card, 1957; signed: Stewart; screenprint on card; 16.5 × 24 cm (6 ¹/₂ × 9 ¹/₂ in.)
Collection Sheila Stewart

Christmas card, early 1950s; screenprint on paper; 20.2 × 9.5 (8 × 3¾ in.)
Collection Lady Alice and Janet Barnes

Design for silk screen, 1959. Illustrated in *Motif 2*

Stewart's colleague Jimmy Cosgrove continued this tradition, producing many memorable posters for the School's events.

Students also saw Stewart print Christmas cards, and many former students and friends still treasure the Stewart family cards collected over many years. Designs varied from angels, abstract designs and symbols to a simple pair of muddy boots with the caption 'I'm dreaming of a white Christmas'. One year, a printed fabric 'card' was sent that could be made up into an oven glove; and another year, he stuck a microchip on the card with the directions that the 'Microprocessor has full logic and capacity to play all the visual data related to the history of Saint Nicholas. It will also graphically output my Christmas card designs from 1982 thru (sic) to 2000, while the internal multilingual micro-processor will play digitised on command Jingle Bells in Gaelic, Welsh and Japanese ... Have a Happy Day.' Stewart was commissioned to design Christmas cards for Mr Singleton of the Cosmo Cinema, Mr McGavigan, a local supplier of art materials, and friends such as the architect A. S. Matheson (when President of the Royal Incorporation of Architects in Scotland) for whom he produced a design showing a Christmas rose in grey, black and gold.

While working for the Edinburgh Tapestry Company during the 1950s, Stewart designed a new company logo for the letterhead which featured a large dove in the foreground with the dovecot in the background. In 1954, when John Noble and Harry Jefferson Barnes took over the Edinburgh Tapestry Company from the Bute family, they were also involved in the establishment of a Crafts Centre for contemporary work in Edinburgh, for which Stewart designed publicity, invitations to openings and exhibition catalogues. Designs from a catalogue for an exhibition in 1957, featuring the seven ages of man, with the accompanying lines from Shakespeare, were reproduced in *Motif 2*.

James Shand of the Shenval Press started this periodical as an antidote to commercial work. It was of the highest quality, printed in both black-and-white and colour, and offered artists the opportunity to have anything they

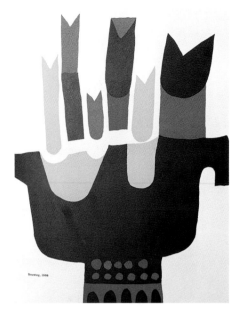

Front endpaper from *Motif 2*, February 1959; illustrated in *Graphis Annual 1959/60*

chose to draw reproduced. Never regarded as a profitable project, normally only 2000 copies of each issue were printed; it ran for only thirteen issues. The last was published posthumously as Shand's memorial in 1967. Shand wrote in the introduction to *Motif 2* (February 1959) 'MOTIF is not edited, designed and produced only for the specialist, be he painter, sculptor, typographer or architect. MOTIF is for the receptive whole man (whether, by profession, artist or laundryman) who can get visual pleasure from Pollock's abstractions, Mies van der Rohe's skyscrapers, Paolozzi's sculptures, or Stewart's sun, moon and stars.' The aim of this issue was to show the work of younger artists and also featured sculpture by Eduardo Paolozzi. The editor, Ruari McLean, had a free hand with the content and one of the first designers he thought of as a contributor was Robert Stewart and he offered him twelve pages to do what he liked. McLean used Stewart's sun design on the

Cover of exhibition catalogue, 1957; drawings on the cover and in the catalogue represent the seven ages of man. They were drawn in ink on blotting paper; 17 × 12.6 cm (6¾ × 5 in.)
Collection Sheila Stewart

Introductory page to his work in *Motif 2*, 1959

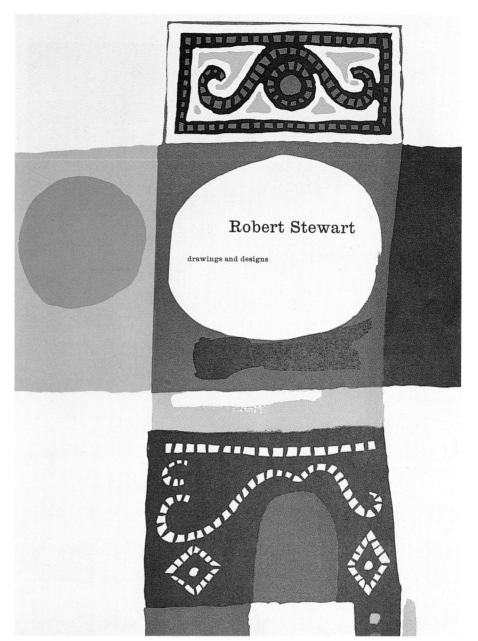

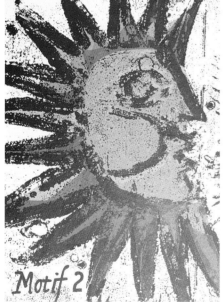

Cover of *Motif 2*, February 1959

cover. Suns and moons are recurrent graphic motifs during the 1950s, but those in Stewart's work are quite distinctive and occur frequently, partly because a circle is a graphic device that can hold a design together and is therefore important to the dynamics of the design, and partly because the sun is important in Scotland, particularly on the wet, west coast. Two of the sun images from *Motif 2* were illustrated in the *Graphis* Annual 1959/60.

Ruari McLean got to know Stewart in the mid 1950s when the distinguished typographer was invited to assess the Graphics Department at GSA. This was McLean's first experience as an external assessor and he found the department competent although very traditional. However, in the Printed Textile department on the floor below, he was amazed to discover exciting work being done on posters, book jackets and stationery. They became friends and Stewart was a designer McLean much admired and described

FAR LEFT: Christmas Design for Austin Reed, 1950s; signed: Stewart; gouache on board; 15 × 11 cm (6 × 4¼ in.)
Artist's photo, collection Sheila Stewart

LEFT: Pre-study for Liberty's Christmas catalogue, 1959; screenprint on paper; 25.5 × 11 cm (10 × 4 in.)
Artist's photo, collection Sheila Stewart

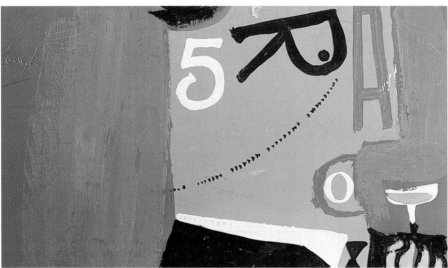

Design for Schweppes, 1950s; gouache on card; 9.5 × 18.5 cm (3¾ × 7¼ in.)
Collection Sheila Stewart

him as … 'a brilliant graphic artist and one of those few who, like Edward Bawden, combined being both fine artist and designer.'[1] McLean, who thought that Stewart would be more appreciated and find greater opportunities in London, suggested that Stewart should consider teaching at the Royal College of Art where he himself taught. He arranged a visit and has described how on the train south Stewart became agitated the further from Scotland he travelled. The visit was not a success, Stewart did not like what he saw and remained in Scotland. Subsequently Stewart regarded GSA as the equivalent to the Royal College and saw no reason why any of his students would want to go there because he himself would not. However, many of his

[1] Ruari McLean, *True to Type*, Oak Knoll Press & Werner Shaw, 2000, p. 119

students did go to the Royal College while others went on to success in other countries. For example, Julie Ballantyne spent a postgraduate year at the Christian University of Texas during which time she won one of the major awards in 'America's Next Great Designers Awards' for 1976 that attracted 16,000 competitors.

Corporate identity was becoming more important during the 1950s and *Design* magazine for 1956 cited Liberty among various companies who mainly conveyed theirs through shop window treatments. With the introduction of self-service stores, packaging and other paper products including promotional material became more important. Stewart was commissioned by Liberty to produce the graphic designs for the 1960 Christmas catalogue. He also did a Christmas promotion for Schweppes and, following the 1967 exhibition at Simpson's of Piccadilly, he was asked to design their Christmas poster for the London Underground. In 1959, his design for Austin Reed's festive promotion featured an amusing design of Santa Claus arriving by helicopter, which was also used for large London Underground posters. Although many graphic designers used eccentric flying machines and balloon devices during the 1950s, the idea of flight remained an unusually constant theme and interest throughout Stewart's design career, cropping up in graphics, ceramics, tapestry and his painting.

Glasgow was chosen to be the centre in Scotland of the Commonwealth Arts Festival which was held in four cities in Britain, outside London, during the last two weeks of September 1965. The Festival was a varied programme of music, drama, ballet, film, conferences and exhibitions with participants travelling from Australia, Canada, Ceylon, Dominica, Kenya, New Zealand, Pakistan, Sierra Leone, Tanzania, Trinidad and Uganda. Local artists and

BELOW, FROM LEFT:

Poster for the Commonwealth Arts Festival, 1965; screenprint; 75 × 50.8 cm (29½ × 20 in.)
Collection Sheila Stewart

Programme for the Commonwealth Arts Festival, 1965; 22 × 9.5 cm (8¾ × 3¾ in.)
Collection Sheila Stewart

Illustrated brochure for the Commonwealth Arts Festival, 1965; 20.3 × 12.8 cm (8 × 5 in.)
Collection Sheila Stewart

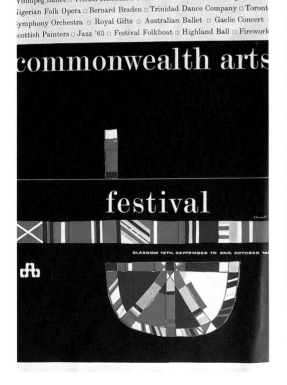

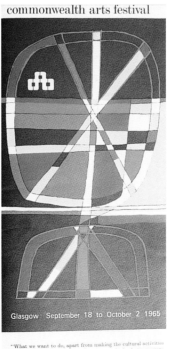

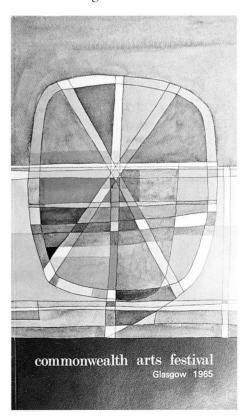

FAR LEFT: Cover for a GSA exhibition catalogue, 1950s; screenprint on linen; 23.2 × 14 cm (8½ × 5½ in.) *Collection Sheila Stewart*

LEFT: *Vista 4*, 1958; cover design by Stewart for Glasgow School of Architecture magazine *GSA archive*

performers were also involved and the aim was to celebrate cultural diversity and to encourage a stimulating exchange of ideas. The Scottish Design Centre in Glasgow had enabled the Festival committee to commission James Smith as poster designer, but his designs were rejected by the committee, which then invited other Glasgow artists to submit. Robert Stewart's designs for a poster and for the cover of the official programme were chosen despite his four-year-old daughter 'redesigning' the poster, just as he was about to leave home for the committee meeting in Glasgow, by painting out half a circle with black ink, but the design was reproduced as it was.

Throughout his career at GSA, Stewart produced posters and invitations for functions, including those involving his own students and many of his students printed posters as part of their pre or postgraduate work. For example, Hugh Barrett designed a poster for the book exhibition held in Stirling Library as part of Glasgow's 1959 International Fair. Through Stewart's initiative in April 1975, an exhibition of Heal's contract range of fabrics was held at GSA. This included fabrics designed by former students including Peter Perritt, Peter McCulloch and Rayne Walker. For this Stewart designed the posters which were printed on fabric, and the private-view invitations were produced as miniatures of the poster, also on fabric.

9

TAPESTRY AND CERAMICS

Tapestry

Modern French tapestries by Picart Le Doux, Coutaud and Lurcat were 'by far the most remarkable and impressive works I have yet seen anywhere on the Continent.'[1] The medium and the fresh approach to design of these artists were new to Stewart and caught his interest during his visit to France in 1948. There was a renaissance in French tapestries as a result of the German occupation when contemporary fine art was regarded with suspicion. Several artists turned to this traditional creative medium as an alternative to painting and, despite or perhaps because of the severe shortage of raw materials, they produced impressive works. As few as eighteen colours were used, in contrast to an average of 1500 colours in an eighteenth century French tapestry. The restricted palette made the work more in tune with medieval tapestry and Lurcat in particular created successful compositions.[2] Stewart must have responded to the textures and studied the works carefully, because on his return to Scotland he lost no time in designing tapestry. He would have approached this, as he did every design challenge, by assessing its intrinsic aesthetic qualities and the restrictions of the technique, and then ask himself, 'What if I did this, or that?' He would experiment, try different approaches, tussle with the design until something new emerged. He had immediate success and two cartoons, one entitled 'Bird of Paradise', the other 'Fishwife', were exhibited at the Saltire Society's Edinburgh Festival Exhibition *Dovecot Tapestries* alongside works designed by Vanessa Bell, Henry Moore, Rex Whistler, Sax Shaw and Anne Redpath. That same year, his design, 'Bird of Paradise' was woven by the Edinburgh Tapestry Company.[3]

There followed a lull until 1968 when Stewart was one of five Scottish designers invited to submit designs for a tapestry for the boardroom of the Scottish Arts Council in Charlotte Square, Edinburgh. Stewart submitted 'Apollo 8', reflecting his interest in the night sky and the American space programme. The dark skies that feature in his work of the late 1960s and 1970s

[1] Letter to D. P. Bliss from the Hotel Simmathof, Zurich, 28 September 1948, Bliss correspondence, Glasgow School of Art archive

[2] *Studio*, vol. 130, July–December 1945, pp 166–7

[3] The whereabouts of this 4 × 3 ft tapestry are unknown and the company records do not show who commissioned it or bought it.

Apollo 8, 1968; gouache;
26.7 x 45.8 cm (10½ x 18 in.)
*Artist's photo, collection Sheila
Stewart*

reflect the night sky above Loch Striven and Stewart's fascination with stars. At this time his designs became more geometric and he produced several based on circles and squares that had potential for use in various media such as tapestries, ceramic murals and posters.

The design by Archie Brennan, resident designer and Director of Weaving at the Dovecot Studios was chosen, but it was decided by the Scottish Arts Council to present a tapestry woven to one of Stewart's designs to the University of Strathclyde, Glasgow (formerly the Royal Technical College). This resulted in one of the few pieces of his work that he really liked and one

Design idea for space flight, 1969; gouache on board; 24.8 x 37.5 cm (9¾ x 14¾ in.)
Collection Sheila Stewart

Genesis, 1968; early design idea
for Genesis project
*Artist's photo, collection Sheila
Stewart*

of the tapestries cited by Brennan as an exemplary collaboration between designer and weaver. Of the three submitted designs based on the solar system, 'Genesis' was accepted. This design was described by Stewart, 'The intense blue-black area on the right represents the immensity of space from which our planet and solar system come. This blue-black area glides through to white leading to a large central circle that suggests both the sun and the cell, which hold the secret of our existence.'[4] At the centre was a double helix, the complex molecular structure of DNA, which encodes genetic data and was first described by British scientists in 1953. Stewart discussed the design

Genesis Tapestry, 1970;
274 × 411.5 cm (96 × 162 in.)
*By kind permission of the Collins
Gallery, Strathclyde University*

[4] Undated *Glasgow Herald* press cutting

Design suitable for mural or tapestry, c1970
Artist's photo, collection Sheila Stewart

with Sir Samuel Curran, the University's Principal, who was intrigued by the inclusion of DNA. However, in the design, this had rather a fragmented form and Curran wrote afterwards to Stewart suggesting a refinement that would clarify the artist's intention. He said,

I believe myself that the whole novelty and originality of the helix discovery is that it is defined and definite in form and because of that it acts in a template manner, reproduction of similar molecules becoming very possible. This suggests to me a defined structure but in your centre-piece there is no real hint of a clear definition of form. Put another way, one might say that the helix shown was rather distorted or broken and incapable of reproduction. It would be exciting to make at least a small part of the helix form obvious. This would combine the scientific idea of the present, the concept of the definition of the bio–molecule, with the uncertainty of our knowledge for the future, symbolised by the somewhat irregular arrangement that you have in your design.

I should stress that this is merely a reflection of the strong interest we have in the work of any artist interested in scientific concepts. However I did think it was worth passing on the thought that something defined in shape and form within the centre-piece could prove intriguing and a guide to the thought of the artist. After all the spectrum on the left shows the light has a definite structure, the colours going in their due order.[5]

[5] Letter dated 6 February 1970, brought to my attention by Laura Hamilton, Curator, Collins Gallery

The final design was amended and the double helix was introduced on the left side of the tapestry with the rainbow incorporated into it. The central cell was woven mainly in metallic and synthetic yarn to simulate the sparkle indicated by the design. The tapestry measuring 2.4 × 39.45 cm (8 × 131½ ft) was completed in 1970.

The Society of Friends of Glasgow Cathedral was left a considerable sum of money by the architect Robert Love who was quite specific that the money should be used to improve and enhance the Bishop of Jocelyn Chapel in the Lower Church. After consultation with the Ministry of Works, the Friends decided to commission a major tapestry to be hung at the western end. A national competition was arranged and won by Robert Stewart. This was to be his most demanding site-specific work. It entailed a careful study of the site for which he constructed a model to ensure that the design submitted worked within the constraints of the building and that it enhanced the sense of place. The result is probably his most impressive work.

The site provided an interesting architectural setting for a tapestry. The Lower Church, 36.9 × 18.3 m (123 ft long × 61 ft wide), was built between 1233 and 1258 and is a particularly fine example of the first pointed style of Gothic and one of the prime examples of medieval Scottish architecture. It is an atmospheric space with many symmetrically arranged pillars like a stone forest, and the twenty-seven lancet windows create constantly changing effects of light and shadow. A raised platform in the centre originally housed the tomb of St Mungo (also known as St Kentigern), patron saint of Glasgow, which became a major pilgrimage destination.

Model for Glasgow Cathedral Tapestry, 1978

Artist's photo, collection Sheila Stewart

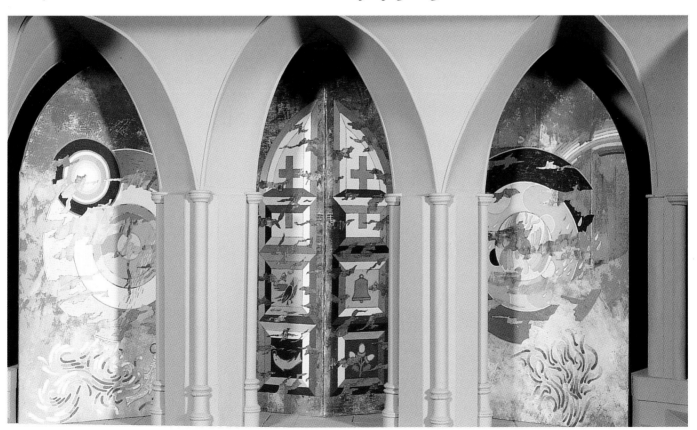

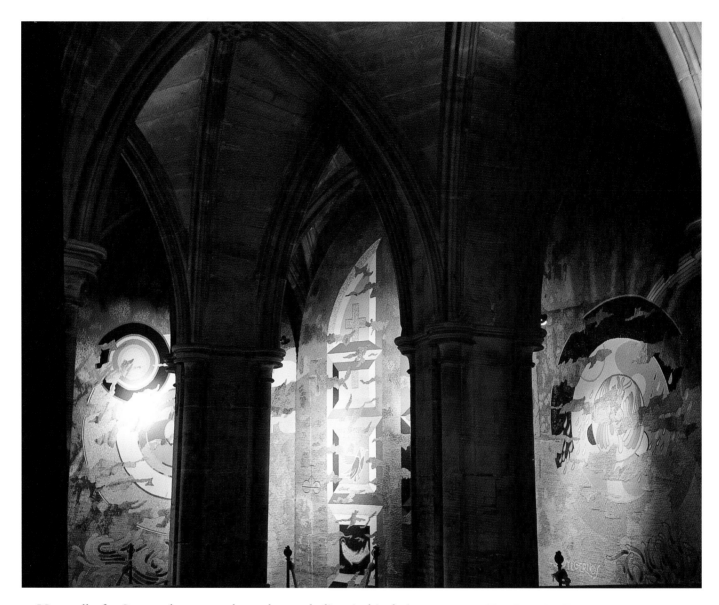

Unusually for Stewart he wrote about the symbolism in his design: *The Cathedral Tapestry in situ*

In the tapestry, very ancient symbols are linked with and unified by the central representation of the Church: all the elements are inter-related, and the position of each symbol contributes to the meaning of the whole.

My starting point was in fact the small device in the bottom left of the central panel, which has been described as the 'spectacle symbol'. The book, *The Lost Language of Symbolism,* tells us that the two-eye symbol was 'probably understood to denote respectively Love and Knowledge,' while in ancient times twin wheels or circles were regarded as a symbol of the Deity. This same figure is also associated with Gemini, the twins: thus by analogy, day and night, morning and evening, summer and winter, sun and moon, light and darkness, Heaven and Earth.

From this concentrated nucleus, the design expands into related and contrasted images. On the South arch is the Moon and the star Sirius, the Dogstar, a reference to St. Kentigern, the Hound-like Lord. Below the

Moon is suggested Water (opposite to Fire on the North panel), incorporating the salmon and ring of the St. Kentigern story. In the North arch are the sun, supporter of life, and fire, and the burning bush. Over and above the detailed symbolism they contain, the North and South arches are intended to glorify the creation of the universe and to praise the immensity of that creation.

Between the North and South panels is the centre panel representing the church in the form of a pierced door. This combines the Cross and the symbols of St. Mungo: the bird, the bell, the salmon and the tree (these are also incorporated in the arms of Glasgow) which is suggested by a trinity of acorns. In the bottom right is shown the old symbol for a hound, another connection with St. Kentigern. Thus the triptych is positioned in such a way that the Church is represented in the centre panel: centre in position and centre in significance.

The shape of the tapestry, with its arched angled panels, was dictated by the architectural shape of the lower church. The design was also influenced in that the central part was given comparatively small detail because the view of it is restricted, while the two outside panels are large in scale, to be viewed from the length of the church.[6]

The three tapestries were the largest and most important commission woven at the Dovecot Studios for many years. The central panel measuring 458 × 300 cm (15¼ × 10 ft), the outer ones 458 × 275 cm (15¼ ft × 8 ft 2 in.). Eight weavers were involved under the directorship of Fiona Matheson. Work began in February 1979 and was completed in August 1979. Again, considerable use was made of lustrous metallic and synthetic threads to enhance the texture and the play of light on the surface in subdued surroundings. The tapestry was dedicated in November of the same year in the presence of HRH Princess Margaret.

Stewart's last tapestry commission was for another site-specific work, the result of an open competition that formed part of the refurbishment of the interior of Glasgow City Chambers' entrance hall. The brief was to design a tapestry 3.5 × 1.5 m to be located behind a new black lacquered reception desk to provide a textural backdrop, creating a soft contrast to the original green marble, to the red and grey granite and to the bold mosaics on both ceiling and floor. The design was to reflect some aspects of Glasgow's past or present. The challenge was to produce a design suitable for a flamboyant Victorian interior. Stewart found this the most difficult tapestry to design and commented, 'Do you fight it or go along with it? It was a nightmare.'[7]

He conceived the idea of simply using Glasgow as he saw it at that time. The result was a subtle, stylised, misty panorama in soft greys. In an almost pixellated image, he drew together typical features such as the distinctive phenomena of vertical fragments of rainbow, a common sight, and a beautiful sunset. The hills of the city clustered with buildings and tower blocks have at the centre the

'Glescau' Glasgow City Chambers Tapestry, 1982

[6] *The Robert Love Bequest*, published by the Society of Friends of Glasgow Cathedral on the occasion of the dedication of the tapestry

[7] *Glasgow Herald*, 23 September 1981

gold cross of the cathedral and St Mungo, the city's patron saint. Below is the River Clyde with touches of bright orange and black representing ship funnels that could still be seen in the city at that time. The design was based on a view over the city he had seen for thirty years from GSA on Garnethill. Because of the height of the City Chambers' entrance hall, he used a horizontal quality in the design which at the same time solved the technical problems of weaving.

All the designs by the competition entrants were exhibited and it was immediately evident to both the selection panel and public that Stewart's design was the most successful, not only because of his imaginative response to the brief, but also because his design could readily be translated into tapestry weaving. His colleague and former student Jimmy Cosgrove's submission was highly commended, but was so complicated it would have been prohibitively expensive to weave. Fitness for purpose was always an important issue for Stewart and it irritated him that artists such as Hockney produced designs for tapestry that Stewart believed demonstrated no attempt to understand the medium. The first prize was for £1000 plus a supervision fee of £350. The tapestry which cost £10,000 and took two months to weave was, like the others, produced at the Edinburgh Tapestry Company's Dovecot Studios and completed in 1982. As a result of this tapestry and his previous commissions he was honoured by the Glasgow Incorporation of Weavers, a distinguished organisation founded in 1514, and made a member on 15 June 1983.

Stewart loved tapestry and it was probably the tapestry commissions of which he was most proud. However, despite having such success with designs in competitions, he was bitterly disappointed that he was not offered more tapestry commissions and that four designs based on a geological theme submitted to British Petroleum Oil for their Glasgow offices in 1986 were not successful. Lyvia Eddlestein's design was preferred and woven two years later by the Edinburgh Tapestry Company. It is likely that he lost out on other commissions because he refused to join what he regarded as establishment organisations such as the Society of Industrial Designers. It was also quite typical of him that he could not accept that a discipline he was enthusiastic about might simply fall out of fashion and public taste.

Ceramics

Stewart designed ceramic murals over a twenty-year period for sites ranging from underpasses to schools, restaurants, swimming pools, hotels, and also an airport, a cinema, a casino and a church. Throughout that time he refined and developed his understanding of the medium as a surface for decoration, although he showed no interest in the malleable sculptural potential of the material. It is not particularly surprising that Stewart with his natural curiosity and awareness of European artistic developments should become interested in this medium. After all, Picasso was painting tiles and ceramic vessels, artists such as Dali and Miró were creating tiles and panels during the 1950s and Matisse became interested in ceramic mural decoration when working in the Chapelle du Rosaire, Vence, near Nice, in 1947. Of particular influence may have been Miró's 'Wall of the Sun' and 'Wall of the Moon' for the exterior of the Unesco

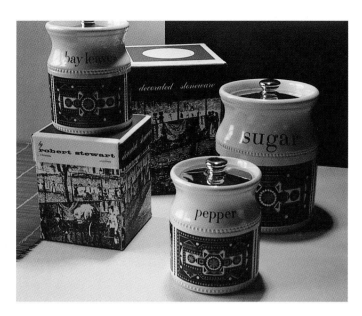

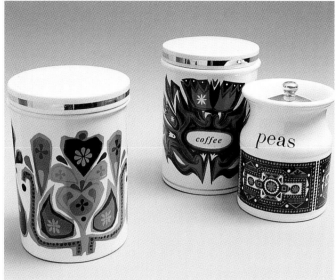

LEFT: Storage jars with packaging, 1957–63
Artist's photo, collection Sheila Stewart

RIGHT: Storage jars, 1957–63; marked on base Stewart + four-leaf clover symbol Transfer printed stoneware and gilding; Coffee jar 20 cm (8 in.) high, Peas 12 cm (4¾ in.) high
Collection Louise Stewart

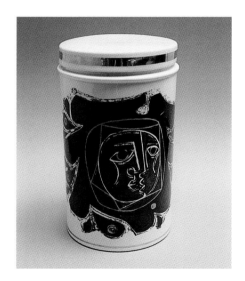

Ceramic Storage Jar, 1957–63; marked on base: Stewart + four-leaf clover symbol; transfer printed stoneware and gilding; 24 cm high × 14 cm diameter (9½ × 5½ in.)
Collection Sheila Stewart

building in Paris, produced between 1955 and 1958 in collaboration with the ceramic artist José Artigos. There were also examples in Britain such as Victor Pasmore's tiled mural for the Regatta Restaurant on the South Bank for the Festival of Britain in 1951, there were articles in journals such as *Design*[8] and by 1955 tile murals were being made at the Royal College of Art.[9] Although during this time screenprinting was applied to tiles to produce murals with flat pattern in bold colours, Stewart was unusual in that he not only designed the murals but also produced them himself, with only a few exceptions working directly onto the tiles rather than printing his design.

An interest in ceramics may have developed when Stewart was a student, and he was clearly fascinated by the potential. A letter in reply to Booths, Stoke-on-Trent, from Allan Walton states that, 'I see no reason why Textile Designers should not be used for pottery... We have in this school attacked the subject to a certain extent and have produced within the last few months a number of designs for dinner ware.'[10] Operating with such restricted numbers, the students in the Design School would have been aware of what everyone else was doing even if Stewart did not design for ceramics himself at that stage. And certainly he is remembered by one fellow student as always looking at what others were doing.[11] It was assumed that he was 'pinching other people's ideas', but he had an insatiable curiosity and was genuinely interested and keen to learn. Later, as a teacher, he was fascinated by his students' ideas, especially if they were not part of the mainstream, and encouraged his students to do likewise, to be aware of what everyone else was working on, believing this encouraged a competitive spirit that urged the students forwards. He regarded such creative interchange as mutually beneficial.

[8] Mark Hartland Thomas, Opportunities with Tiles, *Design*, August 1956, no. 92

[9] 'Tile Murals for Jamaica', *Design*, March 1955

[10] Letter February 1944 to G. Greaves, Walton correspondence, Glasgow School of Art archive, Dir 10/1–16

[11] Conversation with Frieda Scott, 24 January 2002

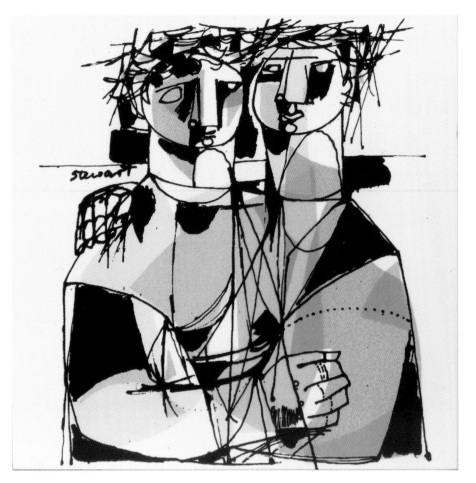

Tile, Edinburgh Tapestry Company, mid 1950s; signed: Stewart; screenprinted earthenware; 15 cm (6 in.) square
By kind permission of the Fine Art Society and Target Gallery

The earliest published record of his ceramic tiles is in a 1954 article in *Scottish Field*, in a feature entitled 'Craftsmen of Scotland', which mentions his tiles exhibited at David McCallum's Centre for Scottish Crafts at St Ninians, Stirling. These were produced at the Dovecot Studios, although there may already have been a kiln in the Printed Textile department by the mid 1950s as students were being encouraged to spread their interest. Misha Black who was an external assessor in 1956 and 1957 noted,

> the influence of this section of the school continues to extend and the use of the silk screen process is by no means confined to printing on Textiles but has been extended to Ceramics, Posters, wood, etc.[12]

Stewart's ceramic output increased when in 1957, with a growing family and the need to improve his finances, he set up a business Robert Stewart Ceramics, to produce high-quality kitchen storage jars and tankards. Initially, the business was run from his Glasgow home where he had a kiln that regularly fused the electricity supply, making him unpopular with neighbours. Stewart also did the selling, but was helped in the production and packing by Sheila. The designs were transfer printed onto blanks supplied by Govancroft in the east end of Glasgow. The ceramics had simple clean lines that showed

Tankard, 1957–63; marked on base: Stewart + four-leaf clover symbol; transfer printed stoneware and gilding; height 14.5 cm (5½ in.). Sheila Stewart applied the transfers to the tankards. The tankards were retailed by Liberty.
Collection Sheila Stewart

[12] Assessors' Report 1957

Design for Tankard, 1957–53;
black separation for tankard design;
10 × 23 cm (4 × 9 in.). 603 was the City
of Edinburgh Air Squadron.
Collection Sheila Stewart

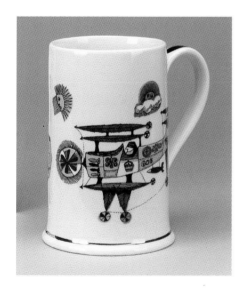

Tankard, 1957–63; marked on base:
Stewart + four-leaf clover symbol;
transfer printed stoneware and gilding;
height 14.5 cm (5½ in.)
*By kind permission of the Fine Art Society
and Target Gallery*

the designs to advantage and were highly decorative as well as practical. Jars in varying sizes for everything from flour and rice to coffee, bay leaves, bath salts and cigarettes were produced. He was constantly adding to the range, including a tobacco jar with a tasselled lid to resemble a smoking cap. Although mainly in Scottish landscape colours, his designs were distinctive and varied widely, including Kintyre and Crinan with abstract pattern, Ardnadam with Cubist-inspired images, quirky line drawings and bright animal figures to appeal to children. Later, unsentimental landscape designs were introduced, but he was conscious that to retain his originality he had to resist the temptation to design for a market. As a perfectionist, he insisted on the highest standard of finish and also designed and produced distinctive packaging and publicity material for the range.

There was considerable demand and the products were sold through many of the more up-market stores such as Liberty's and Primavera in London, Interior Decoration in Sheffield, and Rackhams in Birmingham. In such stores, there was a more coherent and exciting approach to presentation and, in the displays, textiles, ceramics, cutlery and glassware were often shown together. The small tankards sold for £2 4s (£2.20) and the jars varied between £1 6s 6d (£1.32½) and £3 15s (£3.75). Although the Scottish Crafts Centre in Edinburgh was prepared to stock his tiles from the Edinburgh Tapestry Company, it refused his storage jars on the grounds that no matter how well designed, they did not qualify as craft because he had not made the jars himself. This snub rankled particularly after his involvement in the early days of the Centre. However, his range won wider acclaim and was exhibited at the Council of Industrial Design Centre in London, resulting in orders from as far away as Tokyo and the Virgin Islands. It was included in British Fair displays in Tokyo and New York, which brought orders from Nyman Marcus and Sax of Fifth Avenue, and a selection was also displayed, with examples from nine other artists and designers, in a case at the entrance to the British Pavilion of the Seattle World Fair in 1962.

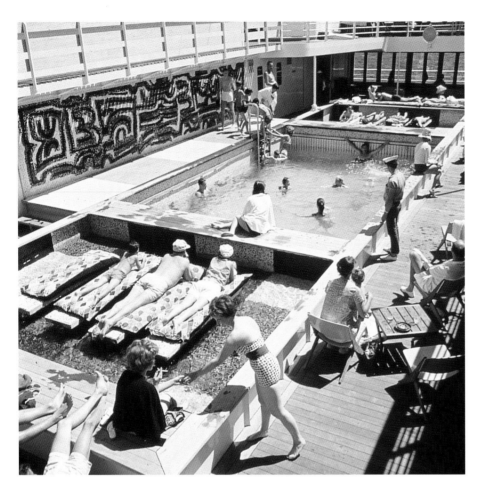

First-class swimming pool, SS Oriana, early 1960s
By kind permission of P&O

The business continued to thrive but as the Stewarts' home was over-whelmed by packing cases during seasonal rushes, production was moved to a factory in Paisley by which time 1500 items a month were being produced. It was suggested that Stewart should consider producing full dinner sets but, because of teaching commitments, the time he could devote to ceramics was restricted. In order to develop and extend the business, he handed the sales work over to Wuidart, a businessman, and concentrated on design. The arrangement did not work and he eventually abandoned the business in 1963 when he discovered that his jars were given away by Embassy in exchange for cigarette coupons. He admitted that losing interest before things were fully resolved was a major fault in his work and that initiating and starting were the most enjoyable aspects of a project because they were the most interesting and challenging.[13] In any case, by 1963 he was becoming more interested in the potential of ceramic murals.

In 1960, Stewart received his first major ceramics commission. This was for the new and very stylish 42,000 ton P&O cruise liner SS Oriana. The liner, built to carry more than 2000 passengers, was launched in November 1959 and destined for voyages across the Pacific from Australia to Vancouver and San Francisco. The Design Research Unit, London, commissioned the design of the interiors and Stewart was approached by Misha Black to design the first-class

[13] *Glasgow Herald,* 18 October 1980

Studio, Hill House, Loch Striven, 1965; ceramic mural for West Dumbarton Burgh Offices in progress; 2.5 × 3 m (8 ft 2 in. × 9 ft 6 in.)
Artist's photo, collection Sheila Stewart

swimming pool. He unified the area, providing a design for a mural along the wall behind the pool, for the lining of both the swimming and shallow pools, and for the sunbathing area. He also supplied an alternative design richly patterned in blues and black which would enhance the colour of the water and provide a strong focus for the area, but this was rejected. A Venetian mosaic company did the construction and Stewart was flown to Italy to see the tiles made. Stewart was one of several designers commissioned to work on the Oriana and although P&O was praised for incorporating a number of works of art as part of the fittings, there was criticism by the design press that individual artists and designers were given no guiding brief. They saw the result as an eclectic mix, likened to a contemporary provincial hotel, which although it provided variety of decoration lacked a coherent style for the ship as a whole.

After the family moved to Loch Striven in 1961, Stewart had a more spacious studio and began to develop ceramic murals seriously. He also manufactured the murals, which allowed him to control each stage of the process. In 1962–63, he was commissioned to produce a ceramic mural and a fireplace for the Campsie Glen Hotel, Lennoxtown. He was not satisfied with the finished work and admitted later that some of his murals were unsuccessful, 'When you're trying out new things and taking a risk you sometimes land up in a mess. You have to learn to live with it.'[14] Taking a risk

[14] Ibid.

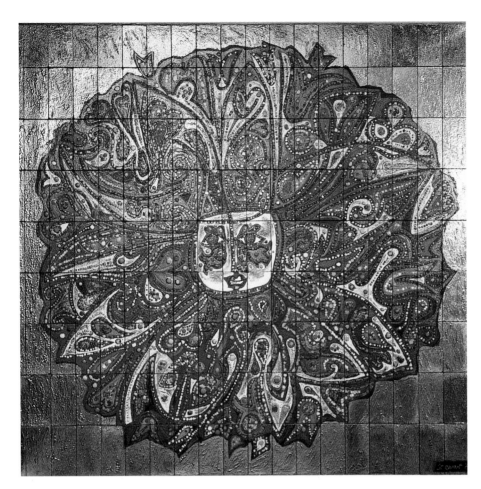

Ceramic mural, Royal Garden Hotel,
Kensington, 1964
Artist's photo, collection Sheila Stewart

and fearlessly exploring the potential of a material or technique were what intrigued him. As with his work in any medium, pushing the boundaries offered him new potential and the process itself provided endless fascination.

Misha Black again commissioned him in 1964 to design a mural for the Royal Garden Hotel, Kensington. Unfortunately destroyed later when the site was redeveloped, this was one of his most spontaneous decorative designs. Measuring 2.2 m square with one of his favourite sun motifs at the centre, he developed the rays into petal forms of lively curving shapes in rich browns, reds and blues with accents of green and yellow, set against a gold ground.

The setting-up of Loch Striven Studio Ltd in 1965 marked an incredibly productive period of mural commissions brought about by an upsurge of building by local authorities. The building of new schools opened up a fruitful market and ceramic murals were ideally suited to enhance the stark architecture of the 1960s and 1970s, for they provided decoration that was both aesthetically pleasing yet sturdy enough to withstand the wear and tear of continuous use. Stewart also recommended to his colleagues that the new primary and secondary schools offered ideal scope as venues for art work commissions.[15]

Sometimes he employed students to work at weekends, Alex Gourlay remembers working on the mural for the Royal Garden Hotel and on another with a design of playing cards for a casino in the Isle of Man. Sheila Stewart

[15] Minutes of Academic Council meeting, May 1973 , Glasgow School of Art archive

often helped, but the children could be less reliable – when left to watch the kiln they sometimes forgot, with disastrous results. Split fire bricks measuring 22 × 11 cm were initially used for the murals and enough for the central area of a mural were laid out in his studio at Loch Striven. A base colour was painted onto the bricks (a silk screen silica-based printing ink was used) or an oxide coating was rubbed on to darken them and vary the tone. The chosen design was squared up and the outline was drawn on the bricks with slip trailing. This method, also known as tube lining, was the conventional technique used to make the tiles for Glasgow's famous decorative 'wally closes' of the late nineteenth and early twentieth centuries. The slip contains 30% clay and has a consistency of stiff paint that allows the design to be drawn out in a controlled way. The tiles were fired and some of the design was then blocked in with colour and small pieces of solid enamel colours were broken up and laid on top. In this way the design was gradually built up between many firings. Ready-mixed earthenware and enamel glazes were readily available, as were copper, gold and platinum metallic glazes, although these were highly poisonous and expensive.

Stewart produced three murals for schools. Those for Adelphi Street, Gorbals, and Eastwood High School, Newton Mearns, were both completed in 1965 and that for Douglas Academy, Bearsden, the following year. The first two are playful in their design and include suns, moons, hearts, birds and devices that Stewart used in other media, particularly graphics, whereas the design for the third was inspired by the sight of a seagull passing in front of the sun while Stewart was lying on his back looking at the sky on holiday on Oronsay. The bird is more abstract and powerful than the one in the Adelphi Street mural and bolder more vivid effects were created by the addition of contrasting colours in thick spots and rectangles.

Mural installation at Eastwood High School, Renfrewshire, 1965; 2.20 × 6.05 m (6 ft 8 in. × 20 ft 8 in.)
Artist's photo, collection Sheila Stewart

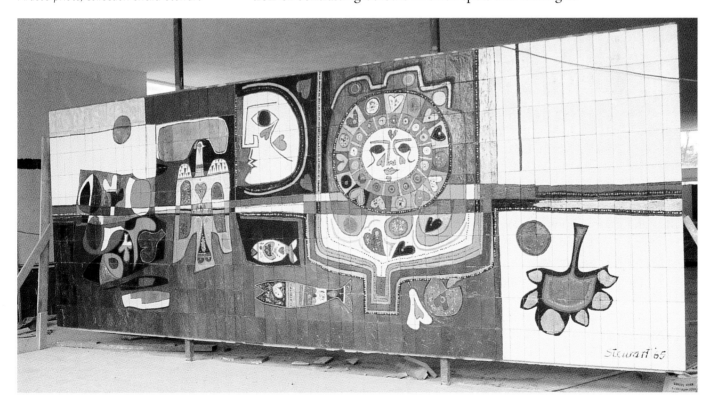

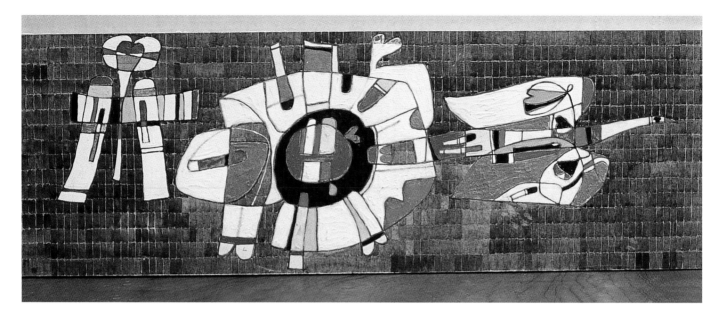

Stewart most usually worked on sheets of paper and card, although he sometimes used sketch books. However, in a sketch book that probably dates from the mid 1960s, which contains a rough drawing for the Douglas Academy design, there are some notes for a proposal outlining a four-month visit to Italy, Greece, Turkey, Israel, Persia and North Africa to study all types of wall decoration in modern and ancient architecture. He may have been inspired in this by plaster casts of fragments of ancient Assyrian murals which still hang in GSA, as there is also a sketch of a lion hunt with Assyrian or Turkish inspired archers. In the outline, he proposed to visit the workshops of designers engaged in such work and believed that 'by going to the roots of a civilisation I hope to discover for myself and then avoid the eclecticism inherent in modern art.' He was obviously thinking of applying for a period of sabbatical leave, but this particular idea was not realised; by 1968 when he was granted leave his travels were less extensive and his attention had turned to working on individual ceramic wall tiles rather than murals.

For West Dumbartonshire County Offices, Stewart produced in 1965 a sunflower design that appears to have been developed from the alternative design submitted for the Royal Garden Hotel, Kensington, but on a dark ground. The designs for Motherwell and Wishaw Concert Hall were more abstract and a development of the bolder technique used at Douglas Academy. Stewart produced a pair of murals for each of the two entrances, filling the space between two sets of double glass doors, thus forming a 'bridge' between the outside of the building and the interior of the theatre foyer. As these murals would be most usually seen in the evening, he made extensive use of lustres that glow in artificial light. They were given the 1967 Saltire Award for Arts and Crafts in Architecture and he was invited to hold an exhibition of his work at the Saltire Society conference that year. The Saltire Society was established in the 1930s to promote the arts and culture of Scotland and makes annual awards in various categories. Although this project won him considerble acclaim, it was not a financially profitable commission because he spent so much time working on the murals. He was later

Mural design for Adelphi Street School, Gorbals, Glasgow, 1965; gouache on board; 21 × 84 cm (8¼ × 33 in.). The actual mural is 14.34 m (47 ft) long.
Collection Sheila Stewart

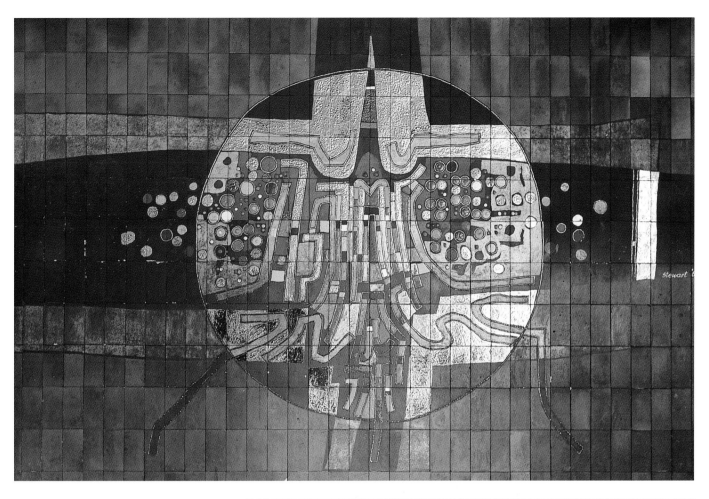

ABOVE: Ceramic mural, Douglas Academy, Milngavie, 1966. The design was inspired by the sight of a seagull passing in front of the sun while the artist was on holiday on Oronsay.

RIGHT: Detail of the Douglas Academy wall

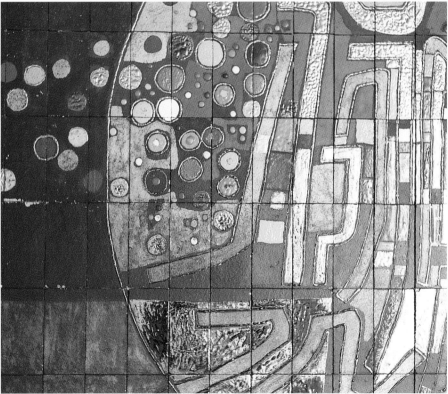

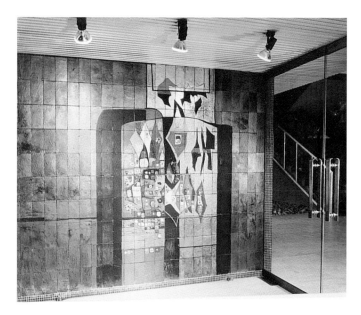

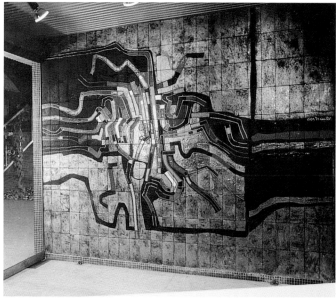

ABOVE: Two of the murals for Motherwell and Wishaw Concert Hall, 1966; each measures 220 × 275 cm (6 ft 8 in. × 8 ft 6 in.)
Artist's photo, collection Sheila Stewart

LEFT: Mural design for Elders, Argyle Street, Glasgow; signed: Stewart '68; gouache on card; 55 × 38 cm (21¾ × 15 in.). The condition of this mural is unknown as it now has a staircase built over it.

Mural, Prestwick Airport, 1973; 1.9 m (9 ft) square. The mural was appropriately unveiled by the Duke of Hamilton, who established Prestwick Airport. He also flew with 602 City of Glasgow Squadron, and, in 1933, was the first to fly over Everest.

Artist's photo, collection Sheila Stewart

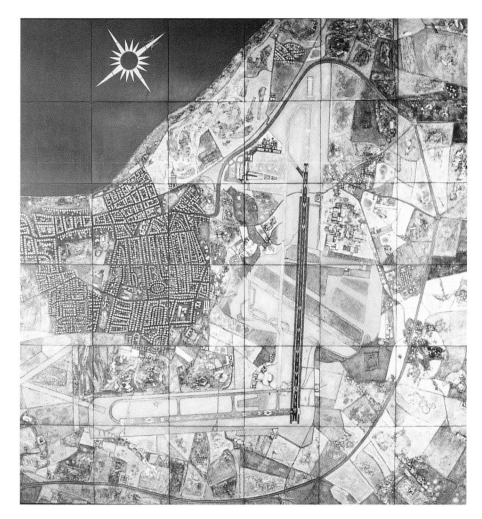

astonished to learn that the tradesman installing the ceramic tiles in the public toilets earned more per hour.

He used a more straightforward technique on two underpasses that were constructed of white glazed bricks, an economical form of structural ceramic whose surface is resistant to water. The surface eliminates the need for cleaning and has the advantage of increasing reflected light. For Greenock, 1964, he used a linear screenprinted design of six Clyde paddle steamers; the underpass at the Brandon Shopping Centre, Motherwell, 1978, had printed on either side photographic images of the shopping street that had been pulled down to make way for the new centre. Peter Anderson, a former student, printed this mural for Stewart and it is interesting that Stewart suggested photographic images for this commission because he had previously been so much against the medium which he regarded as inferior to drawing.

Stewart began using 18 in. (45.7 cm) square kiln bats (ceramic shelves used in kilns) during 1967 for individual works and subsequently also used them for site-specific works. The first of these was commissioned for the student refectory of the new College of Commerce in Glasgow. The architect George Keith wanted durable decoration for such a site and Stewart suggested a series of five or six panels, each 3 ft (91.5 cm) square, set along the

 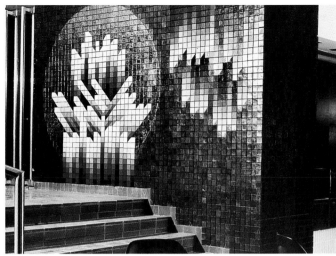

wall as a means of unifying the space. Unfortunately, as happened to several other murals by Stewart, these suffered damage. A student testing out his motorbike within the refectory hit the wall, the petrol tank exploded, reducing the building to a charred shell. The tiles, although smoke-damaged, survived only to be stolen from the site.

His next commission was to design a mural for the international departure lounge at Prestwick Airport in Ayrshire, for the British Airports Authority. Stewart was recommended by the resident architects J. L. Gleave and Partners. The commission, which was in negotiation for two years, included the condition that it should depict an aerial view of the airport. The mural also commemorates Orangefield House, built in 1706, that was well known to Robert Burns, and was formerly on the site. It was the most representational and difficult mural he designed. He fulfilled the requirements of the brief, producing a representational image, but, in addition, in order to render a satisfying design rather than simply a cartographically accurate image, he introduced texture and subtle tonal relationships. To achieve the subtlety of colour and tonal consistencies, some of the thirty-six 18 in. square tiles were fired ten times. Stewart also added platinum, gold and copper lustres to catch reflected light and heighten the effects. The mural involved three months continuous work and was unveiled on Burns' birthday, 25 January 1973.

The only privately commissioned mural was for a new flat in the west end of Glasgow, the interior of which was designed by the Scottish Design Centre and furnished in the latest style. Measuring 137 cm square, the textural abstract design had a pale central motif set against a ground of blues, anthracite and other dark tones with extensive use of gold lustre to complement the interior. The nine tiles were stuck to a board with epoxy resin, then mounted in a stainless steel frame. Later the owner took it with him when he retired to London.

Stewart was invited to submit two proposals for British Rail's new development at Glasgow's Queen Street Station in 1974, the station entrance to the Hebridean and Highlander restaurants, and a mural to decorate the Hebridean restaurant. His colleague Jimmy Cosgrove designed etched glass doors and Chuck Mitchell also contributed work. The entrance design consisted of

ABOVE LEFT AND RIGHT:
Design proposal for the station entrance to the Hebridean and Highlander restaurants at British Rail's new Queen Street Station, Glasgow, 1974; ink and gouache on board; 54.5 × 83.2 cm (21 1/2 × 31 1/2 in.)
Collection Sheila Stewart

Ceramic mural for the Hebridean restaurant, Queen Street station, 1974. Stewart also designed the menus and tablemats.
Artist's photo, collection Sheila Stewart

Ceramic mural, Glendaruel
and Kilmodan Primary School,
1975; 182 cm (72 in.) square

BELOW, LEFT AND RIGHT: Details

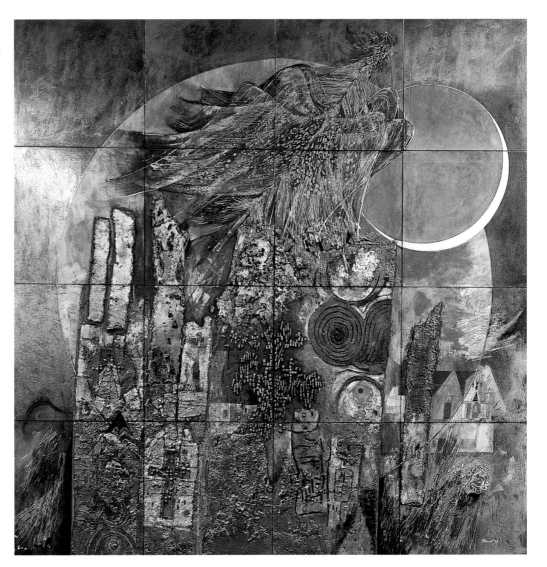

strong blocks of colour to punctuate the space, while the mural was a bold and simple design reminiscent of the aurora borealis. Stewart also designed the tablemats and menu holders for both restaurants. He always took care to ensure that his designs were appropriate to the architectural space and proposed use of an area. Architects liked to work with him, as he was professional in his approach, efficient, well organised, responded to specifications and delivered on time. Allen Matheson first became aware of Stewart's work in the early 1970s and remembers that being a governor of GSA,

> gave me the opportunity to see Bob at work and was impressed with his creativity, enthusiasm and utter professionalism ... No matter what the challenge he was enthusiastic. He was exciting to work with and his continual striving for perfection earned him great respect.[16]

Stewart had a strong belief in his own aesthetic judgement, he would not interpret other people's ideas and was prepared to be difficult and insistent on aesthetic matters. His sound aesthetic judgement also caused him to turn down commissions such as that for a chapel mural in Jerusalem. A priest visiting the basilica at Nazareth saw ceramic tiles on the walls representing religion from all parts of the world but Scotland was omitted. With Father McShane was a business man who offered to pay for the suggested work depicting the Virgin Mary dressed in a tartan sash holding up a map of Scotland. Stewart quickly 'buried his head in the sand with that one,' although he did suggest the alternative idea of a design incorporating a Celtic Cross.[17]

One of the last site-specific works was a mural consisting of sixteen large tiles made for Glendaruel and Kilmodan Primary School and presented by Robert Stewart in appreciation of the outstanding education received by his six children from 1961–75. It was dedicated to the three teachers and given in 1975, the year his youngest daughter Louise left the school. Situated in the central library, art and activity area of this small country school it has a strong sense of place and timelessness. It includes details such as ancient cup and ring marks, and the standing stones that abound in the area and that succeeding generations of children would continue to be familiar with. It also has a sense of mystery to encourage the children's imagination. Because of children's need to touch, this mural is more textural than any other he produced, with the texture mainly confined to the lower area at child height. Stewart's approach to technique in this piece is fearless, building up areas and scraping away others and embedding small smooth metal rivets in the clay. His pleasure in making this piece is palpable. It had such personal meaning for him, the landscape and history of the area were so important to him and, because he was unconstrained by a client brief, he was able to express his own emotional response just as he did in his paintings of landscape.

[16] Letter to author, 21 June 2002

[17] *Guardian*, 15 October 1980

10

PAINTING AND LANDSCAPE: A SENSE OF PLACE

Rugged landscape became part of Stewart's everyday life when, with a growing family and dissatisfied with the education they received in Glasgow, the Stewarts decided to move. It was inconceivable for him to return to the suburbs and, instead, in 1961 he found an isolated plot of land at the head of Loch Striven, a sea loch in Argyll surrounded by dramatic hills. The Hill House, as it became, was built by Dorran, a Perth company specialising in partially prefabricated constructions that were modified to suit the individual client. In this, Stewart was helped by Clunie Powell, an architect at GSA.[1] The move gave him a real sense of achievement because here his six children enjoyed freedom and benefited from an outstanding education in the local primary school, which had twelve pupils and a dedicated and talented teacher. However, it made travel to work difficult, often exhausting. Leaving the house at 6.50 a.m. he drove along a treacherous twisting road to the ferry at Dunoon, crossed the Clyde, then took the train from Gourock to Glasgow, and finally walked – arriving at GSA more than two hours later, although there were often delays, especially in winter. This journey was full of visual contrasts and involved not only a considerable distance but took him from an

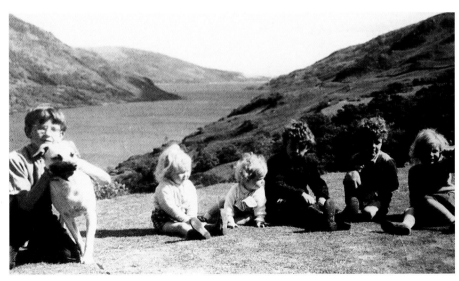

The Stewart children; *left to right:* Bobby, Veronica, Louise, Billy, Allan and Jenny
Collection Sheila Stewart

[1] *Scottish Field*, April 1962

133

ancient but unspoilt landscape inhabited for more than 6000 years, to the ever-changing industrial centre of Glasgow. He was to make this journey twice a day, four days each week during term time, for twenty-three years and this experience together with his travels in the West Highlands gave him a profound awareness of the Scottish landscape. Subsequently his painting exemplified the artist Paul Klee's belief that the artist must engage in a dialogue with nature, not necessarily with the actual details, but with the 'voices'.

At first, Stewart used one of the bedrooms as a studio, but shortly afterwards added a studio building. He often commented that all he desired in life were good health and a warm studio. Like the previous flat, Hill House became a focus for visitors, especially students; it was often busy and chaotic with lively discussions continuing into the evenings in the Glendaruel pub. As the children grew and their friends joined them for weekends, an A-frame was built in the garden to accommodate them. This was designed by Ian Duncan, another architect, who became a friend and collected Stewart's paintings and ceramic panels. The beach below the house was the site of many barbecues and parties on long summer evenings. But the house also became a refuge for Stewart, a place where the energy expended in teaching was renewed and he could develop his painting as well as his design work.

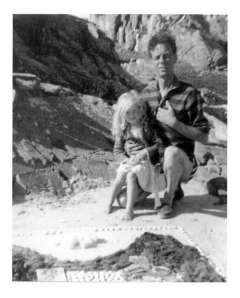

Bob and Veronica sit proudly behind the picture they have made in the sand.
Collection Sheila Stewart

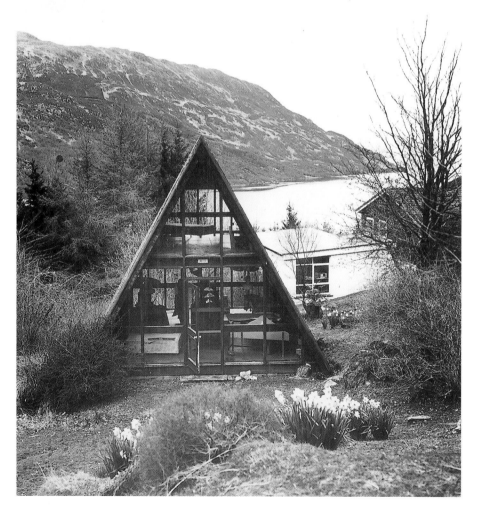

The A-frame behind the Hill House, Loch Striven, with Stewart's studio behind and the house on the right
Artist's photo, collection Sheila Stewart

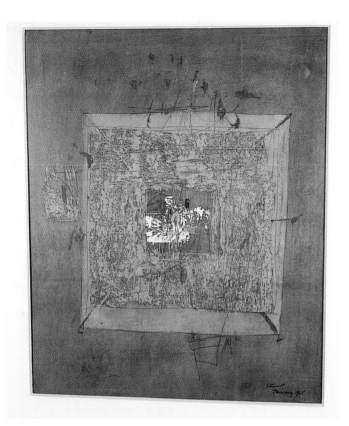 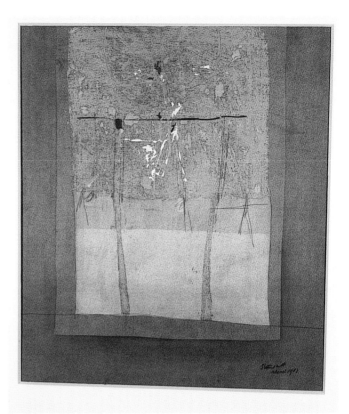

ABOVE LEFT AND RIGHT:
Untitled, 1968; signed: Stewart January
1968; Procion and gouache on paper;
61 × 51 cm (24 × 32 in.)
Collection Sheila Stewart

Untitled, 1968; signed: Stewart March
1968; Procion, grease and gouache on
paper
Artist's photo, collection Sheila Stewart

Although Stewart painted throughout his career, he never used oils. He said that he could not stand the smell of linseed oil and turpentine and preferred the smell of cellulose. He would use gouache, watercolour or inks. In 1967, he was introduced to Procion dyes by Julius Tescher and as he explored the use of this technically demanding and unusual medium, painting became increasingly important to him. Technical control was again allied to intuitive spontaneity in his work, but much of this was internalised and carefully considered before any mark was made. He would stand smoking and thinking but, when he started, he worked quickly, producing finished land and seascapes based on observations and sketches of the geological formations of mountains, transitory effects of cloud and weather, ruined buildings, gravestones, farm implements, the patterns made by woodworms, jetties and ships. His children's activities were a source of fascination. One of his works was based on the carcass of a dragonfly found by one of his daughters. The children's drawings inspired him, too. From such beginnings, he worked incessantly editing images, adding, removing areas and carefully working out placements and juxtapositions of colour and shape with unerring artistic exactitude in the constant effort of working towards an image that he found satisfactory. Cosgrove believes that this concentrated painting activity distilled his artistic language and was for Stewart a form of contemplation that fuelled his creative imagination.

The best of Stewart's landscapes have real integrity and vitality, sometimes including suggested but ambiguous forms that defy identification. As one would expect of a textile designer, an important feature is his sensitive handling of textures that give a rich quality of surface. His use of dye on paper

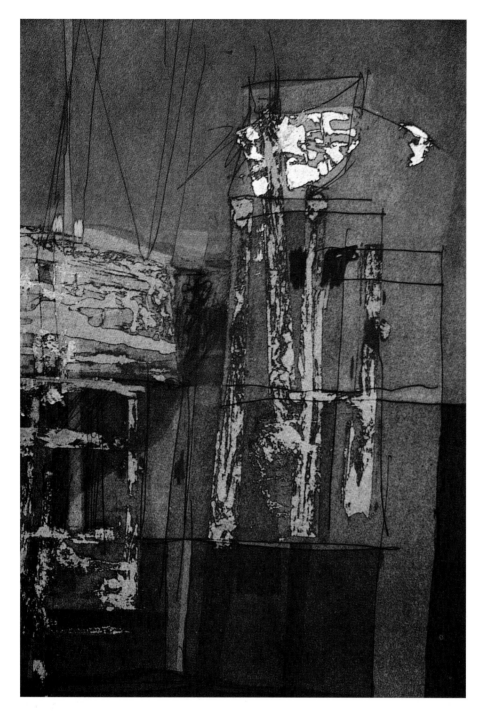

Untitled, 1968 (detail); signed: Stewart
1968; Procion, grease and gouache on
paper
Artist's photo, collection Sheila Stewart

gives saturated colour that sinks into the surface allowing the texture of the
paper to play an important role in the work. Stewart used a pin or scalpel to
scratch sensitive calligraphic marks in the paper, causing the Procion to bleed
into the line and to give a particular precise quality. He sometimes added
small areas of gouache to his Procion paintings, modified the paint with Cow
gum, or something similar, to change the white from a stark white and give
it opacity and texture. Constantly refining the process occasionally led to
over-concern with technique and his paintings were sometimes dismissed
because of their attractiveness and 'artistic play', but he was extremely serious
about what he was doing.

During a period of sabbatical leave in 1968, he visited Germany, France, Italy and Czechoslovakia, and also spent time exploring the use of Procion dye (with Castrol axle grease as a resist) in monoprints. The technique of monoprints usually involves painting with oil colours on a smooth glass or metal plate then taking an impression on paper, which is pressed onto the glass by hand or with a roller. The transfer of images from the plate to paper changes the image, as some of the brushwork is absorbed into the paper giving an enhanced brilliance to the work. Monoprinting also allows freedom and a painterly approach, lending itself to a variety of imaginative approaches that necessitate experimentation to develop a personal method of working (which may utilise fingers, cloths or sticks in addition to brushes). The final print demands a sure touch, spontaneity and swift execution in order that the image on the plate does not dry before it is printed. In other words, this process was ideally suited to Stewart's working method and he had already explored the technique during the late 1950s. Although monoprints had been popular earlier in the twentieth century with artists such as Degas,

Highland Croft with a Fire, 1969; signed: Stewart 1969; Procion and gouache on paper
Photo Patty Carroll, collection Professor Tony Jones

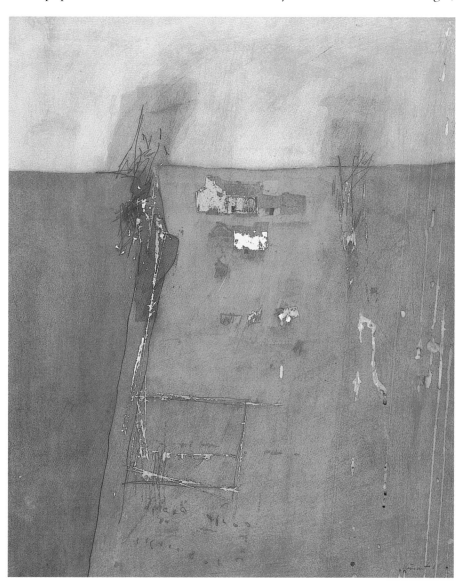

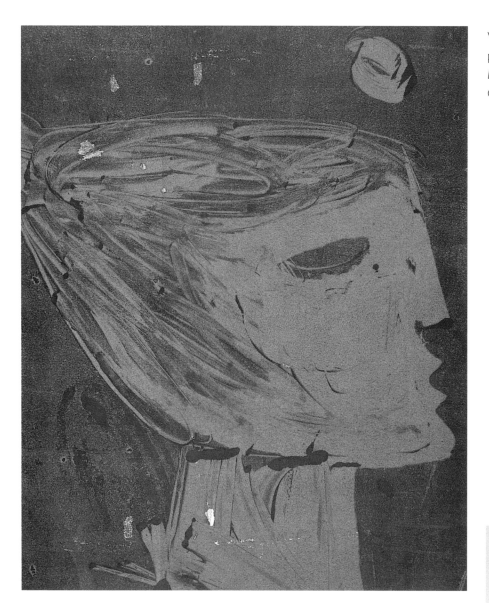

Woman's Head, 1957; monoprint; ink on paper; 44.5 × 36.8 cm (17½ × 14½ in.) *By kind permission of the Hunterian Art Gallery, University of Glasgow*

Poster designed by Stewart for the exhibition of his paintings at GSA, 1968 *Collection Sheila Stewart*

Picasso, Matisse and Chagall, it had largely fallen out of favour – only in the 1960s was its potential explored by a new generation of artists.

Following his sabbatical, monoprints, mostly untitled, and other abstract paintings were exhibited at the Glasgow School of Art and the staff club of Strathclyde University. Stewart was not particularly concerned with titles, and actively disliked artists' statements about their painting, but he had strong views about the overall appearance of the framed work (occasionally positioning a work off centre within the frame) and the design of his exhibition. Each of the fifty paintings in his 1968 exhibition was the same size and framed identically, which unified the exhibits and, according to most critics, attested to his impeccable taste, although a few thought variety of scale was to be preferred.

The originality of this work and the sophistication of the Procion medium were recognised by Richard Demarco, who invited him to exhibit in his 1968 Edinburgh Festival Exhibition where Stewart showed five works in company with, among others, William Crozier, Lord Haig, John Houston, Bet Low and Robin Philipson. The following year, in November, Demarco showed twenty

Clockwork Landscape, 1969; signed:
Stewart October 69; Procion on paper;
72.5 × 97.8 cm (28¹/₂ × 38¹/₂ in.);
exhibited Richard Demarco Gallery,
Christmas 1969
Photo and collection Jimmy Cosgrove

of Stewart's works in a one-man show. This exhibition was part of a pro-
gramme that juxtaposed the concrete poetry of Ian Hamilton Finlay and the
box constructions of Fred Stiven with the impressionistic work of Pat
Douthwaite. Demarco also took Peter Jones, Visual Arts Officer of the Welsh
Arts Council, and the Romanian artists Paul Neagu, Ion Bitzan, and Peter and
Ritzi Jacobi, the latter a tapestry weaver, to visit Stewart in his studio.

Demarco believed that Stewart personified the zeitgeist of the 1960s and
the cross-over between art and design. Recently he stated that:

It seemed inevitable that I should wish him to be regarded as a fine artist
capable of making art works which struck a note of experimentation and
hinted at the European avant-garde touching upon the Scottish art world.
I remember linking his work with artists I believe deserved to be taken into
account who at that time lacked proper patronage. Among them was
Robert Cargill who, like Robert Stewart, delighted in making art from a
variety of media, questioning the limitations of the painted image upon

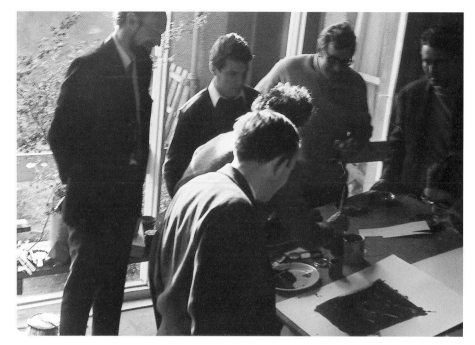

canvas or paper. Robert Stewart helped to give me high hopes of the future for Glasgow School of Art in that he seemed well prepared to develop the nature of painting in Scotland so that it was recognisably in harmony with the tradition of the European post-war avant-garde. I was encouraged by the fact that his exhibition was in every sense a success, it was a near sell out and serious collectors were attracted, not only to his imagery, but also to his extraordinary skill in using Procion dyes to make manifest his love of colour. I felt both a sense of pride that I was able to recognise the serious fine artist that he was and frustration that other institutions in Scotland did not follow the example of the Demarco Gallery.

ABOVE, LEFT AND RIGHT: Stewart in his studio demonstrating his use of Procion during a visit by Richard Demarco and his Romanian artists, 1969
Photos Richard Demarco, by kind permission of the Demarco European Art Foundation

Demarco recommended that to have his work fully and more widely recognised Stewart would be advised to leave Scotland and work elsewhere.[2]

Certainly Stewart was much more influenced by European artists than by the work of other Scottish artists. He may have been aware of the young Italian painters around the 'Fronte Nuovo delle Arti' who emerged in 1948: painters such as Birolli, Sontomaso and Corpora whose work, like his own later work, although in appearance abstract, was imbued with emotional responses to landscape but was not a direct study from nature but a controlled composition of form and colour. In Nicolas de Staël's late landscapes, Stewart would appreciate the balance between abstraction and representation and the play of flatness of plane and colour that conveyed a sense of light and distance without denying the painted surface. Stewart would have been familiar with this work at first hand as he was invited to exhibit in 1960 at the 66th Exhibition of the Scottish Society of Artists in Edinburgh, which also included a special exhibition of De Staël's work.[3]

[2] Interview, 16 May 2002

[3] Stewart exhibited fourteen works, including monoprints and graphics, catalogue nos 166–179

Untitled; signed: Stewart January 1968;
Procion and grease on paper;
67.5 × 50.8 cm (25 × 20 in.)
*By kind permission of the Hunterian Art
Gallery, University of Glasgow*

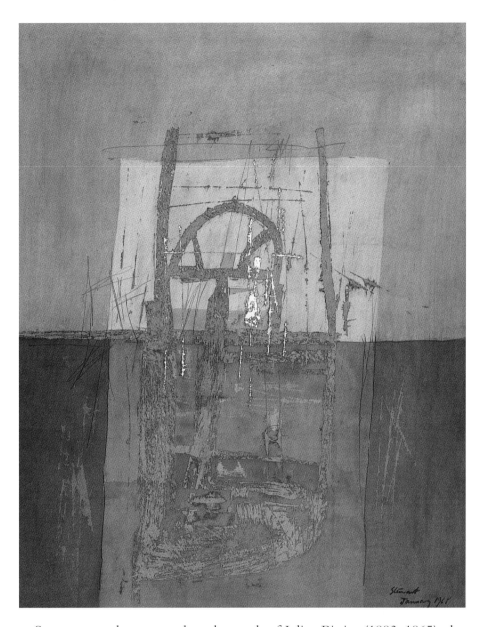

Stewart was also attracted to the work of Julius Bissier (1893–1965), the German artist, whose exploration of the monoprint technique became known in the post-war years. A religious spirituality underpins Bissier's work that includes basic forms as symbols. But Bissier was more concerned with the aesthetic using an ink-painting technique or oil and egg tempera on torn-off pieces of canvas to produce attractive miniature works that included small areas of gold or intense colour offset by more subdued tones. Like Bissier, Stewart revealed little of himself in his painting and personal references are oblique and difficult to unravel.

Antoni Tapies, the Catalonian artist, who worked in various media and whose work is an amalgam of naturalism and symbolism also influenced Stewart.[4]

[4] Stewart owned a copy of *Derrière Le Miroir*, November 1967, which featured lithographs and illustrations of other work by Tapies, that show a marked relationship to the development in Stewart's work.

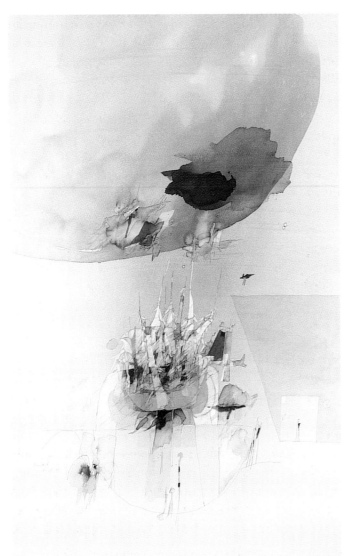 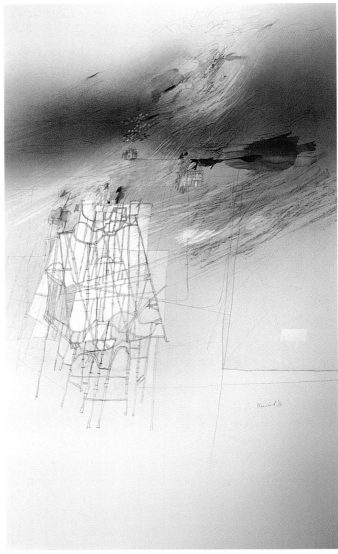

Tapies, like Stewart, loved the grandeur of mountains and wild weather and the strength and vigour of nature. He believed that contemplation was not enough for artists and that they must also constantly experiment with different materials. As Juan Eduardo Cirlot put it, 'Tapies was looking for the coincidence between the textures of the materials of the outside world and the psychic impressions that correspond to them.'[5] In his search, Tapies produced many works on paper that are an exploration of the creative process. In these, he contrasts form and formlessness, bold, deliberate marks with scribbles. And just as Leonardo looked at damp stains on walls or changing shapes in clouds and other artists used automatic writing to liberate their subconscious, Tapies used random marks from peeling walls or bark and graffiti to stimulate his creative imagination; and he frequently incorporated universal signs such as stars, the moon and crosses. But the walls were more than simply a source of imagery; for Tapies they were redolent with past incident, whether grazed by vehicles or pitted by bullets and these marks

ABOVE LEFT AND RIGHT:
Organic Forms and Numerals, 1978; signed: Stewart '76; Procion and gouache on paper; 101.5 × 76.2 cm (40 × 30 in.). Exhibited Compass Gallery 1978 and used as the catalogue cover. Exhibited Collins Gallery, Strathclyde University, 1980.
Artist's photo, collection Sheila Stewart

Farm Machinery, 1976; signed: Stewart '76; Procion and gouache on paper; 101.5 × 76.2 cm (40 × 30 in.)
Collection Mr and Mrs A. S. Matheson

[5] *Destino* no. 949, 1955 quoted in Alexandre Circi's *Tapies Witness of Silence*, Barcelona, 1972, p. 33

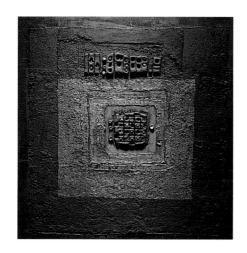

Ceramic panel, 1969; signed: Stewart '69; 45.7 cm (18 in.) square. Exhibited, Scottish Design Centre, June 1969
Photographed by the artist during the exhibition, collection Sheila Stewart

BELOW LEFT AND RIGHT:
Ceramic panel, 1971; signed: Stewart '71; 45.7 cm (18 in.) square
Artist's photo, collection Sheila Stewart

Ceramic panel, 1971; signed: Stewart '71; 45.7 cm (18 in.) square. Exhibited at the Collins Gallery, Strathclyde University, 1980
Collection Mr and Mrs A. S. Matheson

provoked a strong emotional response. Similarly, Stewart was emotionally interested in signs of earlier life in the harsh Scottish landscape, whether it be a ruined croft, Jacobean fortification or an abandoned fishing vessel, all held a fascination and fuelled images which fused with the landscape and weather conditions. Working directly outdoors, often in windy conditions, restricted his physical movement and affected the application of line and colour enabling him to capitalise on the looseness of mark making and texture that resulted.

From Tapies, Stewart learned how he could deal with landscape and how he could marry techniques. Stewart continued his investigation through the use of clay. He began using the large 18 in. (47.7 cm) square ceramic bats (kiln shelving) which he also used for printing. These were the foundation on which various designs were worked in enamel colours. Some were light, glossy decorative designs of the head and shoulders of figures with a folk art influence, perhaps reflecting his visit to Czechoslovakia during 1968, others were abstracts or made with specific individuals in mind. But perhaps the most interesting were darker, textured abstracts and those inspired by landscape. These are more akin to his paintings.

Stewart's was a non-technical approach. He ignored the chemistry and devised a unique method, taking what was almost a direct painterly approach to the use of clay. Texture was built up in clay to which coarse sand or grit had been added. Working quickly, he scored or combed into this to break up the surface, to create a thick impasto. To add richness to the tactile surface, layers of enamel colour were built on top before the final carefully placed punctuation marks of smooth metal rivets, colour and gold or other metallic lustres were added. Each panel required multiple firings and owed much to his ability to recognise opportunities and to take advantage of changes during firing. Working so freely, with such a direct approach to clay,

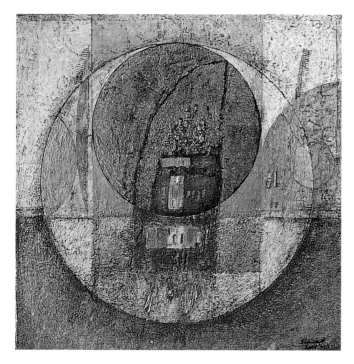

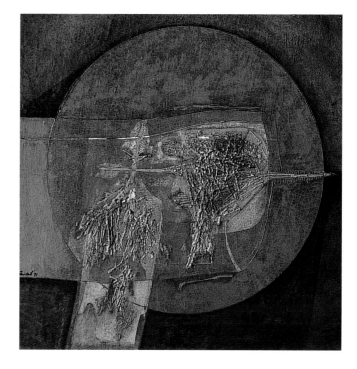

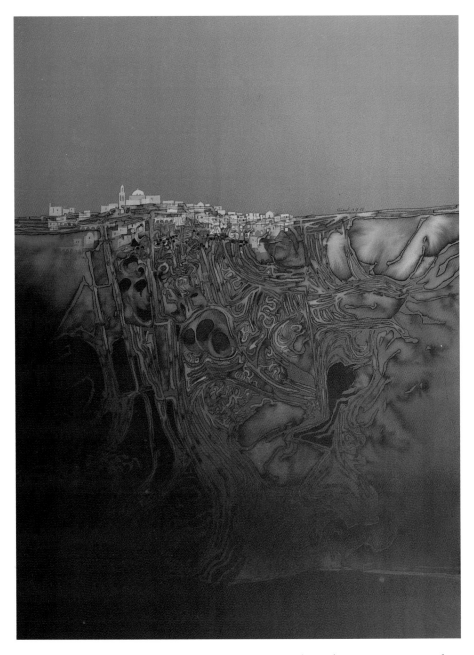

was unusual and his originality was recognised at the time. Even today, ceramic artists rarely work in such a free manner.

The Scottish Design Centre featured several of these ceramic panels at the Handwerkmesse exhibition in Munich in 1968 for which the artist was awarded the Bavarian Gold Medal.[6] The ceramic panels were displayed in room settings featuring furniture and textiles made by twenty Scottish firms and designer-craftsmen. Although Stewart had 'no grand illusions about receiving the gold medal which came as rather a surprise, it did allow him to pursue Germany as a possible outlet for work and was reasonably successful.'[7] In addition, the Scottish Design Centre, which relocated to new

[6] Later stolen from his home in a burglary
[7] Undated letter to H. J. Barnes, Barnes correspondence, Glasgow School of Art archive

PAINTING AND LANDSCAPE: A SENSE OF PLACE

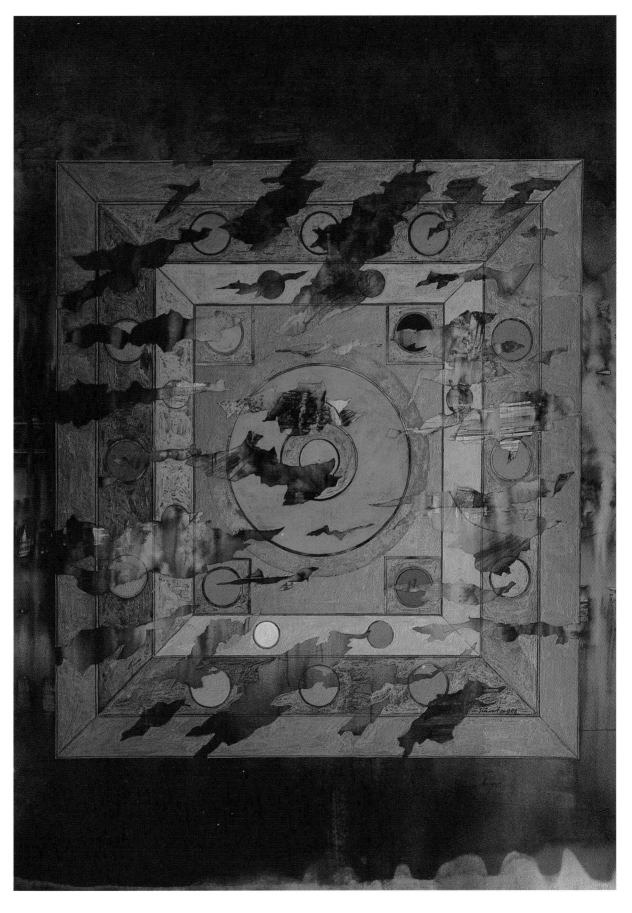

premises in St Vincent Street, Glasgow, offered to hold an exhibition of his ceramic panels. The Design Centre and exhibition of Stewart's work were opened by HM The Queen in June 1969. The work sold well (several banks purchased) and he continued to make them for several years, often giving them to friends and as wedding presents to former students and colleagues. Later, in October that same year, he also had a one-man show at the Caballa Gallery, Harrogate.

Another exhibition of his paintings was held in the Compass Gallery, Glasgow, in 1978. He exhibited twenty-six works, most of which were sold. Several were the result of visits to the Algarve and Santorini 'remembered in warm tinted pictures of tiny white buildings encrusted on the horizon's rim and astride the grainy fabric of the land beneath like icing on a cake.'[8] Other works showed new developments, some painted in delicate opalescent hues incorporating letters or numerals, others such as 'Zodiac' suggest either layers being peeled away or transient clouds fleetingly passing over the surface. The latter effect was used with great impact in the design for the Glasgow Cathedral tapestry the same year.

After his retirement from GSA and during his illness, he was resentful and angry at having to retire. He must have missed working with his colleagues, the constant discussions and feedback on his work and also the stimulus of young student minds. However, when he recovered, he continued to find inspiration from landscape. This was first expressed in air drying modelling clay discovered by his youngest daughter who had a Saturday job in a Dunoon toyshop. These small-scale intimate pieces were made to simulate old stones or perhaps fragments of leather and incorporate ancient marks and symbols found on the carved stones in the Argyll countryside. Others were inspired by marks carved into the stonework of a bridge at Inverary, a tryst where the cattle drovers met their young women. He made casts of some of these poignant marks and pressed them into the clay, combining them with letter forms from old print blocks and personal marks of his own before finally working them up with Procion dyes, printer's ink, gold and silver. The results reflect his enjoyment in manipulating clay and colour and his pleasure in the quality of the marks, but also perhaps make a statement about the continuity of man's impact on and affinity with the landscape of Argyll. As with all his work he pursued this development energetically and showed them at an exhibition in the Peacock Print Studio, Aberdeen, during the mid 1980s, and also in an exhibition in the premises of N. S. Macfarlane, Charing Cross, Glasgow.

In his last years, ill and with little energy, only able to work on a small scale, yet still determined to continue his creative work, Stewart produced small paintings with Celtic imagery, fragments of remembered landscapes and religious symbols in soft warm colours and gold. He also began to work in enamels. He may have remembered that Bissier had created a series of jewel-like enamels in his exploration of colours that had a floating transparent quality. Although throughout his life Stewart was fascinated by the technique

[8] Unidentified press cutting review of the Compass Gallery exhibition

Enamels, early 1990s; 5 cm (2 in.) square
and 6.3 cm (2½ in.) long
Collection Sheila Stewart

he did not explore and exploit the medium, instead he chose to paint, with
the finest of brushes, miniature landscapes of great delicacy, mainly on sheets
of copper, usually square, occasionally oval. Typically, he produced great quan-
tities, often giving them away to visitors and friends and also applied them to
the invitations to his youngest daughter's wedding. He continued working in
this way until almost the end of his life.

COMMISSIONS

Tapestry

1970	• 'Genesis', University of Strathclyde
1979	• Glasgow Cathedral
1982	• 'Glescau' Glasgow City Chambers

Ceramic murals

1960	• First-class swimming pool, SS Oriana
1963	• Fireplace and mural, Campsie Glen Hotel, Lennoxtown – destroyed, hotel demolished
1964	• Royal Garden Hotel, Kensington, London – destroyed, hotel demolished
1964/65	• Greenock Underpass – damaged by contractors, restored by Bill Brown, GSA
1965	• Adelphi Street School, Gorbals, Glasgow – school now a business advice centre, mural still in place
1965	• Eastwood High School, Newton Mearns
1965	• West Dumbartonshire Burgh Offices
1965	• Tappit Hen Restaurant, Brabloch Hotel, Paisley – plastered over, restaurant and mural soon to be demolished
1966	• Douglas Academy, Bearsden
1967	• Motherwell and Wishaw Concert Hall (four murals)
1966/67	• Casino, Isle of Man – destroyed by fire
1973	• Departure lounge, Prestwick Airport
1973	• Private commission, Glasgow
1974	• Hebridean and Highlander Restaurants, Queen Street station, Glasgow – destroyed, site redeveloped
1974	• Public swimming baths, Elderslie
1975	• Glendaruel and Kilmodan Primary School
1976	• Cinema, Dunoon
1978/79	• Brandon Shopping Centre underpass, Motherwell
date unknown	• Altar steps, St Joseph's, Faifley, Glasgow – destroyed by fire
date unknown	• Private commission by Richard Attenborough, Isle of Bute

SELECTED READING LIST

Britain Can Make It, exhibition catalogue, HMSO, London, 1946

The Daily Mail Ideal Home Book, London, 1951–57

Design Magazine, Council of Industrial Design, London, 1949–

Designers in Britain: a Biennial Review of Graphic and Industrial Design, Society of Industrial Artists, London, vols 1–5, 1947–55

Graphis, journal

House and Garden, Condé Nast, London, 1948–56

Lesley Jackson, *The New Look: Design in the Fifties*, Thames & Hudson, London, 1991

Lesley Jackson, *Robin and Lucienne Day*, Mitchell Beazley, London, 2001

David Jeremiah, *Architecture and Design for the Family in Britain*, Manchester University Press, Manchester, 2000

Patrick J. Maguire and Jonathan M. Woodham, *Design and Cultural Politics in Postwar Britain*, Leicester University Press, London, 1997

Alastair Morton and others, *The Practice of Design*, Lund Humphries, London, 1946

Herbert Read, *Education through Art*, 3rd edition, Faber & Faber, London, 1958

Mary Schoeser, *Fabrics and Wallpapers, Twentieth Century Design*, E. P. Dutton, New York, 1986

Penny Sparke (ed.), *Did Britain Make It? British Design in Context 1946–86*, Design Council, London, 1986

Penny Sparke, *An Introduction to Design and Culture in the Twentieth Century*, Unwin Hyman, London, 1986

Richard Stewart, *Design and British Industry*, John Murray, London, 1987

The Studio Yearbook of Decorative Art, Studio Publications, London, 1943–64

Drawing, 1958

Design for silk screen, 1958 (see p. 106)

INDEX

Page numbers in *italic* represent illustrations